THE ART OF THE COSMOS

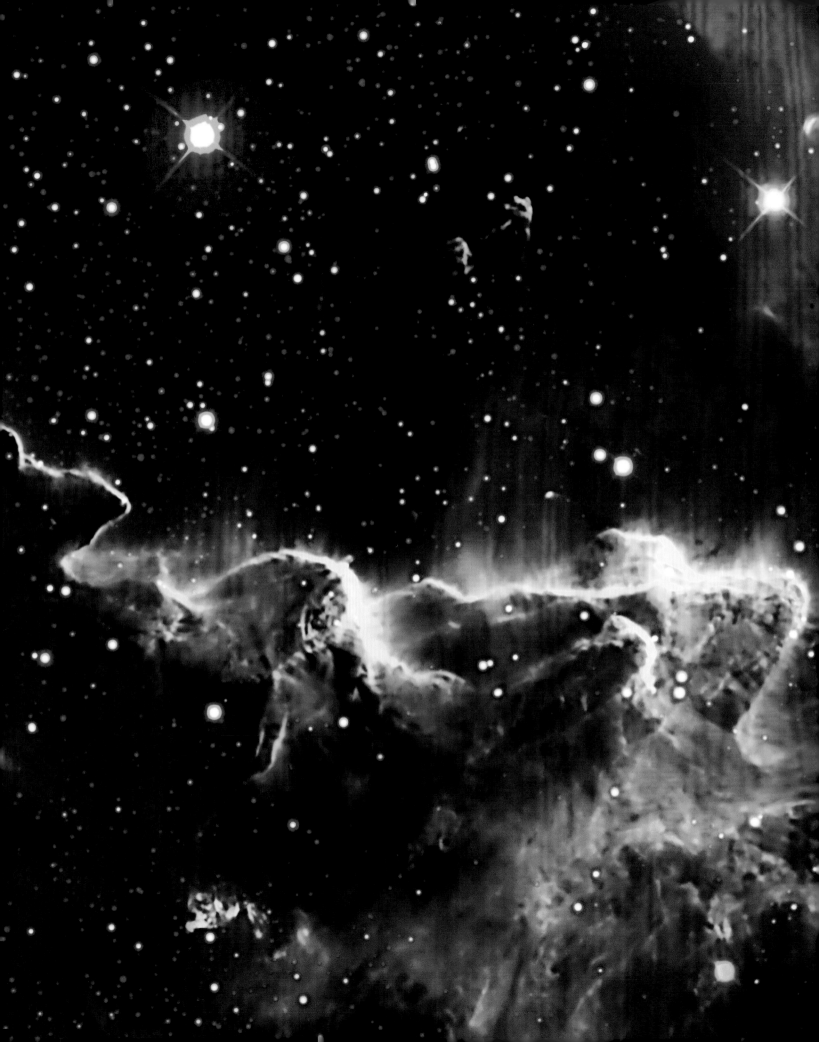

THE **ART** OF THE **COSMOS**

VISIONS FROM THE FRONTIER OF DEEP SPACE EXPLORATION

JIM BELL

U

UNION
SQUARE
& CO.

NEW YORK

UNION SQUARE & CO. and the distinctive Union Square & Co. logo
are trademarks of Sterling Publishing Co., Inc.

Union Square & Co., LLC, is a subsidiary of Sterling Publishing Co., Inc.

ISBN 978-1-4549-4608-3
ISBN 978-1-4549-4609-0 (e-book)

For information about custom editions, special sales, and premium purchases,
please contact specialsales@unionsquareandco.com.

Printed in China

2 4 6 8 10 9 7 5 3

unionsquareandco.com

Cover design by Igor Satanovsky
Interior design by Kevin Ullrich

Picture credits—See page 212

DEDICATION

This book is dedicated to the many scientists, engineers, explorers, and artists who,
together, have created stunning works of art that reveal and celebrate
the beauty, mystery, and sheer awesomeness of our universe.

i: A view of the Helix Nebula, also known as the Eye of God, taken by ESO's Visible and Infrared Survey Telescope for Astronomy (VISTA). The colored picture was created from images taken through Y, J, and K infrared filters. ii–iii: A portion of the Lagoon Nebula imaged by Argentinean astronomers Julia Arias and Rodolfo Barbá using the Gemini South telescope with the

Gemini Multiple-Object Spectrograph. iv–v: The Milky Way over Saguaro National Park outside of Tucson, Arizona, photographed by Jeff Abong.

TABLE OF CONTENTS

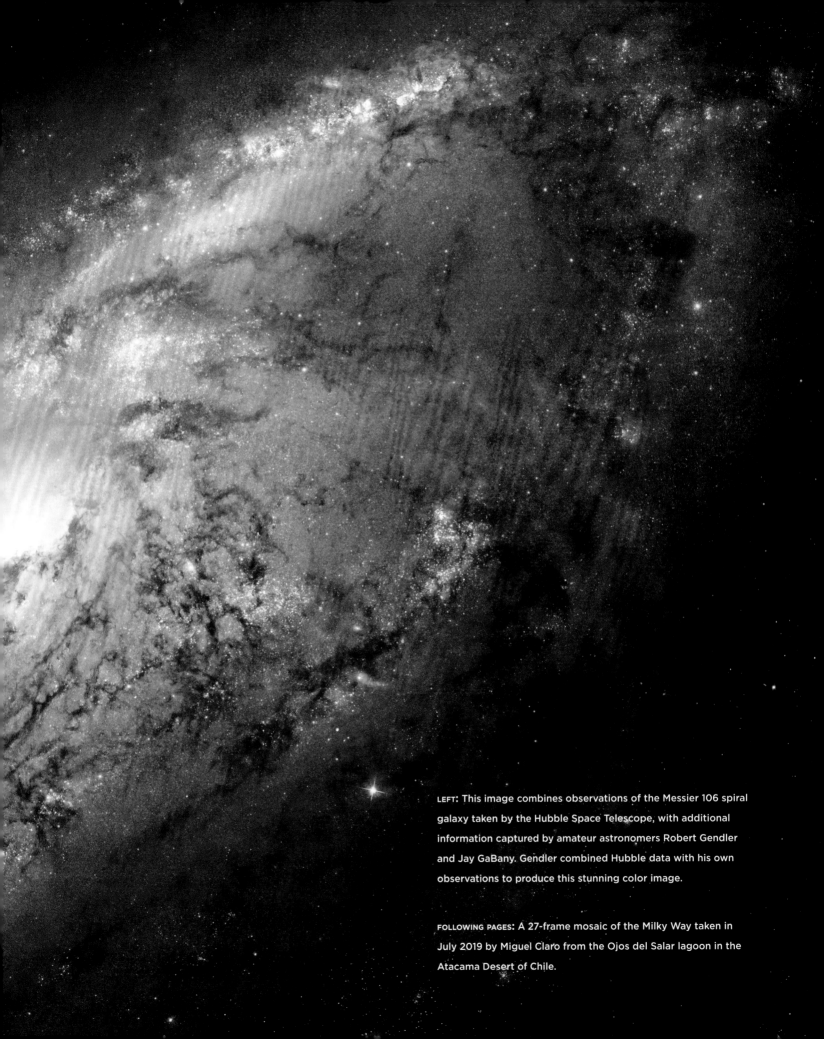

LEFT: This image combines observations of the Messier 106 spiral galaxy taken by the Hubble Space Telescope, with additional information captured by amateur astronomers Robert Gendler and Jay GaBany. Gendler combined Hubble data with his own observations to produce this stunning color image.

FOLLOWING PAGES: A 27-frame mosaic of the Milky Way taken in July 2019 by Miguel Claro from the Ojos del Salar lagoon in the Atacama Desert of Chile.

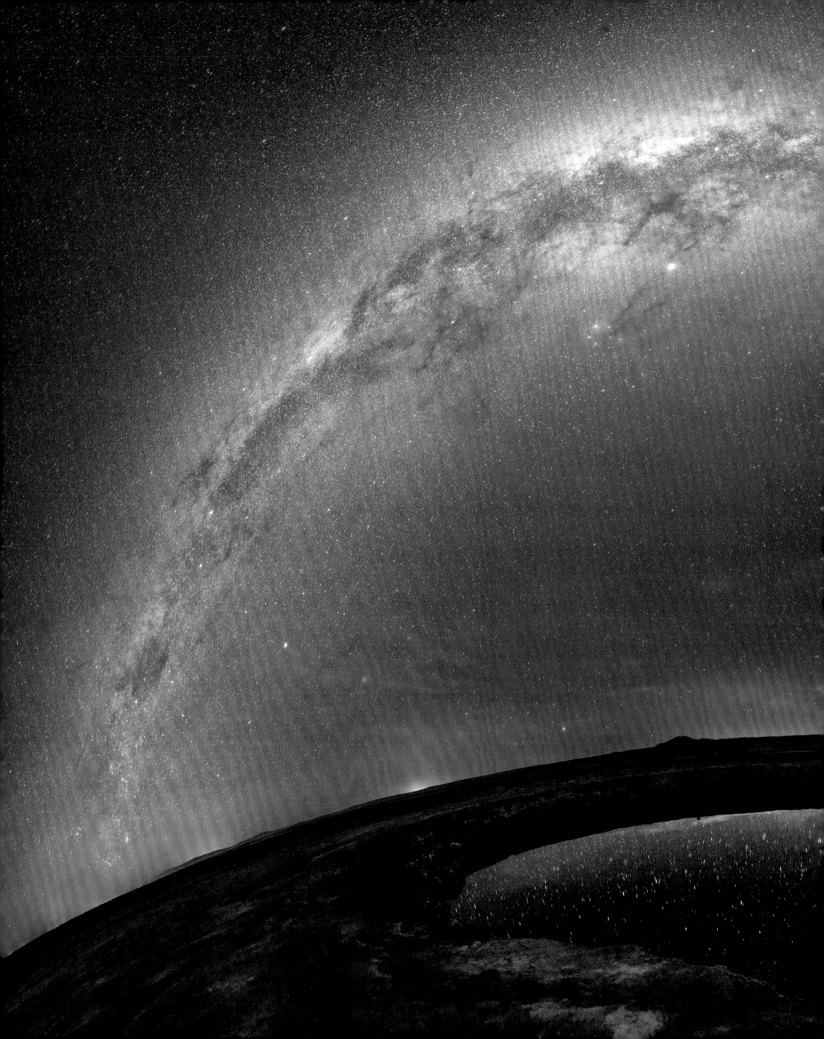

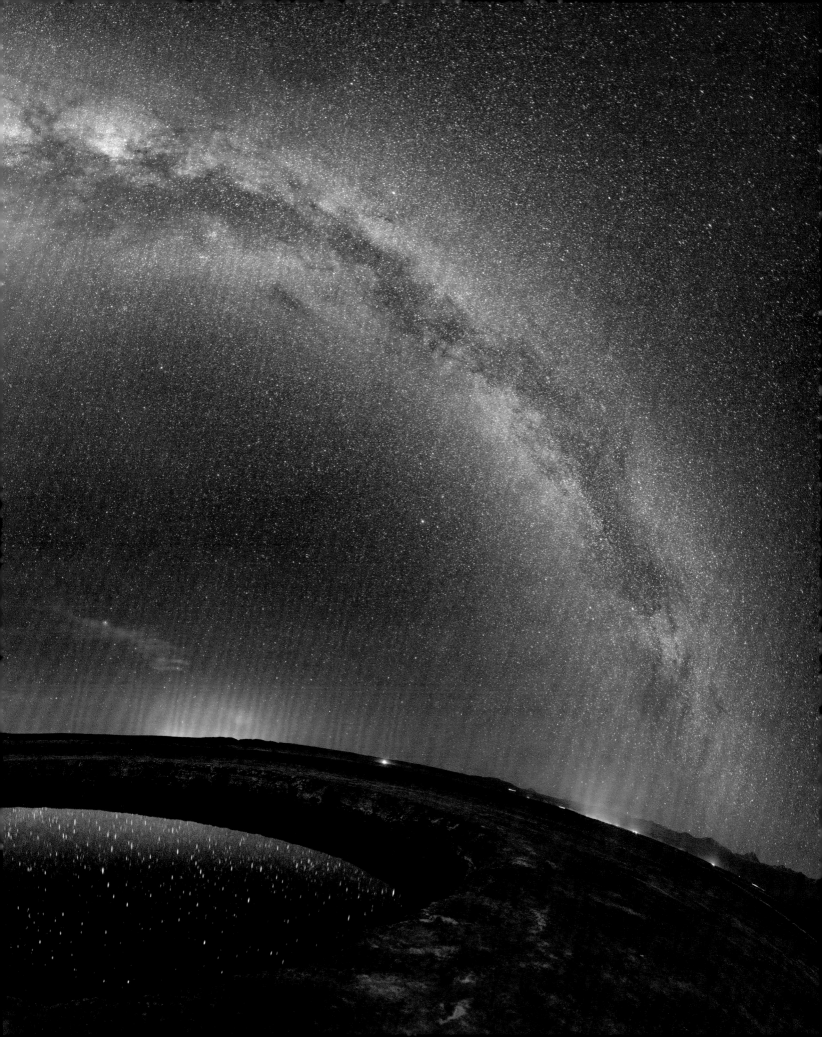

INTRODUCTION

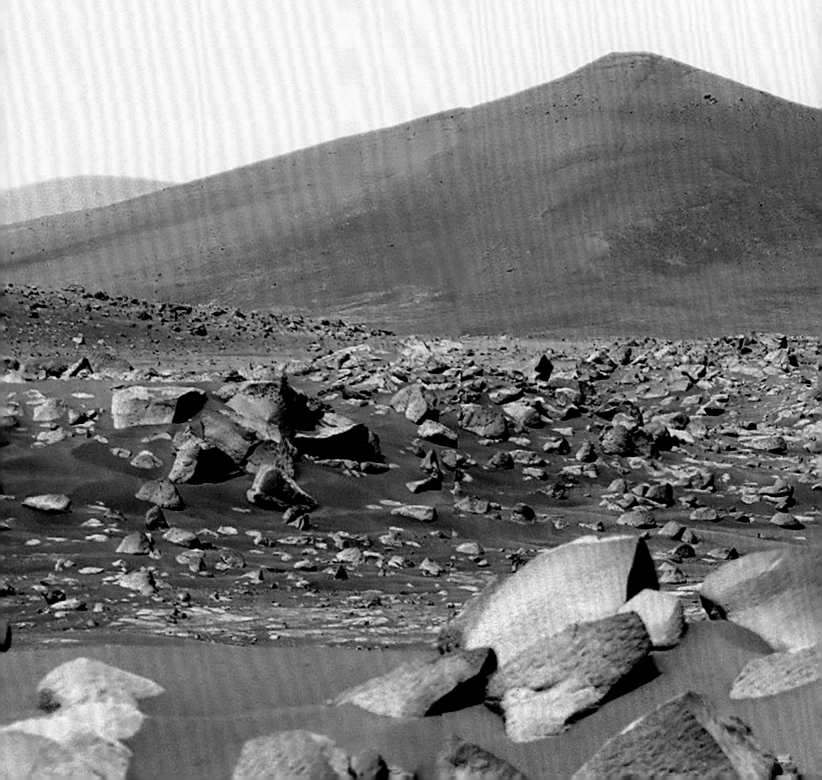

"Photography is an art of observation. . . . It has little to do with the things you see and everything to do with the way you see them."

—Elliott Erwitt, French-American photographer

remember the first sunset I ever saw on Mars. It was in August 1997, and I was living on the Red Planet with a bunch of colleagues who were also working on the *Mars Pathfinder* mission. Of course, we weren't actually *on* Mars. Rather, we were working at NASA's Jet Propulsion Laboratory (JPL) in Pasadena, California, and experiencing Mars virtually and vicariously through the eyes of some high-tech robotic avatars. Pathfinder was only the third mission to successfully land on Mars, more than 20 years after the two Viking lander missions had first done so. Our team helped design, build, and test *Pathfinder*'s digital cameras, and we had spent the month since landing giddily photographing and analyzing the ruddy rocks, soils, and distant hills.

The mission had a huge online following that summer—the Fourth of July landing had been the largest event in the (young) history of the internet! Many of us were keen to try something new, to share with the public our excitement about the mission and the thrill of "being on Mars" again in some tangible, familiar way. Our camera team leader, Peter Smith, was open to new ideas about what to photograph, even if it meant straying a little far afield from our specific geologic-mapping science goals. He and colleagues Martin Tomasko and Mark Lemmon

Mars, as seen from the NASA rover *Perseverance*, showing the ancient rocky plains of Jezero crater and the distant photogenic hill named Santa Cruz.

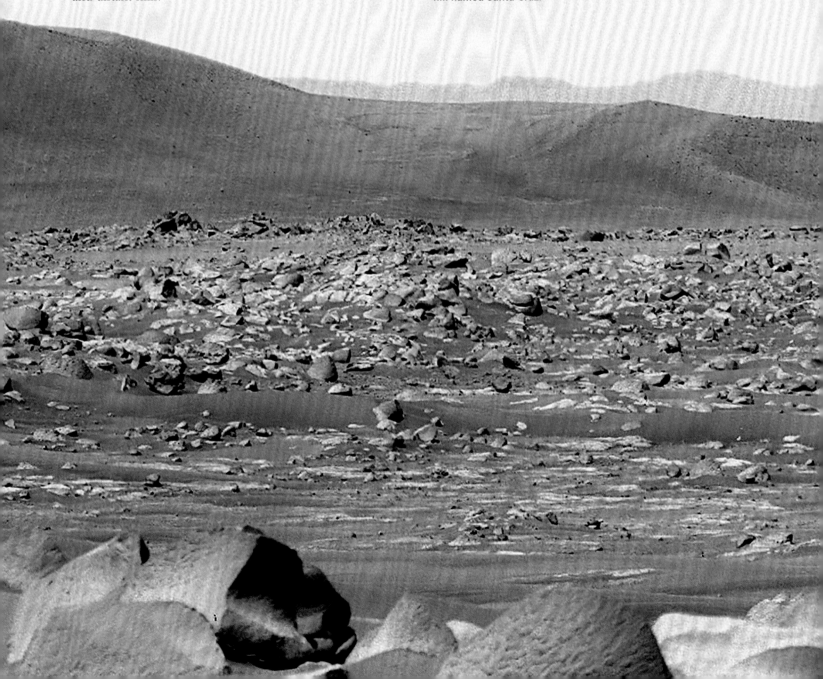

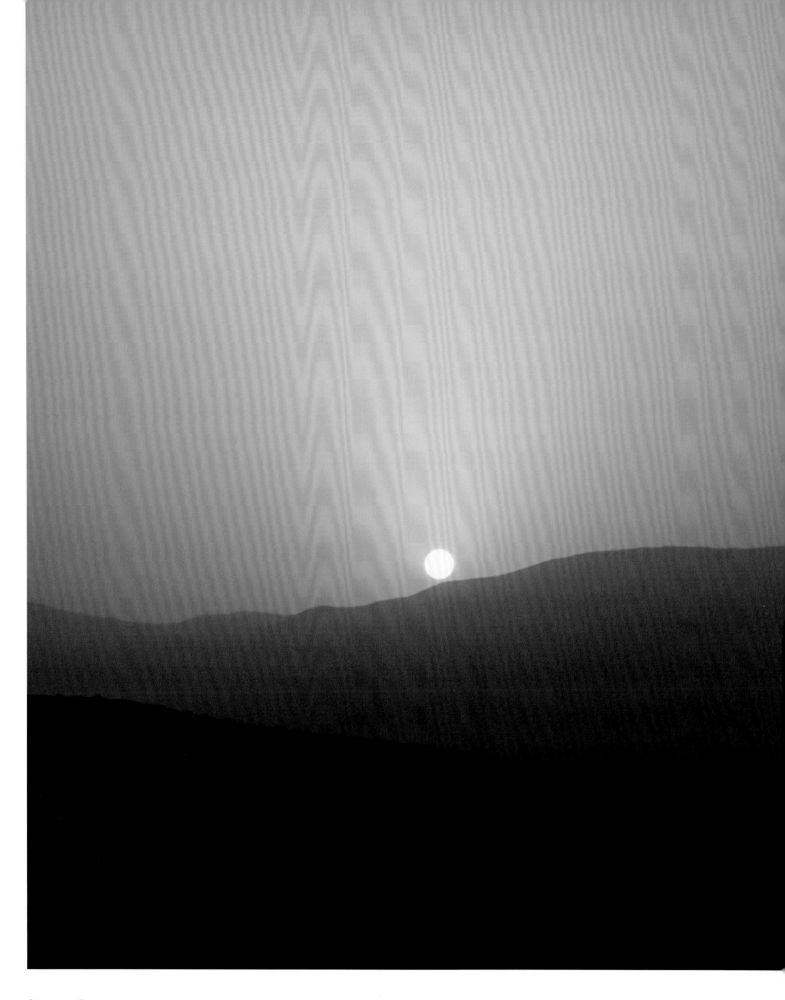

were all interested in studying the planet's atmosphere as well as its surface, so they hatched a plan to try to photograph the setting Sun on another world.

The Viking landers had photographed the twilight sky around sunset back in 1976, but it wasn't possible to actually see the Sun itself without saturating the cameras. We predicted that the more advanced digital cameras on *Pathfinder*, with their greater dynamic range, should be able to do it, but it also depended on how much dust there would be in the atmosphere when we tried. If there was an average amount of dust or more, that would help to dim the Sun along the horizon and the photo wouldn't be overexposed. But if there was a less than average quantity of dust in the air, we might just get a washed-out view. Smith, a bit of a romantic who was always eager to try to make our work interesting and relatable to the general public, was game to try.

The result, seen at left, was both beautiful and surprising. The dust did its part and helped to dim the Sun just enough so that we could see it, hanging there, just above the hilly horizon. But it wasn't yellow or even red, like a sunset through dusty air on Earth—it was light blue. In fact, the part of the sky all around the setting Sun had turned from its normal Martian reddish-ocher hue to a distinctly bluish color. How strange! How lovely! And how distinctly Martian. The gas and dust in that thin atmosphere scatters light very differently than in Earth's. Here, our thick atmosphere scatters blue light away from the Sun, turning it reddish-orange at sunset. On Mars, blue light is not scattered as much and red light is absorbed by the dust, imparting that bluish hue on the scene.

My colleagues got a great research paper out of the photo, but, more importantly, we were able to share an incredible experience—a gorgeous alien sunset— with millions of people around the world. It was a transformational moment for me on another level as well, though. I realized, for the first time, that we could do more than just "take photos"—more than just dispassionately and objectively document the scene around us (as many

A light blue dusty sunset on Mars, photographed by NASA's *Curiosity* rover on April 15, 2015.

think that scientists are only supposed to do). We could, and did, create art.

I think of that *Mars Pathfinder* sunset photo—and even higher-resolution ones that we've taken from cameras on subsequent missions, like NASA's *Curiosity* rover—as art. This is not just because they are beautiful, but also because they exhibit stylistic elements found in other examples of fine art photography: lines that divide and focus the viewer on distinctive scene elements; a sense of depth and framing from near and far horizons and haze; and variable levels of contrast, lighting, and silhouettes that make a scene both familiar and dramatic. Photos like these also carry counterintuitive contextual and situational elements: the photograph on pages 2–3 might be a sunset on Earth but for the unexpected colors of the Sun and sky.

Experiences like this remind us that we live in an incredible age of exploration. Not only have we mapped our own planet's continents, oceans, and interior, but we have also begun to extend our reach out into deep space (beyond Earth orbit, out to the Moon, to Mars, and beyond) to explore the wonders of the cosmos. Hundreds of deep space mission cameras since the 1960s have now taken stunning photos, revealing the beauty, grandeur, and mysteries of our solar system, our galaxy, and the Universe beyond. I believe that many of these photographs are stunning works of space art.

In this book, I showcase more than 125 of those photographs that I believe represent some of the finest examples of the art of deep space exploration. While many of these photos were taken by cameras on robotic planetary landers, rovers, orbiters, or space telescopes, the robots didn't produce the art; people did. Robotic missions and instruments are built by and operated by people back here on Earth, who get to plan and compose the photos, choose the timing and the framing, set the exposures, and digitally process the images afterward. However, some of these artistic views were photographed by very few of us—those astronauts who have had the privilege of traveling into space—from as far away as the Moon, and likely farther in the not-too-distant future.

Why can some of these space photos, presumably mostly taken for scientific purposes, also be classified as art? There are many reasons. They offer us glimpses of reality, but from perspectives that are wholly outside of our human (Earth-dwelling) experience. They can portray the familiar in unfamiliar ways; for example, by showing us the Universe in parts of the spectrum that we cannot perceive with our limited range of human color perception. And they challenge our intuitive but geocentric understanding of the way things work by revealing how dramatic changes in size, gravity, temperature, pressure, or chemistry can result in landscapes or other natural vistas that seem completely unnatural to our earthbound selves.

If one of the roles of art is to extend our senses and our experiences into the realm of the unknown and the unfamiliar, to imbue us with a sense of awe and wonder at the glory and grandeur of nature, and to push the boundaries of what we know and feel, then deep space exploration has provided some of the most spectacular and humbling kinds of art that humans have ever produced.

I started dabbling in amateur landscape photography in high school. I had a decent Nikon single-lens reflex (SLR) film camera, and our photography club maintained a darkroom for developing and printing black-and-white film prints. It was a great introduction to the technology of imaging. The chemicals, paper, timing, and lighting all had to be carefully controlled. I learned that while there was a *procedure* for getting from what I saw through my camera lens to what appeared in the final print, there was also an enormous amount of room for *creativity*, *subjectivity*, and *interpretation* when shooting photos and developing prints. That photography is an art, not just a process, was a revelation to me.

Like many other nerd kids growing up during the 1970s, I was also inspired by space photography, from the Apollo astronauts as well as from telescopes and the *Voyager* and *Viking* robotic probes. I had a set of posters on my bedroom walls from Chicago's Adler Planetarium,

OPPOSITE: Garish Mars. This vibrant false-color photo is a composite of both visual and infrared photos from the NASA Mars *Odyssey* orbiter's Thermal Emission Imaging System (THEMIS). Shades of yellow to red show rocky mesas and ridges; bluer hues show windblown dunes and dust.

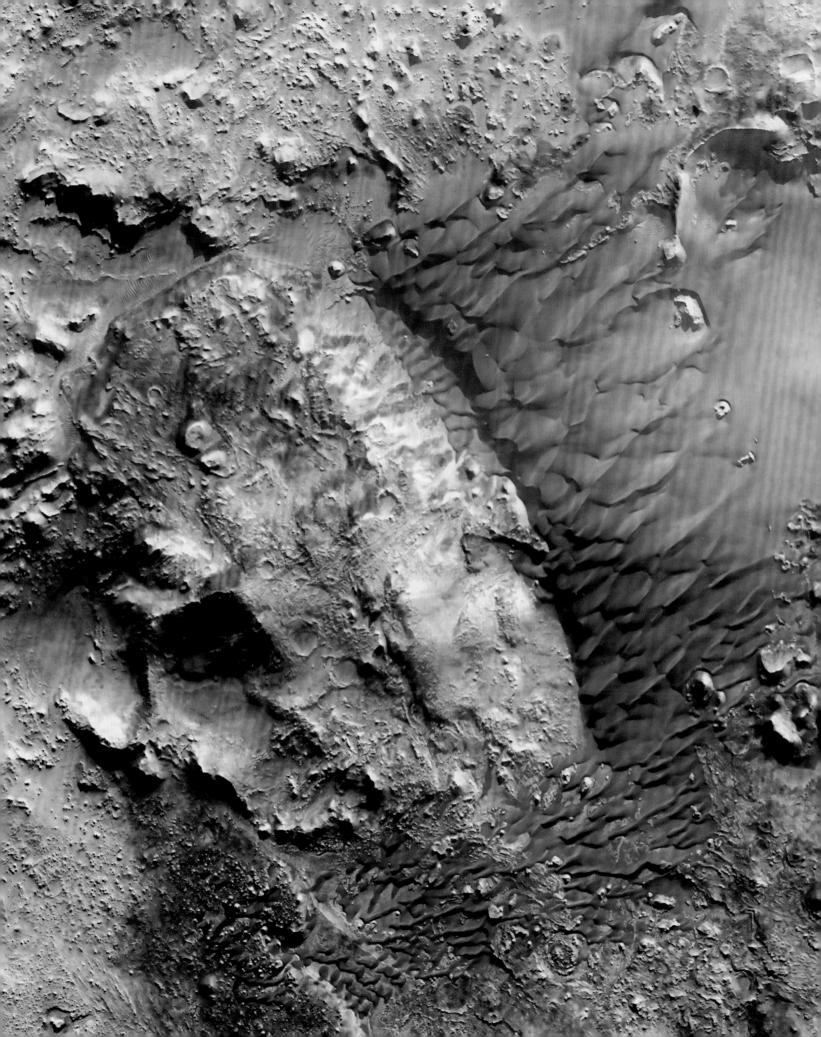

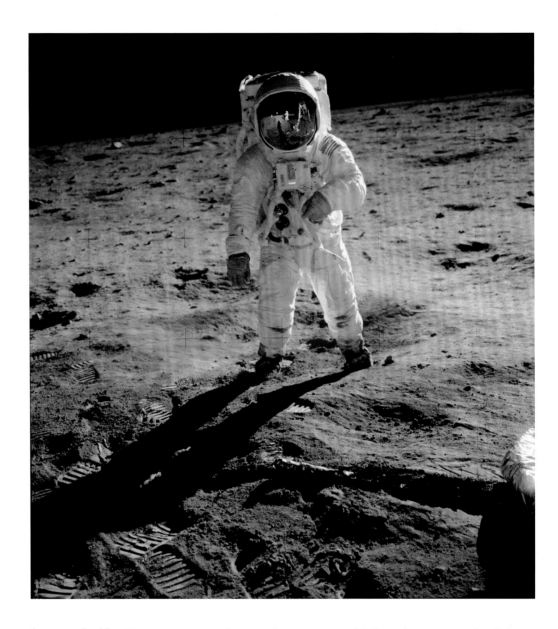

RIGHT: One of the most famous and transcendent photographs of the twentieth century: Astronaut Buzz Aldrin walking on the surface of the moon near the leg of the lunar module *Eagle* on July 20, 1969 during the Apollo 11 mission. Mission commander Neil Armstrong took this photograph with a 70mm lunar surface camera.

OPPOSITE: *Saturn as Seen from Titan*, by American painter, illustrator, and designer Chesley Bonestell (1888–1986). The painting was originally published in *Life* magazine in 1944, and is part of a larger panorama that was shown inside the dome of the Griffith Planetarium in Los Angeles.

showing some of the planets as photographed by *Voyager*, the Great Nebula in Orion as photographed from Yerkes Observatory in Wisconsin, and Buzz Aldrin as photographed on the Moon by Neil Armstrong (above).

But I was also tuned in to the fact that there are other kinds of space art, less literal and more interpretive. Paintings, drawings, and sculptures—art designed not so much to document but to allow us to speculate, imagine, and dream. The International Association of Astronomical Artists (IAAA), a guild formed by the growing number of talented and creative practitioners of this genre, defines *space art* as a "modern artistic expression emerging from knowledge and ideas associated with outer space, both as a source of inspiration and as a means for visualizing

and promoting space travel. Like other genres of artistic creation, space art has many facets and encompasses realism, impressionism, hardware, sculpture, abstract imagery, even zoological art."

I used to love checking out old library books and magazines with gorgeous and artistic drawings of celestial bodies and phenomena by nineteenth-century French artist and astronomer Étienne Léopold Trouvelot. Trouvelot's thousands of drawings and lithographs captured the science of his telescopic observations, but many of them are just simply beautiful pieces of space art (see pages 8–9). And I still enjoy browsing used bookstores for old science fiction stories accompanied by imagined planetary or astronomical scenes painted by one of the

founders of modern space art, Chesley Bonestell. Bonestell combined a lifelong love of astronomy with experience in painting, illustration, and miniature modeling to portray photo-like and seemingly realistic vistas of places that no one had yet seen. Mark Hilverda, a graphic designer and digital specialist with The Planetary Society, notes the extra efforts that Bonestell expended to make his paintings appear realistic. "While he had no reference images of the surface of Titan, he still went ahead and built a physical model of what the surface might have looked like," Hilverda told me. "He then lit that physical model and used it as a reference for his classic 1944 painting of *Saturn as Seen from Titan* (see below). It misses some details we know today, such as the hazy atmosphere, but provides

a fascinating look at the art processes from this time period." I had seen the rings of distant Saturn through my own small telescope for years. But the first time I saw Bonestell's view I felt as if I had been transported across the solar system and was actually standing there, on that icy moon, finally taking it all in.

When I asked him about other inspirational space art favorites, Hilverda, who often helps get works from space artists published in The Planetary Society's journal, *The Planetary Report*, turned me on to the spacey watercolors of planetary surfaces and atmospheres by graphic artist Fraser Hagen. "Watercolor can be a tricky medium," Hilverda told me, "which is part of why these also appeal to me. Hagen's control of gradients and color palettes

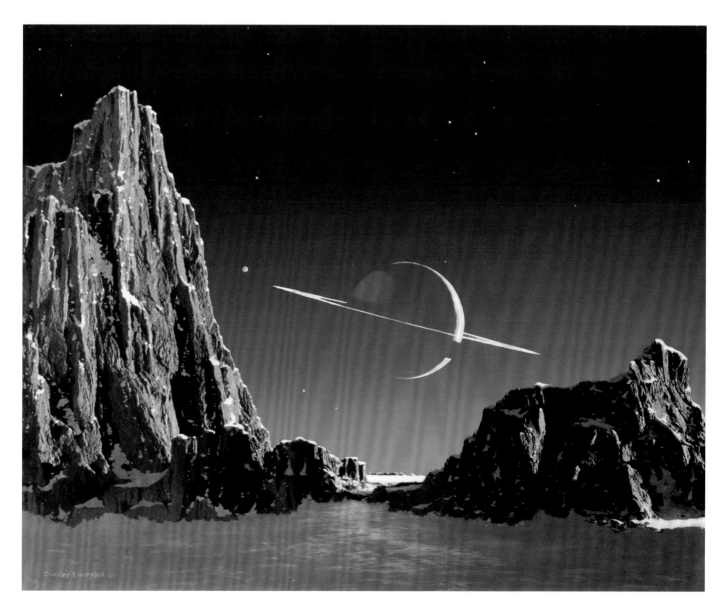

TOP: This 1881 color lithograph depicts Mare Humorum, a large lunar impact basin on the Moon. It was created by nineteenth-century French artist and astronomer Étienne Léopold Trouvelot, from a pastel study he made in 1875. By observing this region shortly after the Sun rose there, Trouvelot was able to discern and record a stunning variety of shapes and forms related to the local geology. The feel here is almost Art Deco, though about 50 years too early.

BOTTOM: Trouvelot's 1881 lithograph (after an 1877 study) of the great star cluster in the constellation Hercules, known by astronomers as Messier 13. The best telescopes available in Trouvelot's time could only reveal a small fraction of the stars in this cluster—the dispersed bright dots he drew here. The dim and ghostly background fog that he saw and drew around those bright stars would, in the twentieth century, be shown to be the combined light of several hundred thousand more stars, all bound together by gravity.

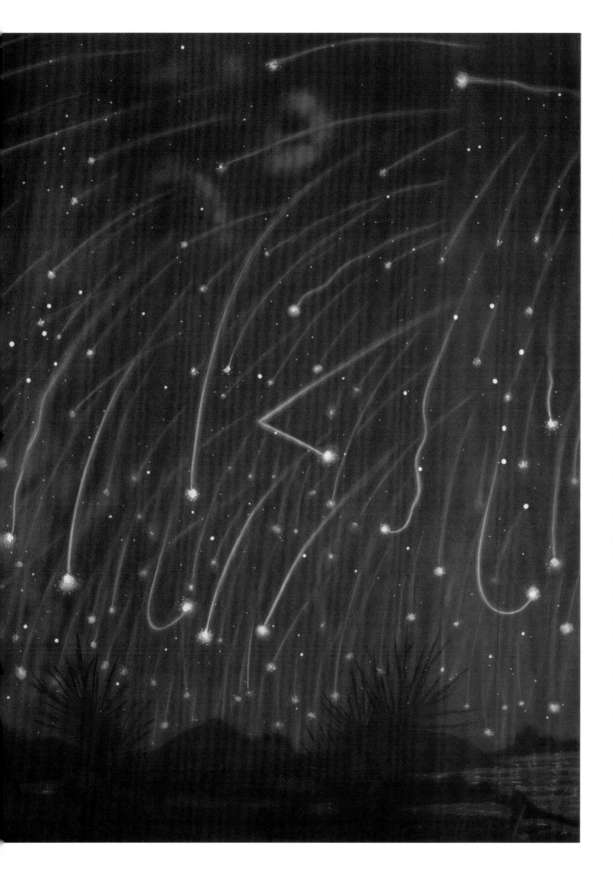

Trouvelot's illustration of the famous Leonid meteor shower of November 14, 1868, which reached a peak of more than 1,000 shooting stars per hour in dark skies. The lithograph here (after the 1868 pastel) is a composite: a sort of time-lapse drawing showing examples of the colors, trails, and sometimes wild trajectories of many of the most memorable meteors that he observed between midnight and 5:00 a.m. In the introduction to his 1882 book *The Trouvelot Astronomical Drawings Manual*, he reflected on his strategy and skill at recording and interpreting what he saw in the sky: "While my aim in this work has been to combine scrupulous fidelity and accuracy in the details, I have also endeavored to preserve the natural elegance and the delicate outlines peculiar to the objects depicted; but in this, only a little more than a suggestion is possible, since no human skill can reproduce upon paper the majestic beauty and radiance of the celestial objects."

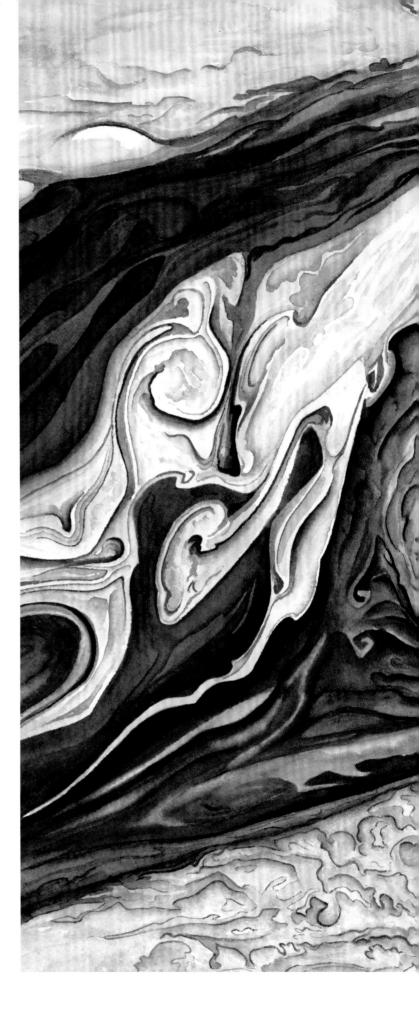

is really beautiful, bringing depth and texture to artistic views of worlds in our solar system." Some of Hagen's works, such as the one seen at right, make me feel as if I were gliding in a plane above those distant worlds.

I've had similar fanciful experiences with other forms of space art. The first time I saw some of glassblower Josh Simpson's imagined worlds from his *Planets* series (see page 13), I was reminded about the many ways that color, shape, form, and texture mingle in the atmospheres of real planets in our own solar system. Josh makes glass from a mixture of sand and other minerals, heated to 2,300°F (1,260°C). "When making *Planets*, I gradually build up and shape layer after layer of glass to create a solid sphere that looks (perhaps!) like an imaginary world in some distant galaxy," he told me. "I wanted to use glass to express my own interests, in particular my fascination with space, the cosmos, astrophysics, and the workings of the Universe. My *Planets* started out as simple marbles that I made to entertain children, each one containing an Earth-like little core inside a clear glass sphere. Gradually, the worlds became more and more complex as I explored different ways to express my ideas in glass. Now some of my largest *Planets*, called *Megaplanets*, are more than 13 inches [33 cm] in diameter and weigh more than 100 pounds [45 kg]." Science informs art, but given the hundreds of billions of real planets that are out there in our galaxy alone, even art may not be able to entirely capture the incredible diversity of planetary vistas that are waiting for us to discover.

While many space artists work in traditional hands-on media, the genre now fully encompasses the digital graphics art domain as well. For example, digital space artist Ika Abuladze creates stunning, fused montages of different planets that highlight both the diversity and commonality of worlds in the same pieces (see page 12). There is also the wonderful series of *Planetary Parks* and

Storms of Jupiter (2020), a watercolor painting by Canadian artist Fraser Hagen. Hagen describes the inspiration for the painting on his website: "As the largest storm in the solar system and twice the size of Earth, Jupiter's Great Red Spot roars across the planet. As the ferocious winds churn up the gases, vast bands of colorful clouds spill across the atmosphere."

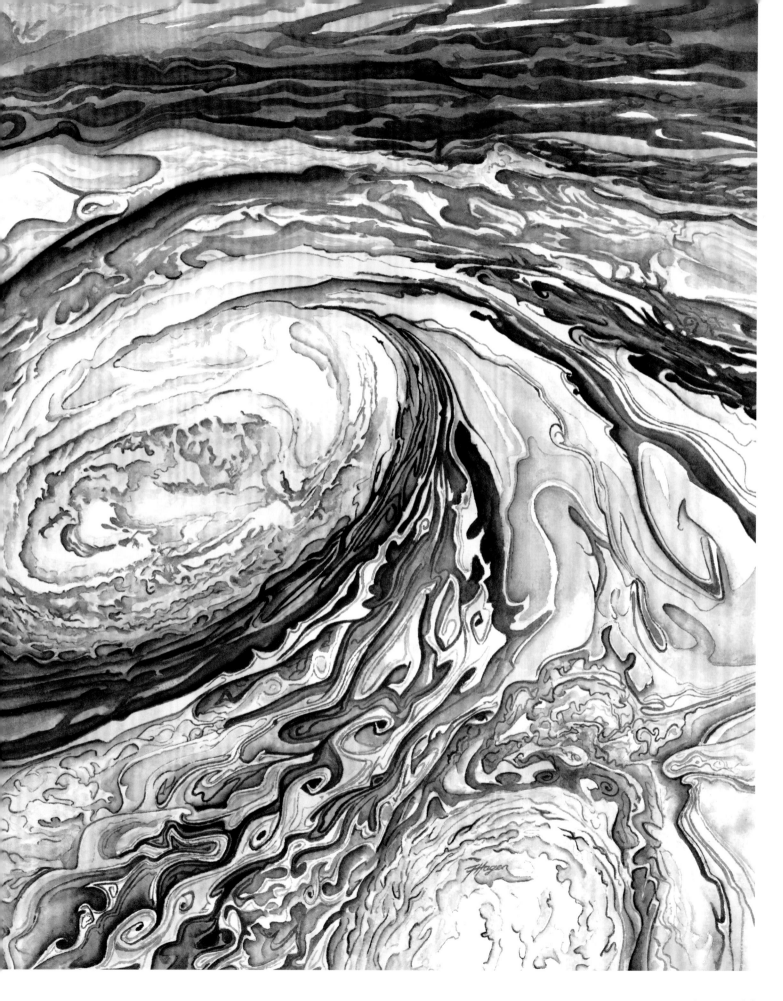

other similar Art Deco–style graphic arts travel posters that space artists Tyler Nordgren, Steve Thomas, and artists from NASA/JPL and SpaceX have put together, with titles like *Mars Explorers Wanted*, *Ski Pluto*, and *Enceladus Cold Faithful* (see an example on page 214).

Many more examples of both traditional and nontraditional space art are showcased online on sites such as the IAAA's Space Art Gallery, and in events and shows like the annual Spacefest gathering in Tucson, Arizona. As the IAAA points out, "Though artists have been making art with astronomical elements for a long time, the genre of space art itself is still in its infancy, having begun only when humanity gained the ability to look off our world and artistically depicted what we see out there." The community and variety of space artists continues to expand.

I've been able to keep working as an amateur landscape photographer over the past few decades as that artistic medium has transitioned into the digital age, and as more and more sophisticated cameras have been sent out into space. Indeed, I have been incredibly lucky over the course of my career to have a front-row seat on some amazing virtual voyages of exploration, using cameras on telescopes and deep space robots. I've worked with or led teams of scientists and engineers who live the vicarious thrill of seeing and experiencing alien vistas through the lens of our robotic avatars. It is a bittersweet thrill, though, because most of us would rather be there ourselves, hiking down Martian canyons, chipping into the ice on a distant moon, or soaring above Jupiter's colorful clouds.

It's more than just a thrill, however. Visiting these places virtually with robots or studying them from a vast distance using the latest space telescope and imaging technology is a responsibility as well as an opportunity. Those of us involved in modern space exploration have an obligation to our stakeholders—taxpayers, governments, corporate or private investors—who have entrusted us with the significant resources needed to do that exploration. Space missions are expensive endeavors, with typical costs in the hundreds of millions to several billions of dollars for robotic missions, and up to a hundred times that or more for human exploration

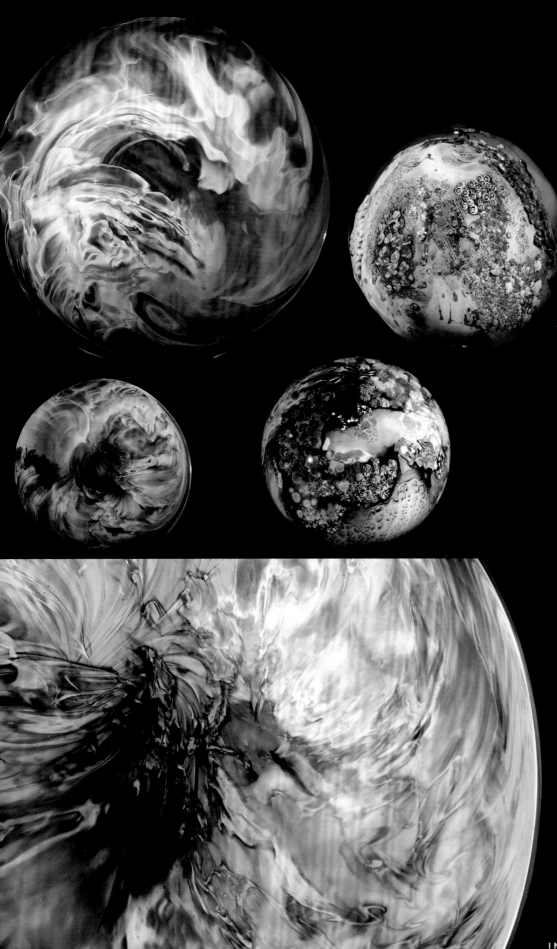

OPPOSITE: *Solar System Planets* (2021), a thought-provoking montage by digital artist Ika Abuladze from Tbilisi, Georgia.

LEFT: Photo montage of some of the mesmerizing glass "exoplanets" made by American artist and glassblower Josh Simpson for his *Planets* series.

missions like Apollo and the upcoming Artemis lunar programs. We have a responsibility to generate a substantial return on the investment that these stakeholders have made. But the return isn't tangible, like money. Rather, it is intangible: making scientific discoveries; filling textbooks with new knowledge about our Universe; inspiring our kids and their teachers about science and engineering; bringing a sense of national pride and purpose in shared achievements; and giving us all a deeper understanding of our planet and our species.

Beyond such intangible responsibilities, though, there are also tangible opportunities to create lasting works of art. Sometimes we can go beyond the use of photography as a way to merely document a place and scientifically measure its properties and characteristics. As Ansel Adams said in his 1970 book *Camera and Lens: The Creative Approach,* "Countless photographs are dull and unrewarding simply because they convey only the surface light and shadow of the world—not the substance or the spirit. . . . The difference between the creative approach and the factual approach is one of purpose, sensitivity and the ability to visualize an emotionally and aesthetically exciting image. To further verbalize on this is futile; it can be explained only through the photograph itself."

Occasionally in the space exploration business we might have what I refer to as the "luxury" of thinking and acting like Ansel Adams and other professional photographers. That is, teams of people who are planning photographs using space cameras might sometimes be able to think about or plan for specific lighting conditions, specific orientations or alignments of their subjects, or particular ranges of focus and depth of field. Or, in post-processing, individuals might choose specific combinations of filters, styles of mosaicking, or ranges of color and tone contrast that go beyond simple mundane or monochromatic presentation of the data. Or maybe individuals who are actually out there in space can actually take a moment to just let it sink in—the remarkable reality of where they are and what they are doing—and photograph something in that moment that captures some of that feeling. Sometimes on purpose and sometimes by accident, we might be able to elevate the planning, acquisition, and/or post-processing of space photography to the realm of space art.

A key pragmatic factor in a space photograph also being considered space art is time. Is there time to compose a particular scene, to choose among different lighting or viewing conditions, to try multiple settings or multiple filters? Is there any time during busy and micromanaged robotic or human space mission operations to just stop and look around, to think deeper thoughts about these alien environments, and to try to capture those thoughts in artistic renderings? Another key pragmatic factor is *bandwidth*. Getting pixels downlinked to Earth is challenging and slow—there is no interplanetary high-speed internet (yet). Sometimes, space photographers are limited to capturing only very small numbers of photos at a time; these photos might have to be heavily compressed (like low-resolution pixelated web images) just to get a few of them sent back home. The bandwidth limit is especially problematic for cameras that are traveling very far from Earth: The power of the radio signals that are used to beam photos back from space decreases as the square of the distance from Earth.

This book focuses almost exclusively on space photography as space art. Part of the reason for this focus (pun intended) is that photography is the most widely acquired and easily communicated medium of information gathering yet used for space exploration. Photography is a form of *remote sensing*, meaning that the information contained in photographs can be gathered remotely, and often autonomously, without the photographer even necessarily having to be physically there with the camera. Surely over time, as sculptors, musicians, painters, and other "in-person" artists begin to work their craft in space and on other worlds, examples from these other media will begin to represent a larger and larger fraction of the media recognized as space art.

But another reason to focus on photography as space art is that there are now a very large number of examples of beautiful, enigmatic, surprising, or historic space photos that exhibit many of the classic characteristics of "traditional" earthbound photographic art, and especially landscape photographic art. These include specific

photographic composition and image-processing design elements like framing, lighting, perspective, context, depth of field, contrast, and color, but also more general stylistic elements that are typical of many forms of art, like line, shape, form, and texture.

For example, photos that include the horizon can exhibit a physical, horizontal line (if the scene is flat), or an implied line between "here" and "there" or "known" versus "unknown," in the case of a rugged planetary landscape. But context is also closely tied to the visual interpretation of linear elements in space photographs. In a geologic context, lines can denote ridges, faults, layers, cracks, or other manifestations of physical processes that require a familiarity with the physical world to interpret. In a broader context, the curved limb of a planet or moon represents a dramatic line demarking the edge of space, and straight or wavy lines in a planet's atmosphere can provide a sense of dynamic motion to a scene (see pages 34–35 and 110–11. But sometimes linear features might not have any terrestrial analogies at all, and the viewer

might then have almost no intuitive context or sense of scale with which to interpret the relatively abstract scene. Close-up views of thin gaps in photos of Saturn's rings (pages 124–25 and 126–27) are great examples.

Another example culled from my Mars rover experience is the way that foreground spacecraft parts or components can impart a sense of depth to photographs that might not otherwise convey an intuitive sense of scale or context. The arm of a Mars rover, or the solar panel or communications antenna of an orbiting spacecraft might help provide scale or offer familiarity to what could otherwise be an unfamiliar and thus unapproachable scene. Sometimes the effect is entirely on purpose; for example, when camera teams shoot "selfies" of planetary landers or rovers in order to present the familiar (at least to the camera teams) against a backdrop of the alien. In my opinion, the tension between the known and the unknown creates dramatic photography, and the postcard-like feeling of the spacecraft as a tourist visiting an alien land helps to further anthropomorphize our avatars.

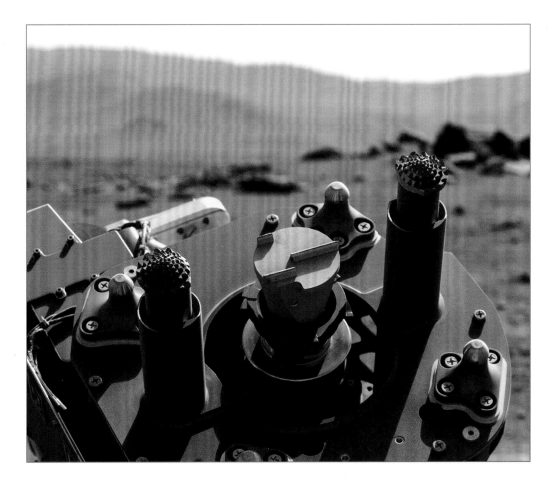

A photo of the rock abrasion bit on the end of the drill on the NASA Mars rover *Perseverance's* arm, taken on February 9, 2022. The depth of field is accentuated in this scene by the near-field focus on the drill contrasting with the somewhat out-of-focus dark rocks on the mid-field ridge and the very out-of-focus mountains along the horizon.

A natural color photo of comet NEOWISE, taken from a ground-based telescopic observer in Germany on July 14, 2020. The comet's straight blue tail comes from ice grains being ionized by sunlight, while the curved reddish-pink tail is from dust grains shed off the comet as it travels on its orbit around the Sun.

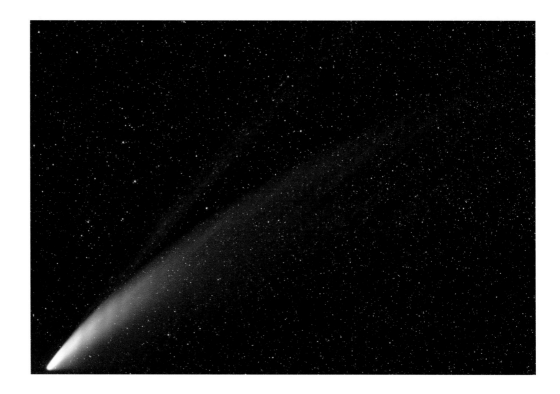

Photographs of deep space astronomical subjects, like comets or nebulae or galaxies, automatically incorporate strong elements of contrast—the subjects are set against the blackness of space, after all. Color can be challenging to interpret in such photographs, however, depending on the filters used for color imaging and the intrinsic colors of the subjects themselves—such as comets, many of which exhibit beautiful color variations when photographed with the same kinds of red, green, and blue filters that are built into standard cell phone cameras (so-called "true" or "natural" color). An additional stylistic bonus for some bright comets is that they have gas and dust tails that form graceful straight lines and curved arcs that give the scene a sense of motion and direction, with linear gas tails pointing away from the Sun and dust tails tracking the comet's recent curved orbit around the Sun.

But based on the kinds of cameras and filters used to photograph them, the physical and chemical nature of these subjects (how hot or cold they are and what they are made of) is often encoded into the color composite of the resulting photos. So reds in an image might indicate the presence of dusty or warm gas, while greens and blues might indicate specific atoms or molecules. The resulting colors—for example, in the garish composite seen here of

the famous supernova remnant called the Crab Nebula, opposite—are thus almost never what we would see with the naked eye, and thus the context and meaning of these "false" or "enhanced" colors can only be interpreted via some sort of key (or a degree in astrophysics). Still, false-color images are the norm in astrophysical photography, and they are often spectacular.

Another interesting source of both perspective and tension in photographs of deep space astronomical subjects is the built-in ambiguity between shape and form. Objects in the sky appear as if they only had two-dimensional shapes, rather than three-dimensional forms. A perfectly spherical shell of dust and gas from an exploding star, for example, would be shaped like a two-dimensional circle in the sky. Occasionally a more accurate sense of the 3-D forms of these objects can be

OPPOSITE: An enhanced-color composite of the Crab Nebula, the remnants of gas and dust flung into space by a supernova explosion in 1054 CE. Red colors are from hot dust photographed in the infrared by the European Space Agency's Herschel Space Observatory; shades of blue and purple are from ionized atoms of oxygen and sulphur photographed at visible wavelengths by NASA's Hubble Space Telescope. Merging these images enhances both the scientific and artistic appeal of such scenes.

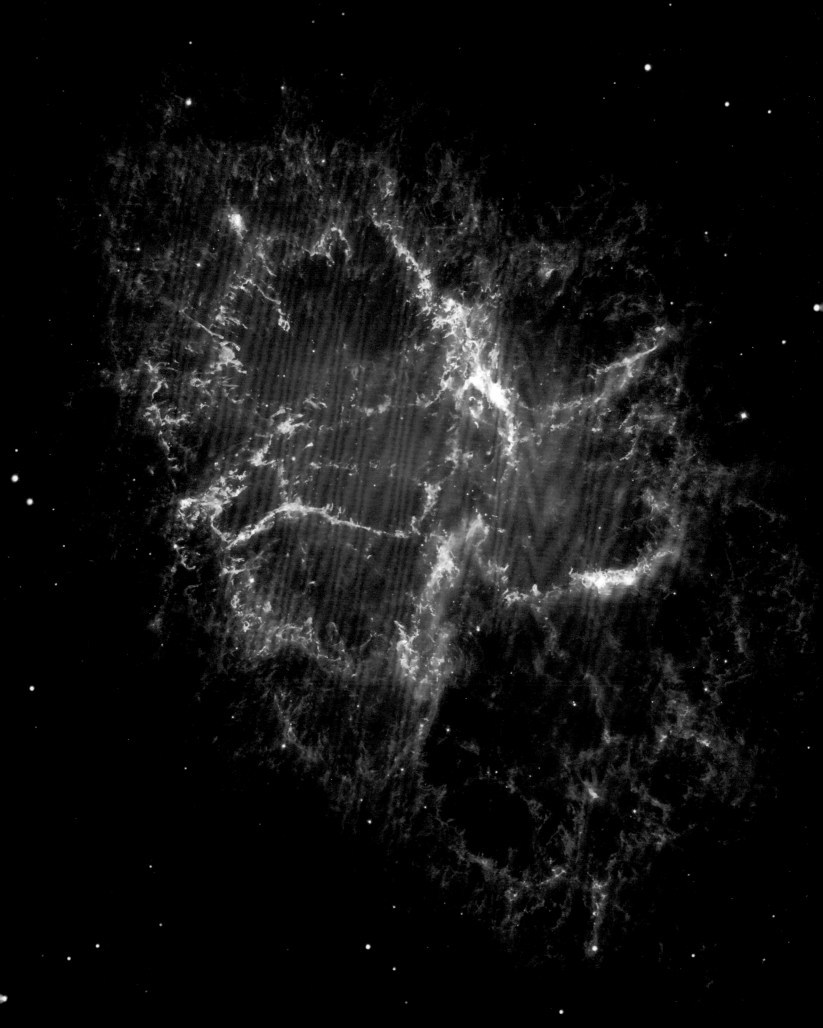

perceived if they are elongated and observed at an angle, or if the viewer can link the appearance of other similar objects seen from different angles to the new one being viewed. For example, spiral galaxies viewed "face-on" have a characteristic and almost iconic shape (page 191), so a viewer familiar with that shape and presented with a similar object viewed nearly "edge-on" (page 186) can infer the nature and context of the scene.

One more specific artistic element that is incorporated in many of the most beautiful and dramatic terrestrial and space photographs is texture. Natural geologic and atmospheric processes produce numerous examples of regular textures and patterns. Spacecraft photographs of some such patterns, like sand dunes on Mars or cyclonic storm systems on the giant planets, are familiar, and their context is often clear. But many other patterns and textures seen in space photography, especially those that aren't accompanied by any sense of scale or context or that involve truly alien processes (like weird volcanoes on Venus or high-energy jets spewing gas and dust out of dying stars), defy simple understanding. Part of the appeal of those kinds of textures and patterns, in my view, is the abstract and almost fractal nature of their beauty.

The photos featured in this book thus attempt to showcase examples from all the stylistic elements of photographic art, though the sample of works included is far from complete. Some of them are "straight out of the camera" shots from publicly available space photo archives maintained by NASA or other space agencies, with little or no special processing or adaptation. But many of them have been carefully and sometimes painstakingly assembled and processed by a group of international amateur and professional space photography artists and experts whose work I admire and who have agreed to have their photos featured here. When possible, I've tried to provide some short quotes or stories from these folks in the image captions, to relay a sense of what these space artists were thinking and feeling and trying to achieve during the detailed processing and presentation of their work.

I'll confess to a bias, however, among the collection of artistic space photos presented here. My work in space imaging has been primarily focused on planetary science—the study of the planets, moons, asteroids, and comets in our solar system, using cameras on robotic flyby, orbiter, lander, and rover spacecraft. In addition, all of the more than 200 deep space missions sent out to explore the cosmos that are not space telescopes have only flown past or visited places in our own solar system. Perhaps not surprisingly, then, most of the photos in this book feature solar system objects as their subjects. Still, as a big fan and past user of the Hubble Space Telescope and other telescopic facilities, I couldn't just ignore the enormous number of spectacular space art photos of stars, nebulae, and galaxies beyond our solar system that have been taken by telescopes.

We explore space not only with our rockets and spacecraft and instruments, but also with our hearts and souls and minds. Ansel Adams once said, "The picture we make is never made for us alone; it is, and should be, a communication—to reach as many people as possible without dilution of quality or intensity." *The Art of the Cosmos* is a gallery of human accomplishment that celebrates the scientists and engineers and explorers who push human civilization—including the ways in which we produce and experience art—beyond the physical limits of our planet. It is a testament to the (mostly) earthbound explorers who strive to share the experience of space exploration not only through science but also through an emotional, awakening perspective on our place in the cosmos, and thus our responsibility to our home planet.

OPPOSITE: The California Nebula, also known as NGC 1499, is seen here photographed and beautifully color rendered by talented amateur astrophotographer Luca Remidone from Pesaro, Italy, in December 2013. The enhanced-color composite merges light coming from ionized hydrogen (red), oxygen (green), and sulfur (blue). The energy to heat and ionize these atoms in the California Nebula's gas and dust comes from the bright blue star just above and to the right of the nebula. That star, known as Xi Persei, is thirty times the mass of our Sun and glows nearly six times hotter. Stunning detail can be captured in such long-exposure photos partly because that star and the nebula are so close—only about 1,000 light years away, in the constellation Perseus.

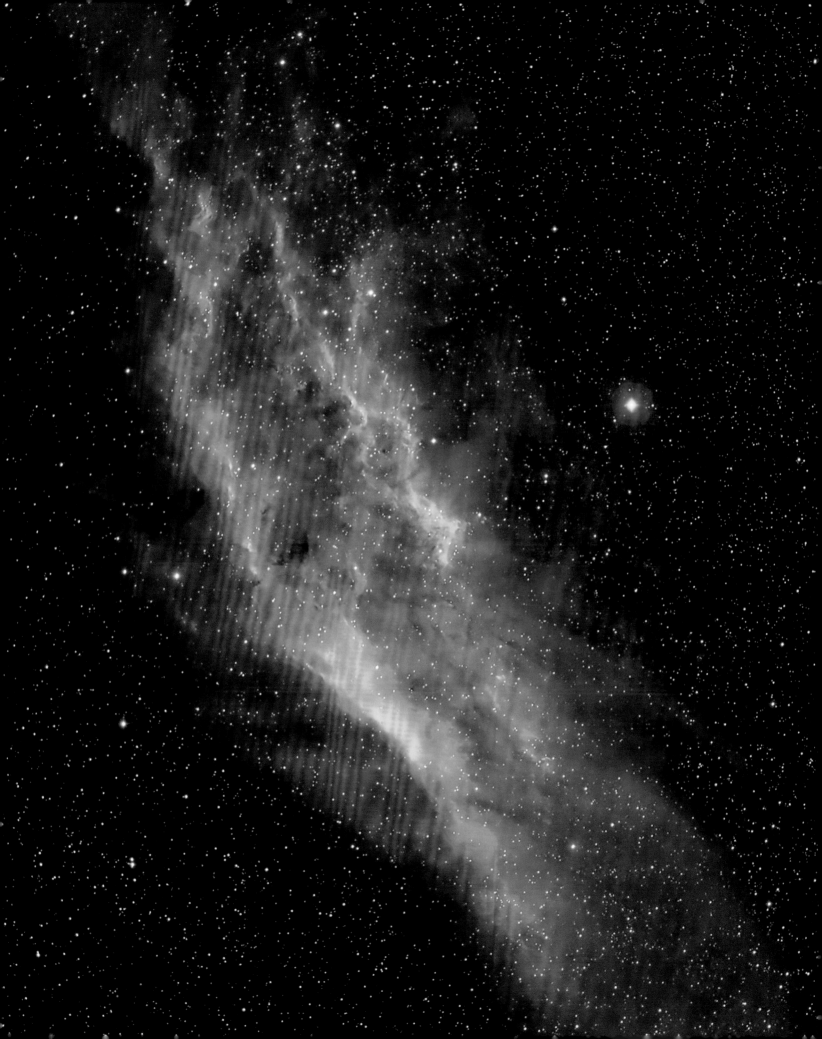

1

CLOSEST TO THE SUN

The Sun, Mercury, Venus, Earth, and the Moon

EARTH SELFIE

The first photographs of the Moon taken from lunar orbit were shot by NASA's *Lunar Orbiter 1* spacecraft. They were taken with black-and-white film using a special camera system built by Eastman Kodak and developed in the early 1960s for Earth-orbital spy satellites. The system not only took the photos but, amazingly, it developed the film onboard the spacecraft and scanned the negatives, fax machine–like, to digitize and radio the pictures back. Among those images were the first photographs of the Earth from the Moon, taken on August 23, 1966. The original image showed many artifacts, but the first "Earth selfie" from deep space was good enough to win some Cold War points in the US space race against the Soviets. More recently, a group of NASA and aerospace researchers reprocessed the original tapes and significantly improved the image quality. Space artist Don Davis, who often focuses on the history of photographic space exploration, processed, mosaicked, and colorized two of those restored images to create the fantastic shot on pages 20–21. "Such high-quality photos deserve to have their content emphasized, rather than their flaws, and as an artist I was happy to emphasize the sight itself using my abilities," Don told me. The result is a spectacular and emotive artistic restoration of one of the most historic photographs of the Space Age.

PREVIOUS PAGES: Artistic restoration by Don Davis of an "Earth selfie" taken by NASA's Lunar *Orbiter 1* spacecraft on August 23, 1966.

SUN FLOWERS

Sunflowers are my favorite flower. They present such a cheery disposition to the world. Their yellow faces reflect the Sun's color, and they track the light from our star over the course of the day; the French word for "sunflower" is *turnsole*—"turning with the Sun." Vincent Van Gogh captured their vibrant, swirling colors and textures in some of his most famous paintings. This spectacular example of photographic art is not from a Van Gogh, but it easily could be. Instead, it's a photograph of a small part of the Sun from the Swedish Solar Telescope at La Palma, Chile. The colorful, radiant, and radial forms here are sunspots—areas where intense magnetic fields stream out of the Sun. The centers of the sunspots are darker because they are a few thousand degrees cooler than their 10,000°F (5,540°C) surroundings. Not only the temperature but the size is also staggering on a human scale: Five Earths would fit across the scene here. These Sun "flowers" are set against a backdrop of Texas–sized convective cells of superhot gas, which seem to roil and churn like oatmeal in a stovetop pan in time-lapse photos from solar telescopes. Like sunflowers, sunspots represent fleeting beauty, coming and going with time, and tracking the cycles of the Sun's pulsations.

OPPOSITE: A photo of sunspots taken by the Swedish Solar Telescope at La Palma, Chile, on July 15, 2002.

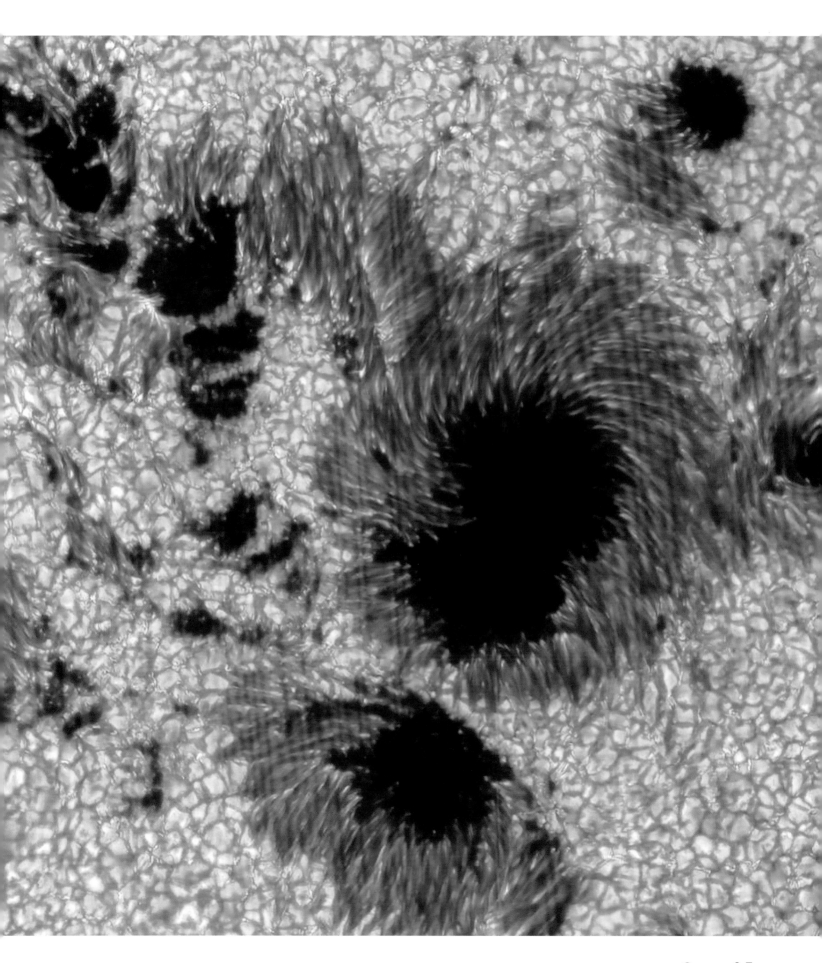

RARE SUNS

We perceive only a tiny fraction of the Sun's power, limited to the small part of the spectrum where our eyes (visible light) and skin (thermal energy) are sensitive. Because we can't look directly at the Sun with our eyes, we mostly sense it indirectly—a steady, warming, yellow disk, slowly moving across the sky. To reveal the full extent of the Sun's power requires space technology—telescopes and cameras high above our atmosphere that can sense and record the high-energy ultraviolet and x-ray light streaming out from our star. That otherwise invisible radiation, captured here in a false-color composite from NASA's Solar Dynamics Observatory (SDO) space telescope (see opposite page, top), provides a fresh and vibrant palette for digital photographic artists. London-based artist and space image-processing expert Seán Doran created this digital composite by combining SDO images from filters designed to isolate the high-energy light from the Sun's visible surface as well as its atmosphere. The goal here is not scientific but entirely artistic. Which combinations of colors and contrast produce—in the artist's eye, and for this particular subject—the most dramatic combination of textures, hues, form, and motion? "Making films and images is a form of therapy," writes Seán. "Every day there is new data and a new creative puzzle to solve."

Time-lapse photographic composites provide a way to capture motion in an otherwise static piece of art. A rich history of such works exists, going back to the chronophotography techniques of late-eighteenth-century pioneers like the English photographer Eadweard Muybridge and his documentation of galloping horses and people in motion. The technique is no less spectacular when using modern digital cameras to capture rapidly changing celestial events. A rare and beautiful example is seen here (opposite page, bottom), in this time-lapse composite generated from ultraviolet-filter photos from the SDO space telescope. On June 5, 2012, the planet Venus passed in front of the Sun as seen from Earth—a "transit" in astronomical parlance. Venus marched across the Sun's disk over the course of six hours, and NASA scientists stitched together fourteen snapshots from that march for this chronophotographic composite. Transits can only be seen for planets closer to the Sun than ours (Venus and Mercury) and they are rare: A Venus transit won't be seen again from the Earth until the year 2117. But astronomers are now able to see such transits of planets passing in front of *other stars* beyond our solar system. Thousands of such exoplanets have been discovered this way over the past few decades. How many might be like Venus? Or Earth?

OPPOSITE TOP: NASA Solar Dynamics Observatory (SDO) digital composite of the Sun, created by Seán Doran.

OPPOSITE BOTTOM: NASA SDO time-lapse composite of Venus's June 5, 2012, transit across the Sun.

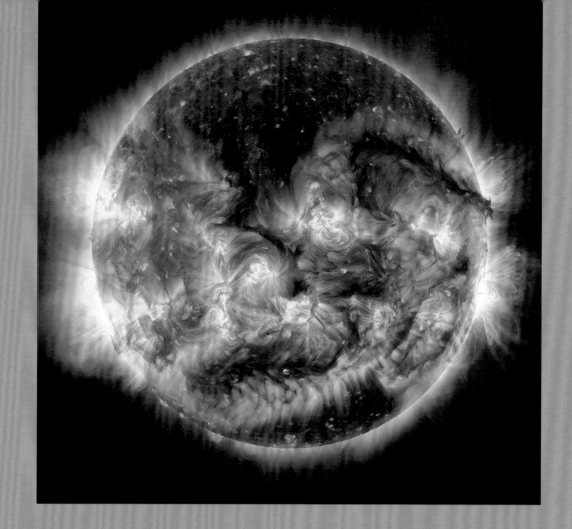
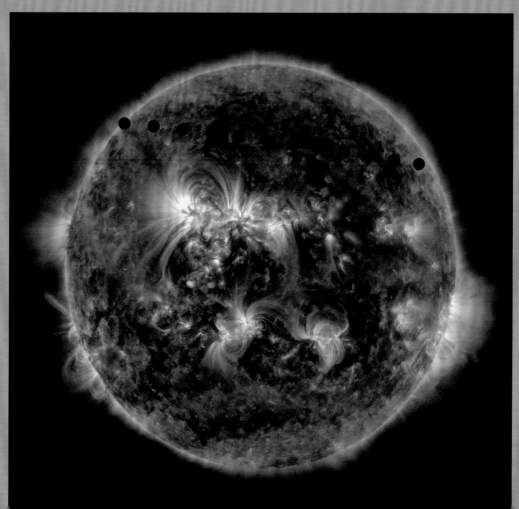

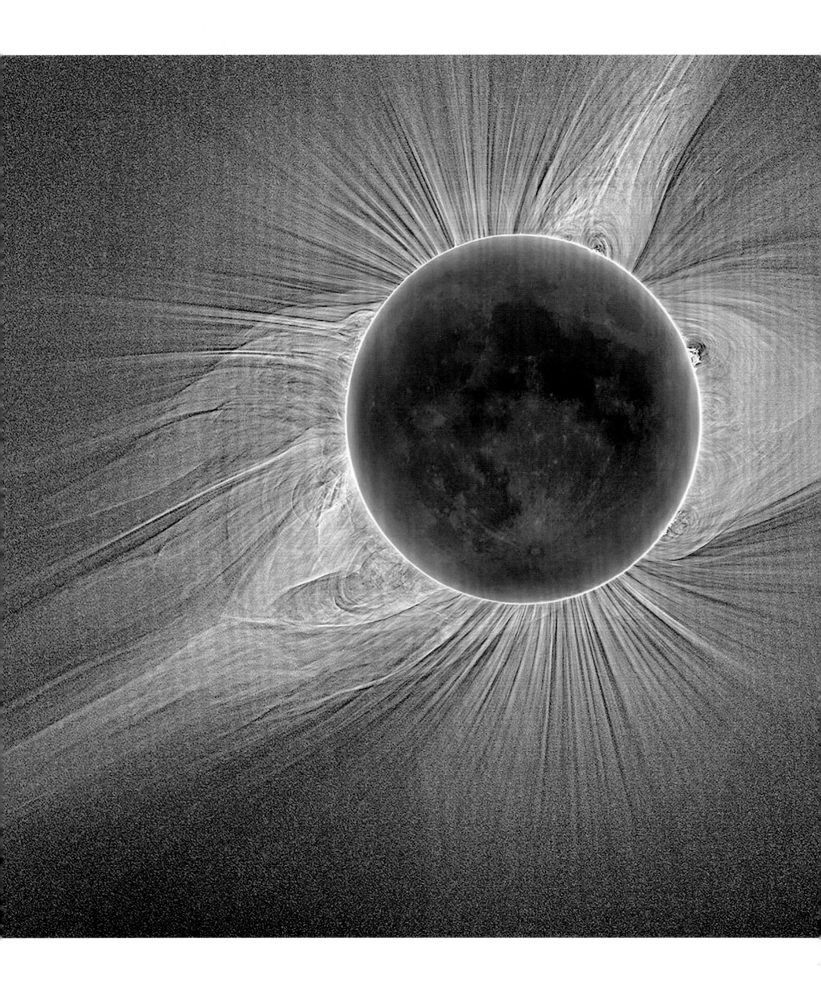

GREAT AMERICAN ECLIPSE

It was dubbed the "Great American Eclipse." On August 21, 2017, the Moon passed between the Earth and the Sun and cast its shadow on our planet. Over about 90 minutes, that shadow sped at more than 1,500 mph (2,400 km/h) along a curved path from Oregon to South Carolina. The path was narrow, less than 70 miles (113 km) wide, but if you could get yourself into that zone for exactly the right few minutes—as millions of people did that day—the reward would be a glorious total eclipse of the Sun. Astronomer and longtime eclipse chaser Professor Jay M. Pasachoff from Williams College in Williamstown, Massachusetts, assembled a team to photograph the eclipse from Salem, Oregon. They used special digital cameras, filters, and image-processing techniques, designed to capture fleeting moments of exceptional atmospheric clarity and subtle tonal and textural differences in the Sun's corona. The corona is the uppermost part of the Sun's atmosphere and can only be seen in detail when the glare of the rest of the Sun is blocked, like during a total eclipse. The team's composite of their 68 best photos—including the near side of the Moon illuminated by earthshine—is not just scientifically interesting but among the most spectacularly detailed pieces of solar space art ever produced.

Total eclipse of the Sun of August 21, 2017, photographed from Salem, Oregon, by the Williams College expedition, led by astronomer Jay M. Pasachoff.

ANNULAR ECLIPSE

Not all solar eclipses are total solar eclipses. It is an amazing cosmic coincidence that the Moon can sometimes block out the Sun—the Sun is about 400 times bigger than the Moon, but the Moon is on average about 400 times closer to Earth! But the Moon's orbit is not a perfect circle, so if it passes in front of the Sun at a point where it appears slightly smaller than the disk of the Sun, the result might not be a total eclipse but instead an *annular* (from the Latin for "ring") eclipse. This lovely chronophotographic composite shows the progression of the annular eclipse of February 26, 2017, as photographed from Patagonia by Jay M. Pasachoff. Over the course of a little more than 90 minutes, the new Moon slowly drifted across the Sun's disk until it was *almost* a total solar eclipse: At its "ring of fire" midpoint, the Moon blocked 99.2 percent of the Sun! The view was fleeting, however, lasting only about 45 seconds. Then, over the next 90 minutes or so, the Moon gracefully drifted away. The filters, processing, and composited progression in this wonderful piece of space art emphasize contrast and symmetry: Sun, Moon, crescent, ring; before, during, after.

Chronophotographic composite of the annular eclipse of February 26, 2017, by Jay M. Pasachoff and space operations engineer Muzhou Lu.

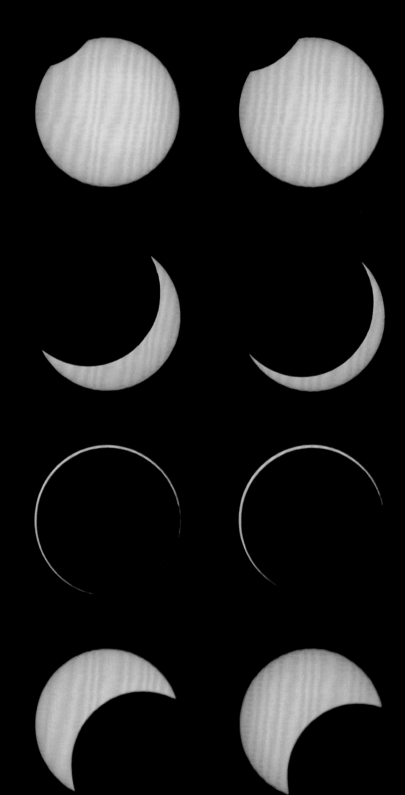

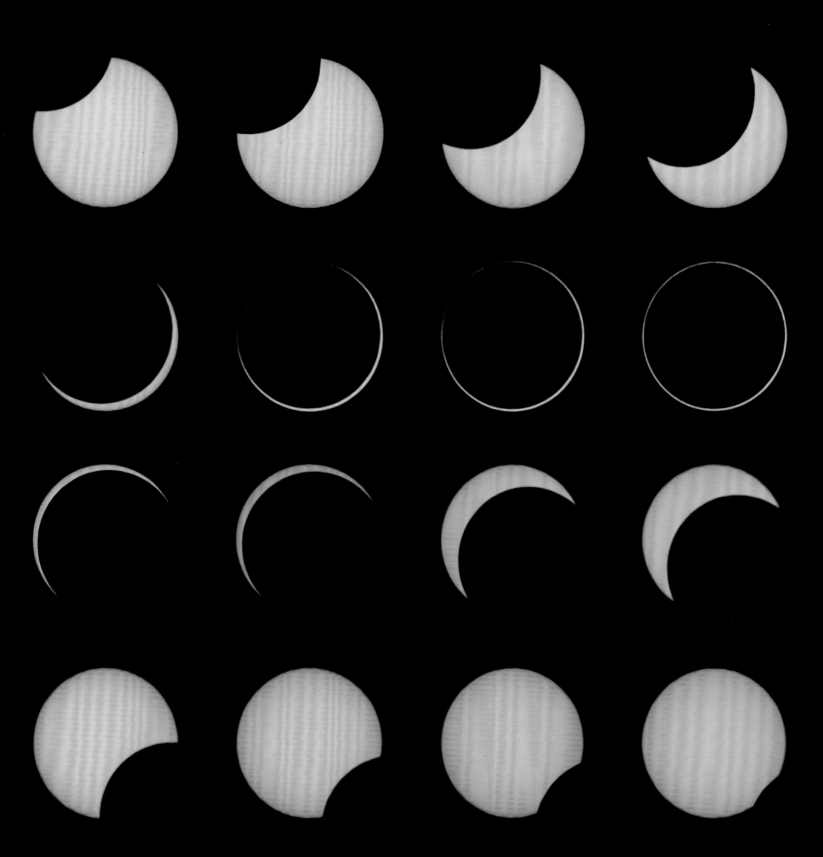

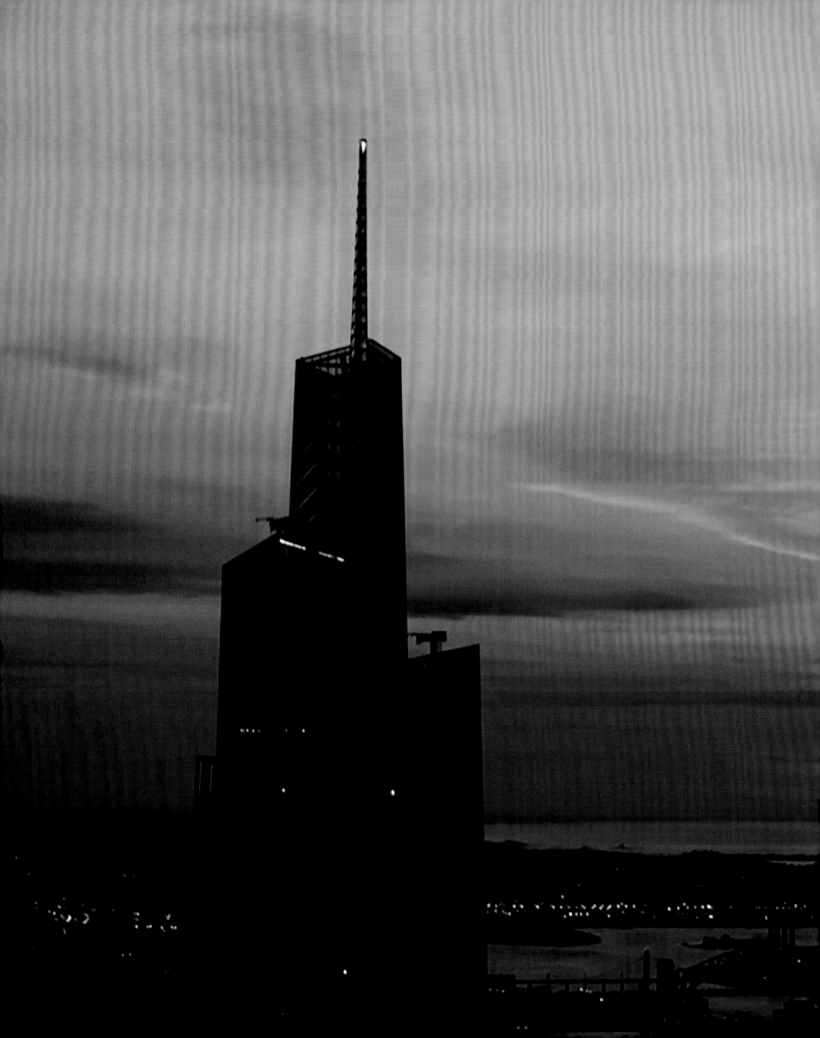

SUNLIGHT SPIRE

Timing is everything, especially to eclipse chasers. Such folks (and I am one of them) are almost addicted to getting themselves in exactly the right place, at exactly the right time, to witness rare and beautiful solar eclipses. That's what drove eclipse chasers Darren Olah and his mother, Janine, to the top of the Empire State Building in New York City on June 10, 2021. Astronomers had predicted that the partially eclipsed Sun would be visible from the city right around sunrise. Because of the COVID-19 pandemic, Darren notes, "Only a very limited number of tickets for the eighty-sixth-floor observation deck were made available to the public, and my mom and I were lucky enough to obtain two. Since so few could be there, pressure was on to capture this fleeting moment to share with others." Using a wide-angle lens, Darren captured the rising "horns" of the Sun and a spire of sunlight piercing the auburn sky against a backdrop of the city skyline and the East River. This piece of photographic art reflects a stunning moment of cosmic planetary alignment and perspective that won't occur again for thousands of years. Darren describes the moment to me as "breathtaking," and Janine adds: "What a unique, once-in-a-lifetime experience!"

A stunning photograph by Darren Olah, showing a partially eclipsed sunrise as seen from the Empire State Building observatory, June 10, 2021. The skyscraper at left is the 93-story One Vanderbilt on East 42nd Street.

MERCURIAL MOSAIC

Sometimes the value in art is helping us to see what can otherwise be difficult or impossible to see. For example, most people have never seen the planet Mercury in the night sky, even though it is bright enough to be seen by the naked eye. And even when you're *trying* to see Mercury, it can be challenging or impossible because it is typically quite close to the Sun in the bright pre-dawn or post-sunset twilight sky. We have thus come to rely on robotic spacecraft—flyby and orbiting satellites—to help us truly see the planet for the first time. And because these spacecraft carry cameras and other instruments with superhuman vision (able to see ultraviolet and infrared colors, as well as the visible spectrum), the way we are able to view celestial bodies like Mercury from space probes is distinctly different—and distinctly artistic— from the way we see with our own eyes. This photo, for example, is a composite mosaic from the NASA Mercury orbiter called *MESSENGER*, merging monochrome photos of the planet's mountains, craters, and plains with garish colors chosen to represent different kinds of iron- and titanium-bearing mineral compositions detected from infrared data. Such data fusion enables new scientific discoveries while often creating art in the process.

NASA orbiter *MESSENGER* mission composite of data taken between 2011 and 2015 from its Mercury orbit.

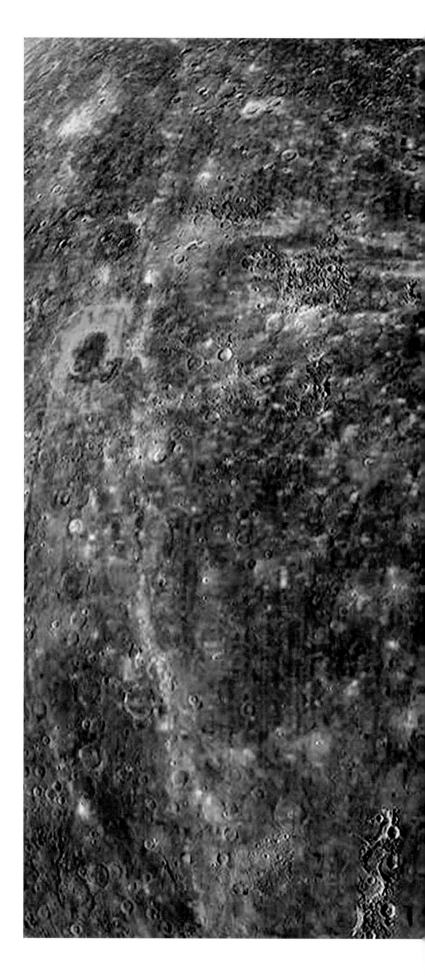

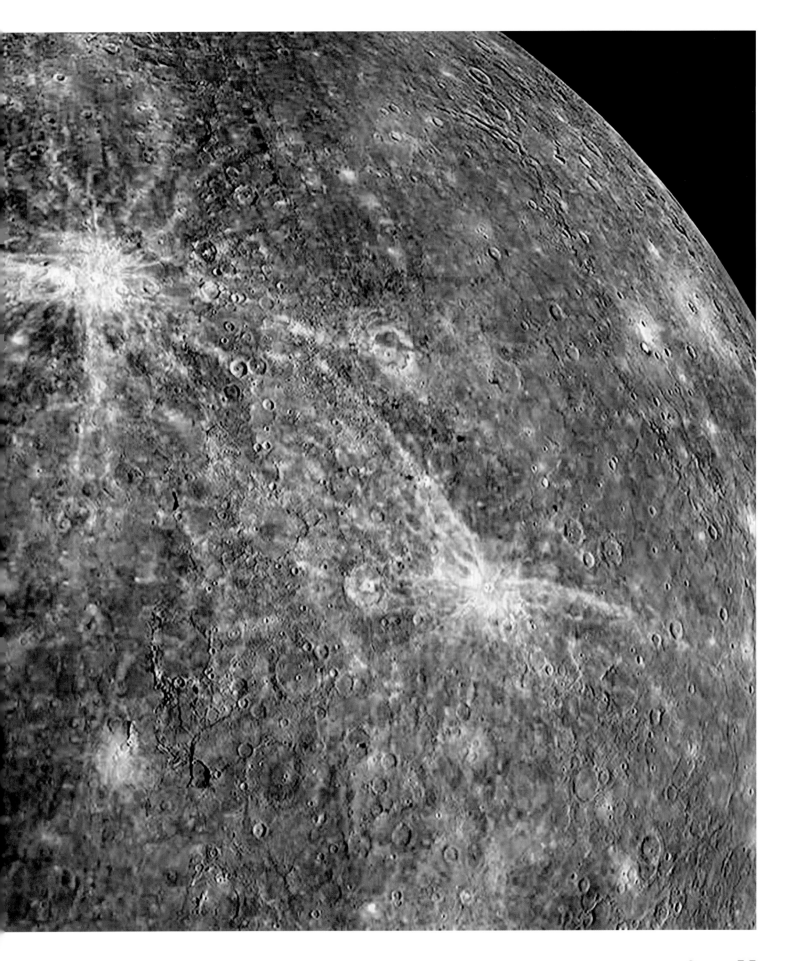

VENUS CLOUD LAYERS

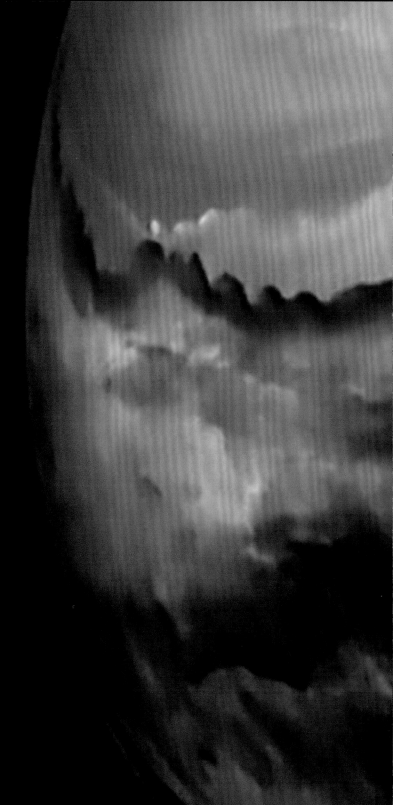

Despite Earth and Venus being almost identical in size and mass, and close to the same distance from the Sun on the scale of the solar system, the two planets couldn't have more dissimilar atmospheres. Through cameras on telescopes and on most spacecraft, Venus's thick and hazy, CO_2-laden atmosphere—nearly 100 times denser than our own—is generally bland. But equipping spacecraft with special ultraviolet and infrared filters can bring out amazing details, like the clouds and storm fronts seen in this spectacular photo. Taken from Japan's *Akatsuki* (meaning *dawn*) Venus orbiter mission, this is an infrared-composite view of heat coming from the surface on the planet's night side. Darker areas are cooler places where thicker, lower clouds block more of the surface heat. The processing was done by French digital photographic artist Damia Bouic, who has only started working with *Akatsuki* Venus images recently. "I wasn't too interested in this probe," she writes on her blog, "until the day when I decided to push curiosity to find the dedicated website and came across the RAW images of this mission. And I said to myself that it would be a good idea to try to process a few images, just to 'see what happens.' I am not disappointed with the result." Me neither.

Japanese *Akatsuki* Venus orbiter infrared-composite image from October 19, 2016, processed by Damia Bouic.

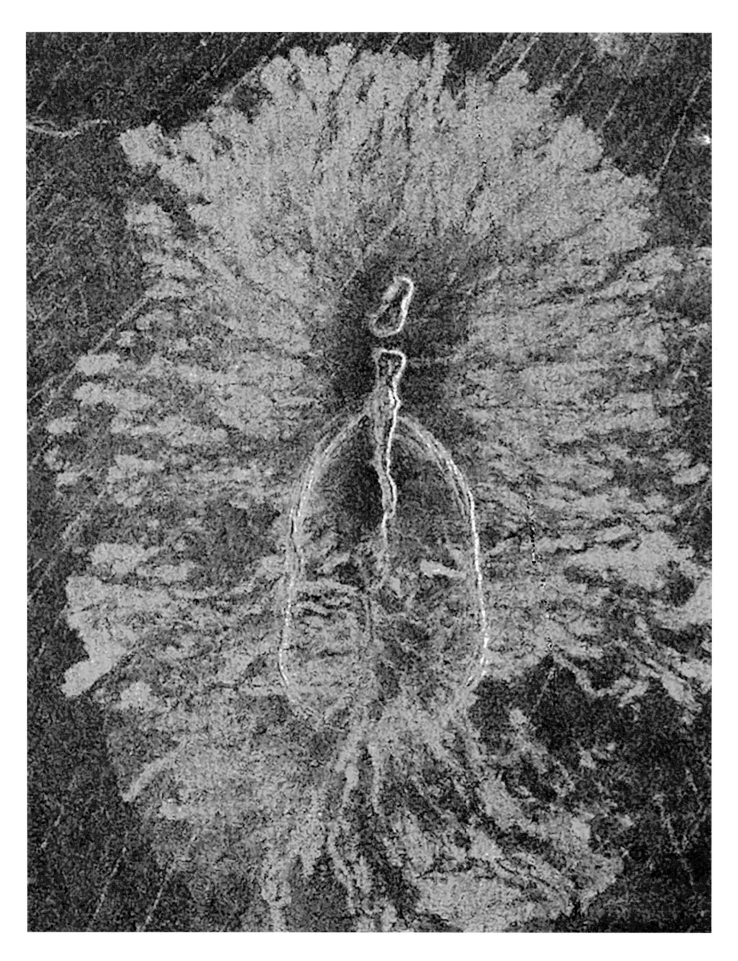

ANEMONE OF VENUS

We can't see the surface of Venus, shrouded in its thick layer of clouds, hazes, and oppressive atmosphere. Fortunately, radar technology first developed in World War II provides a way to "see through" thick clouds and haze using radio waves. Advanced versions of that technology were used by NASA's Venus *Magellan* orbiter team to finally map the entire planet's surface between 1990 and 1992. The resulting radar photographs reveal Earth-like mountains and volcanoes and canyons and channels, and even some impact craters. But they also reveal weird and enigmatic landforms that make for outstanding and puzzling abstract geologic art. Radar measures roughness, not tone. Dark areas in radar images are smooth—they reflect radar waves away like a mirror. Bright areas in radar images are rough, with rocks and boulders and ridges reflecting more waves back. This *Magellan* photo, for example, reveals a rugged 25-mile (40 km) wide uniquely Venusian kind of volcano, dubbed an "anemone" because of its resemblance to the sea creature. But it is also wildly abstract, lacking scale and context, but clearly exhibiting structure suggesting form and flow. There is also a flower-like aspect to this photo, perhaps reminiscent of a Georgia O'Keeffe painting.

NASA *Magellan* orbiter radar photograph of a volcano on Venus from November 1, 1991.

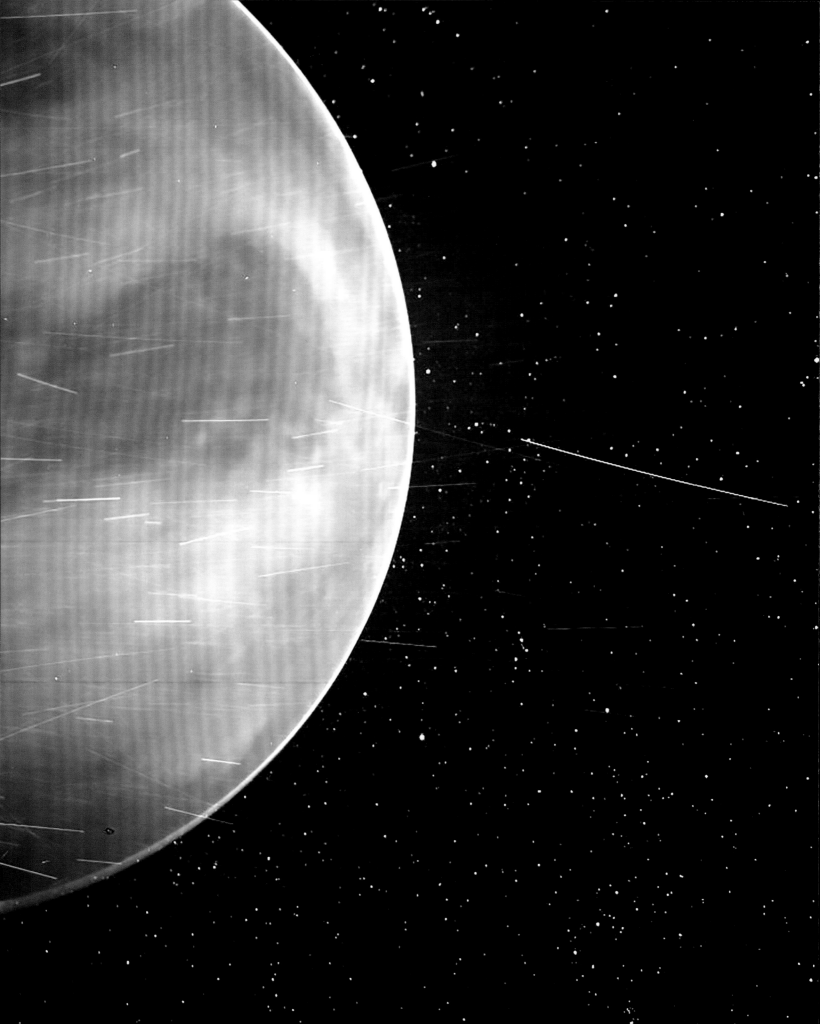

COSMIC FIREFLIES

The Sun is an active star, spewing out a steady stream of visible light and heat and high-energy radiation across the solar system. NASA and other space agencies have developed special satellites and sensors to study this stream, known informally as the "solar wind." One of those NASA satellites is called the *Parker Solar Probe*, and it is designed to pass closer to the Sun than any other spacecraft has yet. To do that, *Parker* will fly past Venus seven times to use the planet's gravity to slow itself down, along the way taking remarkable photos like this one of the planet's night side. The numerous streaks and splotches give the photo a sense of motion, like zipping past a field of fireflies. Indeed, the spacecraft is zipping past the planet at more than 6,000 mph (9,656 km/h). Many of these streaks are from sunlight reflecting off grains of space dust and some are from high-energy cosmic rays, all of which the satellite's cameras are designed to detect. Scientists weren't expecting to see features in the planet's atmosphere, however, but the cameras prove to be sensitive to infrared-heat variations coming from changing cloud thickness. The combination of light, heat, speed, the expected, and the unexpected make this compelling space art.

NASA *Parker Solar Probe* photo of the solar wind stream streaking past Venus, July 2020.

VENUSIAN SURFACE

It's hard to imagine what it must be like to be on the surface of Venus. The stagnant air has a crushing pressure of nearly a hundred times Earth's and is almost entirely CO_2, and the temperature—about 900°F (483°C)—is twice as hot as your oven. A spacecraft has to survive a rapid deceleration in that dense atmosphere to land, and then parachute down through clouds of sulfuric acid. Despite all that, the former Soviet Union was successful in landing 10 probes on the surface between 1970 and 1985. Even though the landers were built super-rugged and with a steampunk-like vibe, they only survived from 20 minutes to a few hours in that hellish environment. Panoramas like this one from *Venera 13* have been processed and projected to a simulated human-like view by retired research scientist and amateur historian of the Soviet space program Donald P. Mitchell. The platy and crumbly rocks have a composition somewhat similar to typical volcanic rocks on Earth, and the thick air is too hazy to see the Sun or the cloud layers higher up. "In a perpetual dead calm, the surface of Venus is almost untouched by wind erosion," notes Don on his blog. Part of the attraction of photos like this is exactly that tension and juxtaposition between the serene and the extreme.

Soviet *Venera 13* lander mosaic from March 1, 1982. One of the lander's legs and the ejected camera cover can be seen in the foreground. The projection is by Donald P. Mitchell, and the colorization by the author.

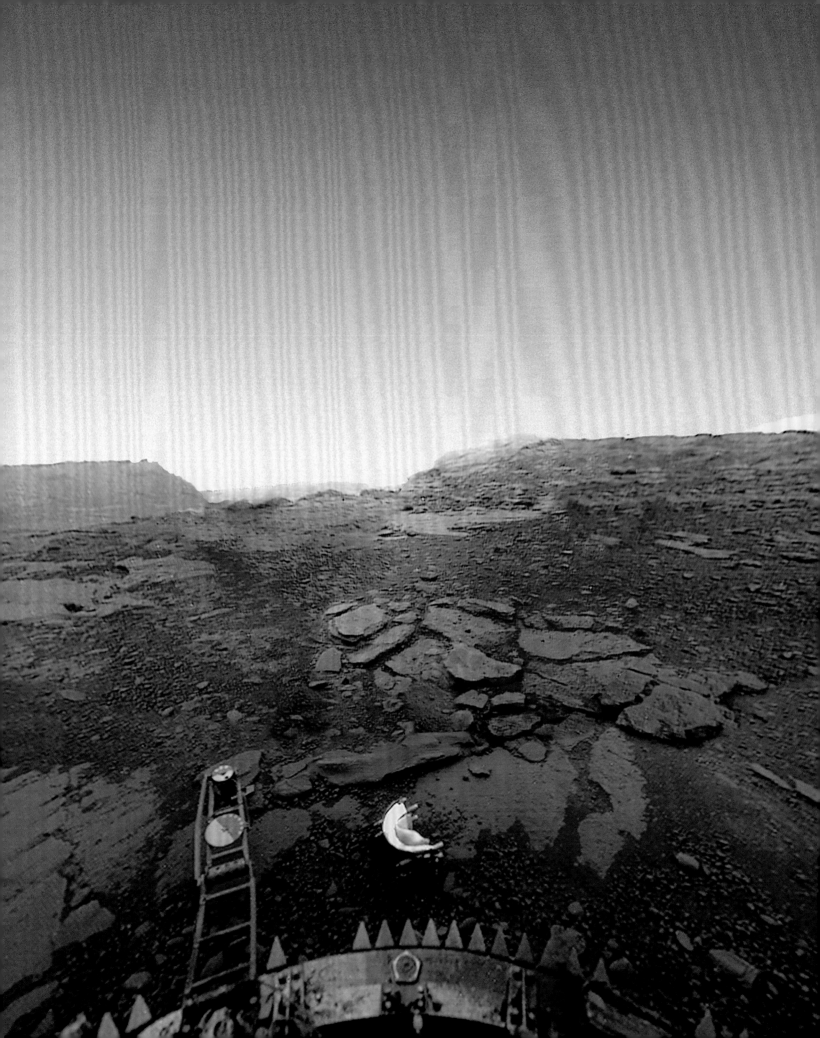

EARTH AIRGLOW

Perspective comes from both where we are and how we look. For example, you might imagine this scene as coming straight out of a science fiction film. Perhaps new settlers have just arrived in orbit above a strange new alien world. In reality, the "where we are" here is high above our own planet, with part of the International Space Station in the foreground. But the "how we look" is definitely more alien, as this long-exposure photo was taken with a digital camera much more sensitive to dim light and faint colors than the human eye. The eerie orange hue of our planet here is caused by a phenomenon known as "*airglow*." High-energy ultraviolet (UV) light from the Sun streams down onto Earth's atmosphere all the time; most of it is thankfully blocked from reaching the surface by the ozone layer. Some of the UV energy is also absorbed by nitrogen and oxygen air molecules, which collide and release that energy as particles of light (photons) at lower energies and in a variety of colors, including orange. Like the aurora, airglow varies dramatically in place and time, providing a beautiful perspective on the patterns of "space weather" in the upper atmosphere.

NASA/ISS photo taken 250 miles (400 km) above Australia, its cities agleam, on October 7, 2018.

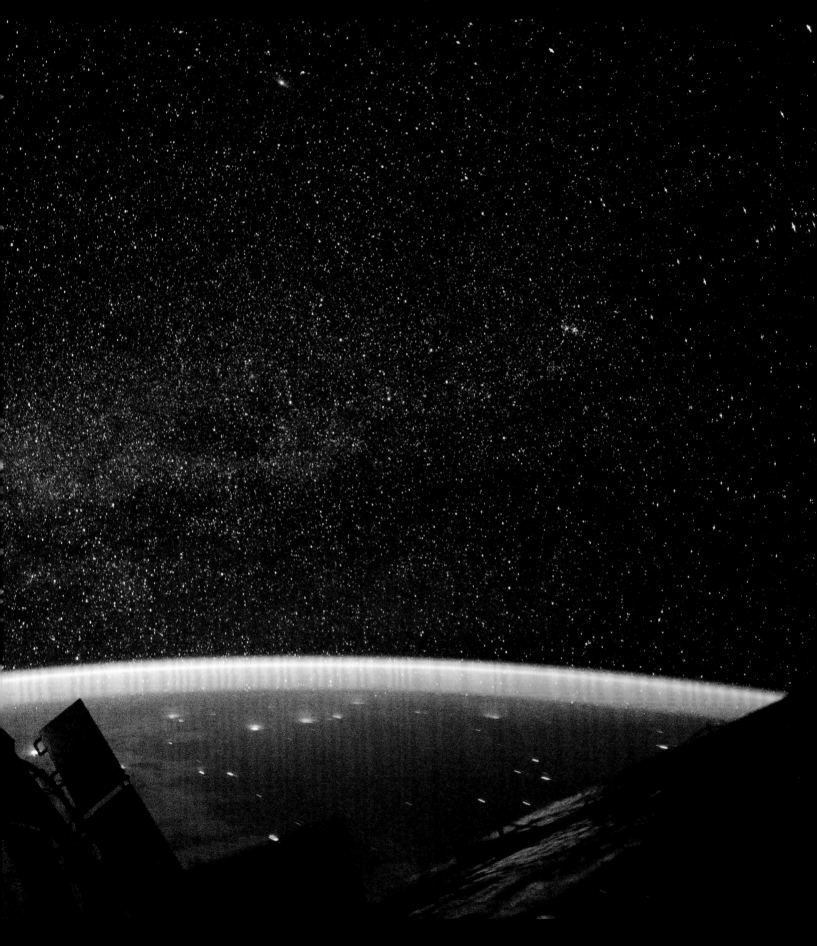

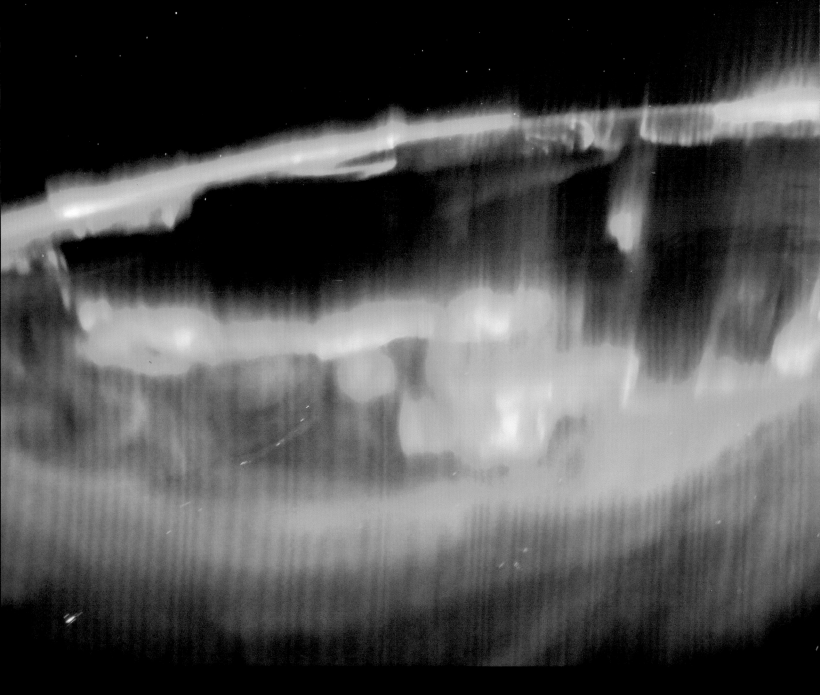

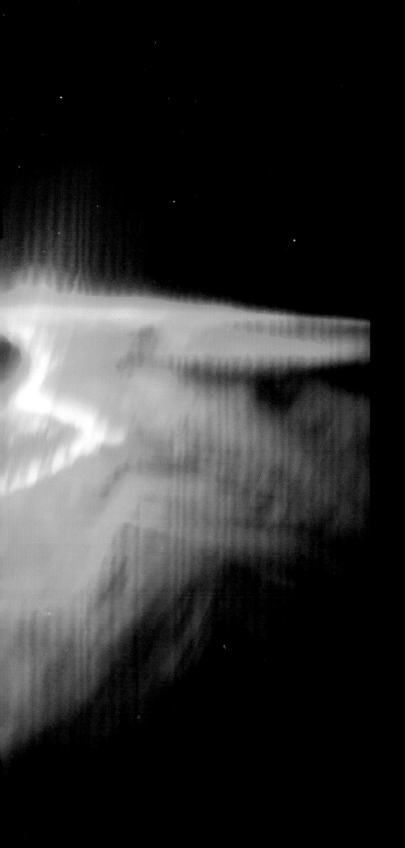

SPACE STATION AURORAS

Auroras are among the most beautiful and dynamic expressions of the relationship between the Sun and the Earth. High-energy solar wind particles captured by Earth's strong magnetic field spiral down into the atmosphere, accumulating in the regions near the north and south poles where the magnetic field lines come together. The solar wind energizes different atoms and molecules—mostly oxygen and nitrogen—at different heights in the atmosphere, and when those atoms de-energize to their earlier state, they release some light in the process. That light—the Northern Lights (or Southern Lights)—glows in spectacular hues of red, yellow, green, and teal. One of my favorite artistic photos of the Northern Lights is the one shown here, taken from the International Space Station by European Space Agency astronaut Thomas Pesquet on November 4, 2021. Describing the view near the end of their mission, he wrote, "Nature decided to offer us a final bouquet for the departure: the most intense aurora borealis of the whole mission. . . . It drew a real crown over North America, with peaks that seemed to exceed our altitude, and rapid pulsations that drew blue-green waves, it looked like breathing! We flew through it, our noses glued to the windows." What a view!

Another stunning aurora, shown on pages 46–47, was captured at the International Space Station a few months earlier by NASA astronaut Shane Kimbrough. "Magical aurora sightings this weekend from @Space_Station," he tweeted. "The white dots on the bottom half of the pic are stars—millions of them!"

Auroras photographed from the International Space Station by Thomas Pesquet, November 4, 2021, left, and by Shawn Kimbrough, August 9, 2021, following pages.

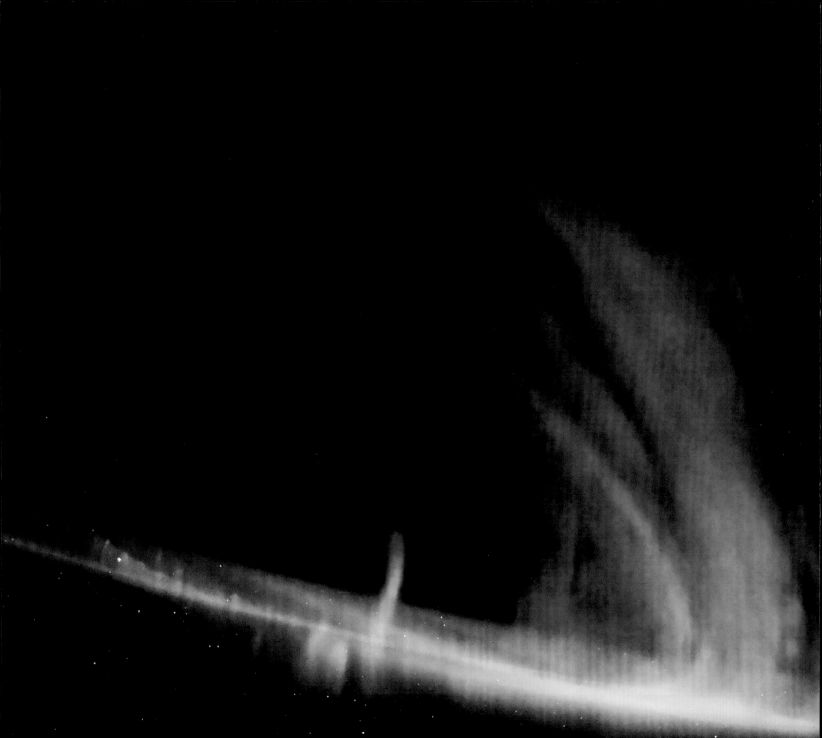

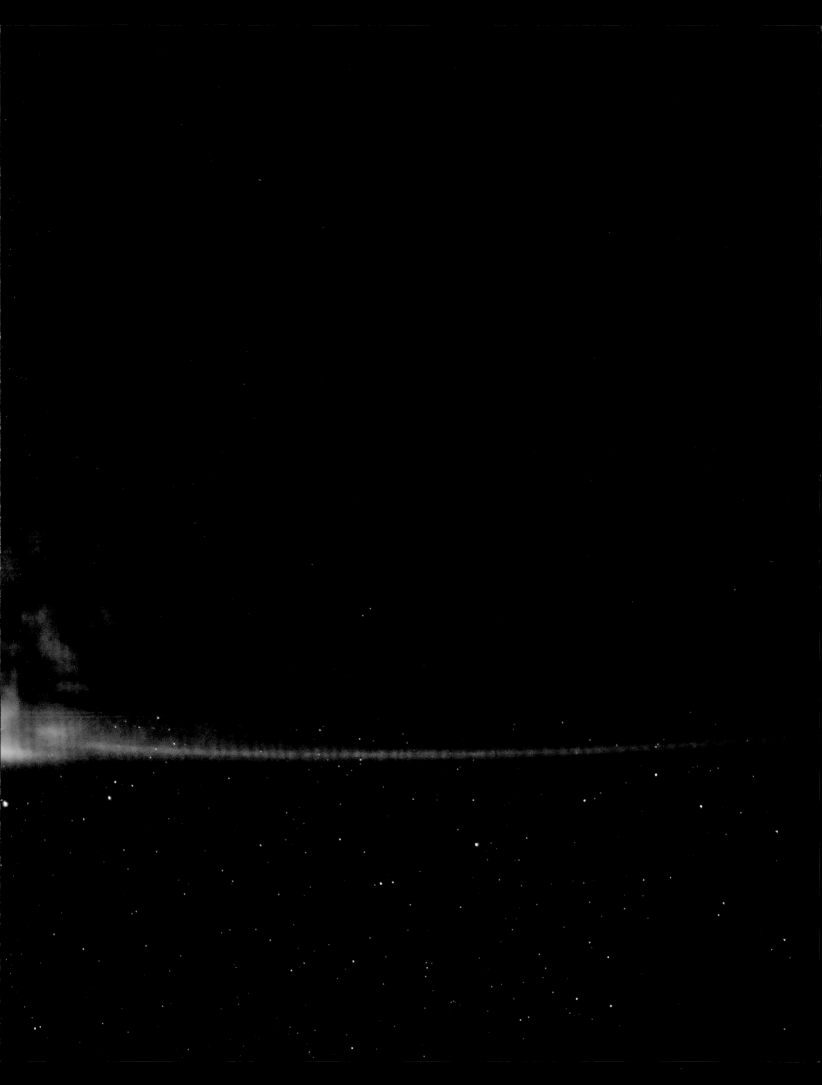

AURORAL DISPLAY, MICHIGAN

Imagine if the clouds that we see in a typical daytime sky were alive with color and changing every second with motion, vibration, and pulsation. We'd have to speed them up, maybe at sunrise or sunset, to see them behave so dynamically. Instead, though, if you're lucky and in the right place, nature can provide just such a show, at night. I've seen the Northern Lights myself in clear winter skies far from city lights, subtly in Upstate New York, and in all their amazing and emotional grandeur in Iceland. Photographic artist Shawn Malone captures spectacular examples, like this one, from the Upper Peninsula of Michigan. The most extraordinary auroral displays appear in cloud-like sheets and streaks and waves that move, dance, and fade away as quickly as they appear. It is fleeting planetary space art, a moment of sunlight and magnetism captured in abstract form on the grand palette of the sky.

Aurora above the Upper Peninsula of Michigan, photographed by Shawn Malone.

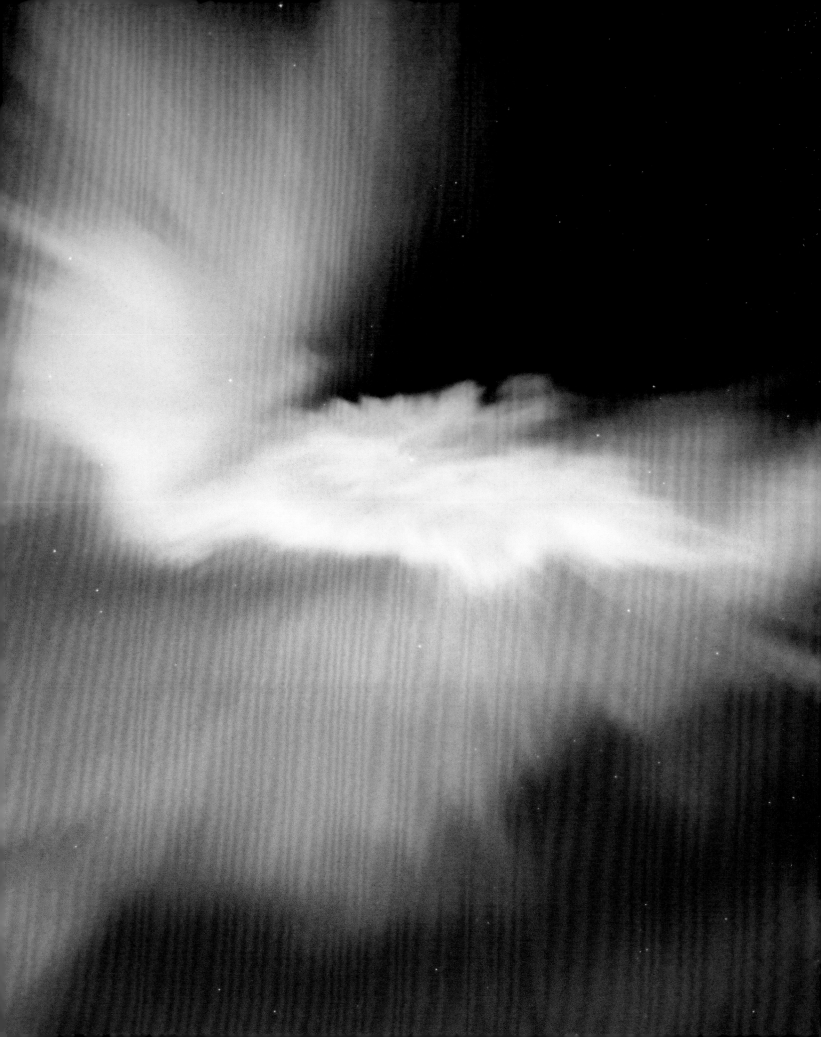

COLORS OF THE MOON

"Do not swear by the Moon, for she changes constantly," Juliet warned Romeo in Shakespeare's most famous play. It was good advice, as Italian astrophotographer Marcella Giulia Pace reminds us wonderfully in this composite of 48 different shots of the full Moon. Typical photos from astronauts or spacecraft show the Moon as rather bland and colorless—black volcanic plains ringed by rugged gray and white mountains. But back on Earth our atmosphere suffuses the Moon with reddish, yellowish, and even bluish hues when its light passes through more humid or dustier or smoggier air. Pace's Archimedean spiral reveals a remarkable palette of lunar colors, ending in a reddish Moon deep within the Earth's shadow during a total lunar eclipse. Not only the color but the very *shape* of the Moon can change when it is close to the horizon, as thicker air bends light rays and compresses the round Moon into an oval. It took a decade for Pace, an award-winning schoolteacher and artist, to capture her *Colors of the Moon* composition. We often perceive things as only black and white, but as she writes on her website, pieces like this "remind us of the fallacies of our own sight."

Colors of the Moon, by Marcella Giulia Pace, 2010-20.

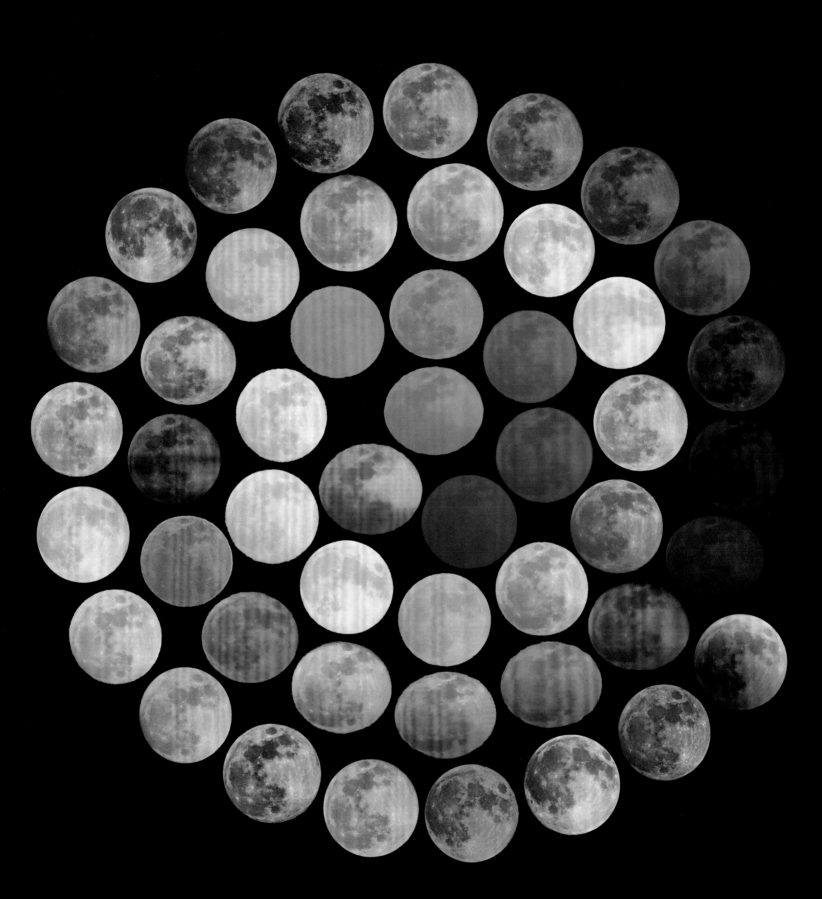

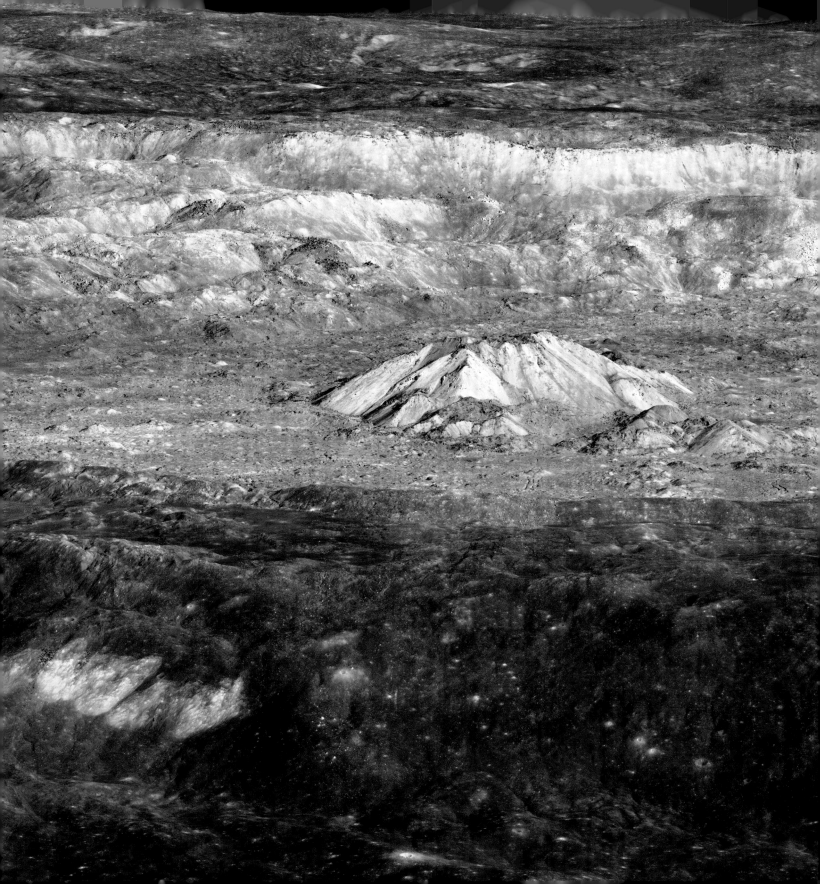

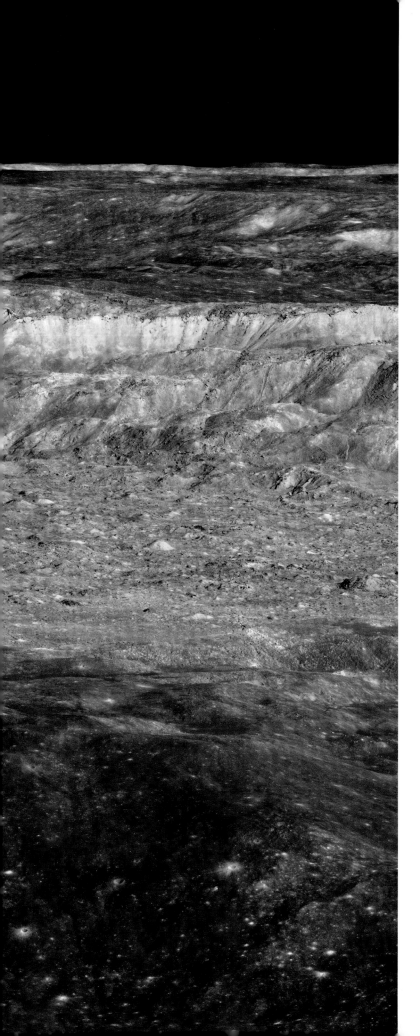

TYCHO

Planetary scientists know that one of the best ways to get to know a world is to get into orbit above it and spend quality time looking down and mapping the place in detail. That's certainly been true of humanity's exploration of the Moon. Since 1966, thirty different international robotic space probes and eight crewed spacecraft from the Apollo program have orbited the Moon and taken spectacular photographs and scientific measurements. The robotic probes usually take pictures pointed straight down at the surface (nadir) to get the best resolution, but once in a while they can be "rolled" to point off-nadir to view specific features of interest. That was the case with this spectacular photo of the crater Tycho taken by NASA's *Lunar Reconnaissance Orbiter* team. Tycho is a hole in the ground about 53 miles (85 km) wide, created when an asteroid hit the Moon some 100 million years ago. The hole is more than 2.6 miles (4.2 km) deep from the flat crater floor to the rugged slumped rim. The so-called central peak in the middle of the crater was formed during the rebound of the impact shock wave. Those mountains cover about the same area as Washington, DC, and they rise some 6,500 feet (1,980 m) above the floor. This image is an impressive and inviting example of great lunar landscape photography.

NASA *Lunar Reconnaissance Orbiter* photo of the lunar crater Tycho, taken on December 23, 2009.

LUNAR PORTRAITS

The 12 astronauts who walked, drove, and worked on the Moon between 1969 and 1972 took thousands of photographs, using both black-and-white and color film. Their equipment included Hasselblad 70-mm cameras with Zeiss lenses that they could operate handheld or mounted to their spacesuits. While all the photos taken on the Moon are, of course, historic and rare, some of them stand out as wonderfully artistic. For example, seen below is a beautiful shot of the Apollo 14 mission's lunar landing module *Antares*, sitting proudly on the rugged plains north of the crater Fra Mauro. Part of the job

of astronauts Alan Shepard and Edgar Mitchell was to photographically document their landing site during their first moonwalk. This photo is from a 360° panorama with 24 individual frames taken from due west of the lander, looking east toward the low and slowly rising Sun. At that location, the camera was in the shadow of *Antares*. But the Sun streams brilliantly into the photo anyway, through the windows of the lunar module. According to NASA, after the flight, when the astronauts saw the developed photos, they said this one made them feel that *Antares* was a brilliant jewel resting on the surface of the Moon.

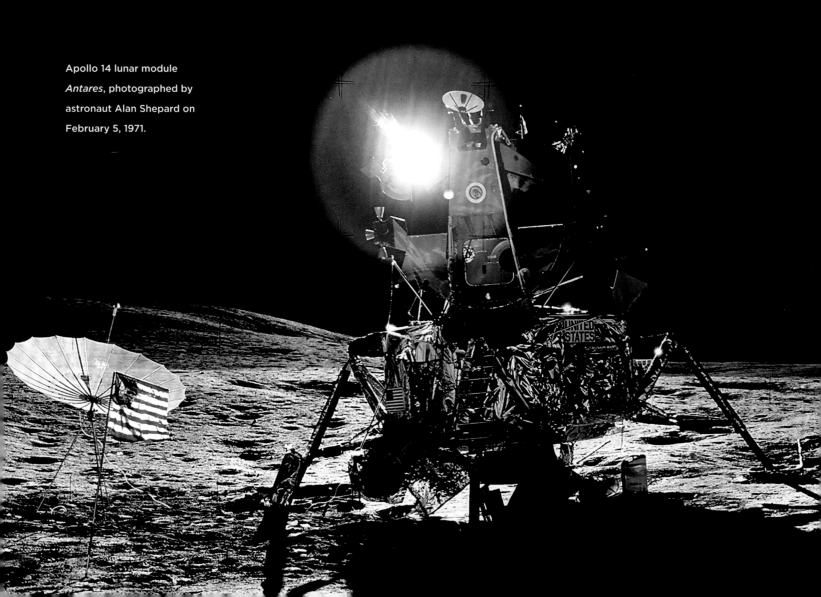

Apollo 14 lunar module
Antares, photographed by
astronaut Alan Shepard on
February 5, 1971.

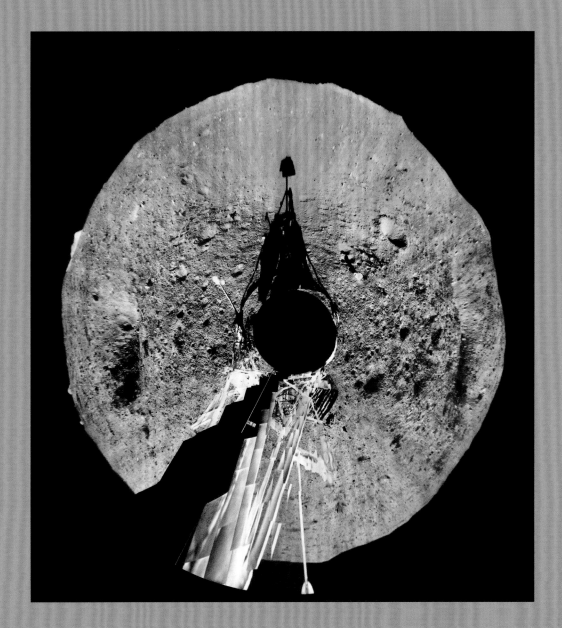

Before the Apollo astronauts got to the Moon, orbital and landed robotic missions scouted the way for them in the late 1960s, helping to identify possible landing sites and validate the technologies needed to land on the lunar surface. The landers were called *Surveyor*. In addition to demonstrating safe soft-landing on the Moon, the *Surveyors* carried cameras and other instruments to enable some lunar science. The photo above is a mosaic made from the 360° landing-site panorama taken with the zoomable TV camera on *Surveyor 1*, from the Moon's "Ocean of Storms." Canadian space researcher and planetary mapper Phil Stooke created this mosaic from the original *Surveyor 1* images, recasting them into

a "polar" projection that makes the landing site seem like a mini-planet of sorts. "*Surveyor* images are almost disregarded these days because the original mosaics were marred by very visible seam boundaries," Phil told me. "The original images have been retrieved now by scanning archival negatives, and heavy processing was needed to remove the seams." To me, the choice of projection here, along with the lander's shadow and antenna, gives the scene a three-dimensional feel. Five of the seven Surveyor missions were successful, and the *Surveyor 3* landing site was also chosen as the landing site for the second human mission to the Moon, Apollo 12 (November 14–24, 1969).

The interplay of light and shadow on the Moon is stark and artistically interesting because of the complete lack of air and the associated effects that haze and scattering have on our perception of landscapes. Distant mountains seem like an easy hike away in lunar surface photos taken by the Apollo astronauts. Textures on rocks and soils are especially enhanced in such an environment by micro-scale shadowing when the Sun is low in the sky. Another gorgeous photographic example, below, from the Apollo 14 mission, shows that effect beautifully here. Astronauts Alan Shephard and Edgar Mitchell didn't have a lunar rover like their colleagues who went to the Moon later on. Instead, they had a hand-pulled cart called the Modular Equipment Transporter, or MET, that carried their tools, experiment packages, and samples. The lunar soil got compacted by the wheels of the MET, and the flatter soil patches act like little mirrors that reflect more of the Sun's light into the camera than the looser more evenly scattering soil nearby. The lack of haze also means a lack of the normal photographic cues to scale and distance. *Antares* seems fairly close, but it's nearly two football fields away from the astronauts in this unique and artistically framed shot.

The Modular Equipment Transporter's track with lunar landing module *Antares* in the background, photographed during the Apollo 14 mission on February 5, 1971.

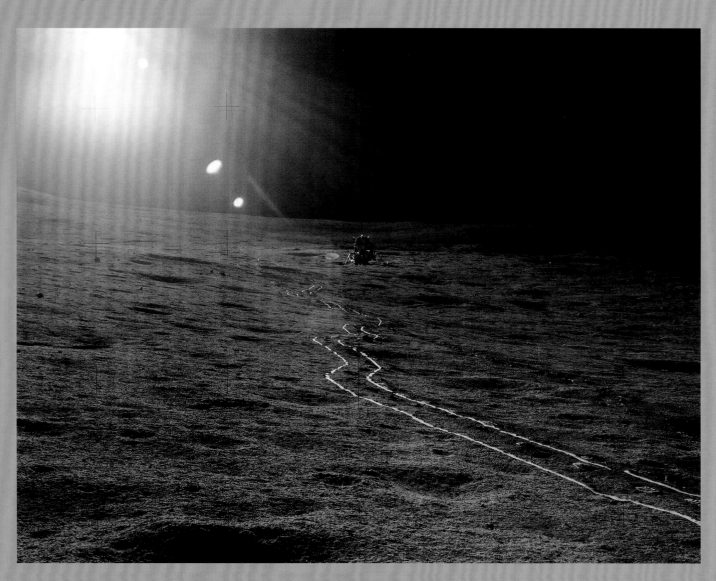

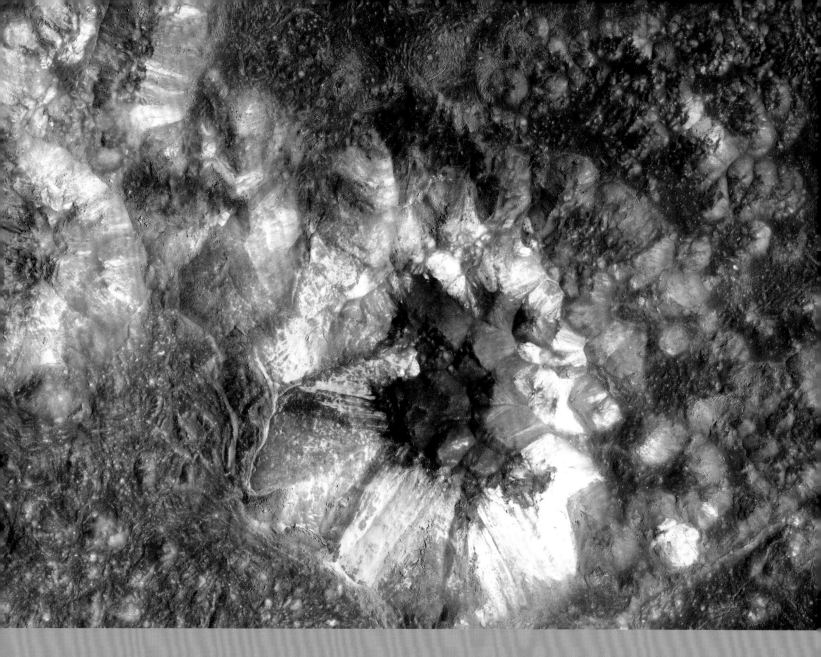

The team operating the telescopic 700-mm, focal-length cameras on NASA's *Lunar Reconnaissance Orbiter* have taken more than 2.2 million high-resolution photographs of the Moon since the spacecraft went into orbit back in 2009. The photos document the craters, plains, mountains, fractures, lava flows, and even individual boulders at a scale down to just one foot per pixel, similar to what terrestrial geologists can get with aerial photos. There's lots of great geology in this amazing and growing archive of lunar photography, but there are many examples of stunning art in those photos as well. The team's lead, PhD planetary scientist Mark Robinson from Arizona State University, is also an amateur photographer with a degree in fine art. Mark is always looking for opportunities for the team's photography to advance not only the science of the Moon, but also to advance the public appreciation of the starkly alien-but-familiar "beautiful desolation" of the lunar surface, as Apollo 11 moonwalker Buzz Aldrin noted. This fantastically abstract and almost cubist view, above, zooms in on the central peak mountains of a 45-mile (72 km) wide crater named Jackson on the far side of the Moon. The jagged peaks here rise more than 6,500 feet (1,980 m) from the crater floor and expose a spectacular range of contrast and textures.

NASA *Lunar Reconnaissance Orbiter* photo from March 11, 2013.

FAMILY PORTRAIT

While the Apollo astronauts were on the Moon, almost every moment of their time was tightly choreographed by NASA flight controllers and others back in Houston. They were given precious little time for levity and reflection. Such times included Alan Shepard's golf shots during the Apollo 14 mission and Dave Scott's famous hammer-and-feather drop experiment during Apollo 15. Commander John Young and Lunar Module Pilot Charles Duke of Apollo 16 had trained for years to follow the plan for their three-day stay in the rugged Descartes Highlands region, but they were also allowed a little latitude now and then. One of those times produced one of the most personal and poignant examples of photographic art in the entire collection from the Apollo missions. Near the end of his last day on the Moon, while packing things up, Charlie walked a little ways from their lander, *Orion,* and gently laid a color photo of his family on the fine gray soil. "As I dropped this family photo onto the Moon," Charlie told me, "I experienced this deep feeling of love for my precious family. Here we were 'together' on the Moon!" My heart races when thinking about such a unique, stirring, and intimate moment in the midst of one of the most intense and extreme experiences in human history.

The Duke family, photographed by *Apollo 16* astronaut Charlie Duke on April 23, 1972.

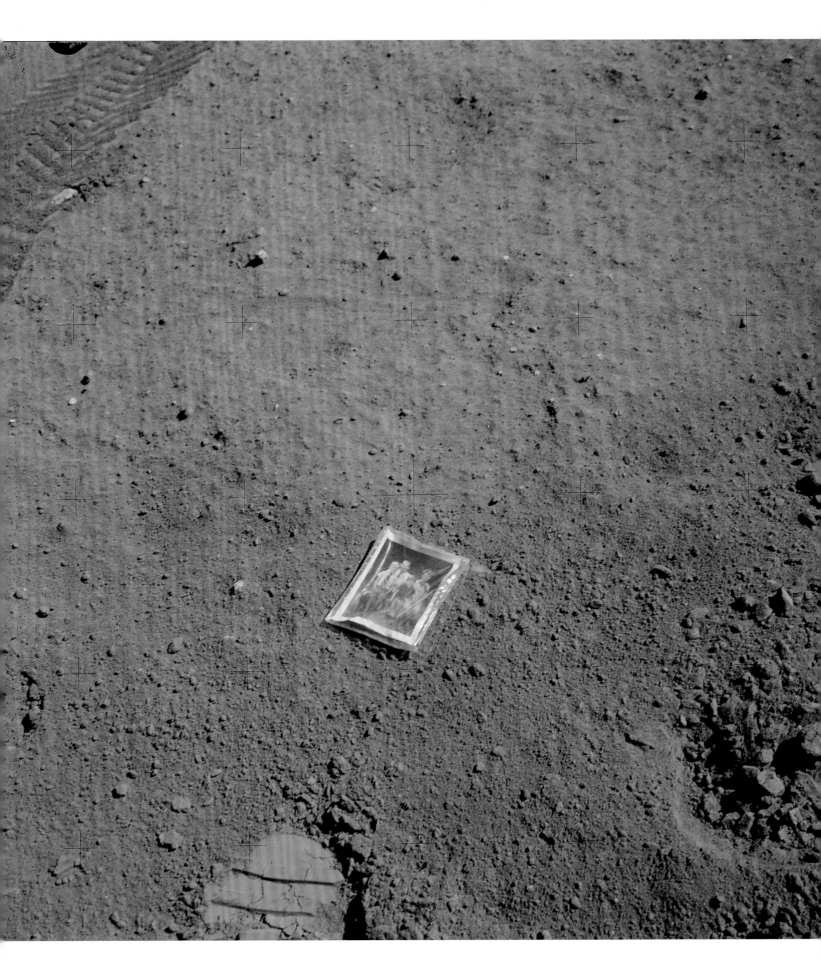

2

MARS
and Small Bodies
of the Solar System

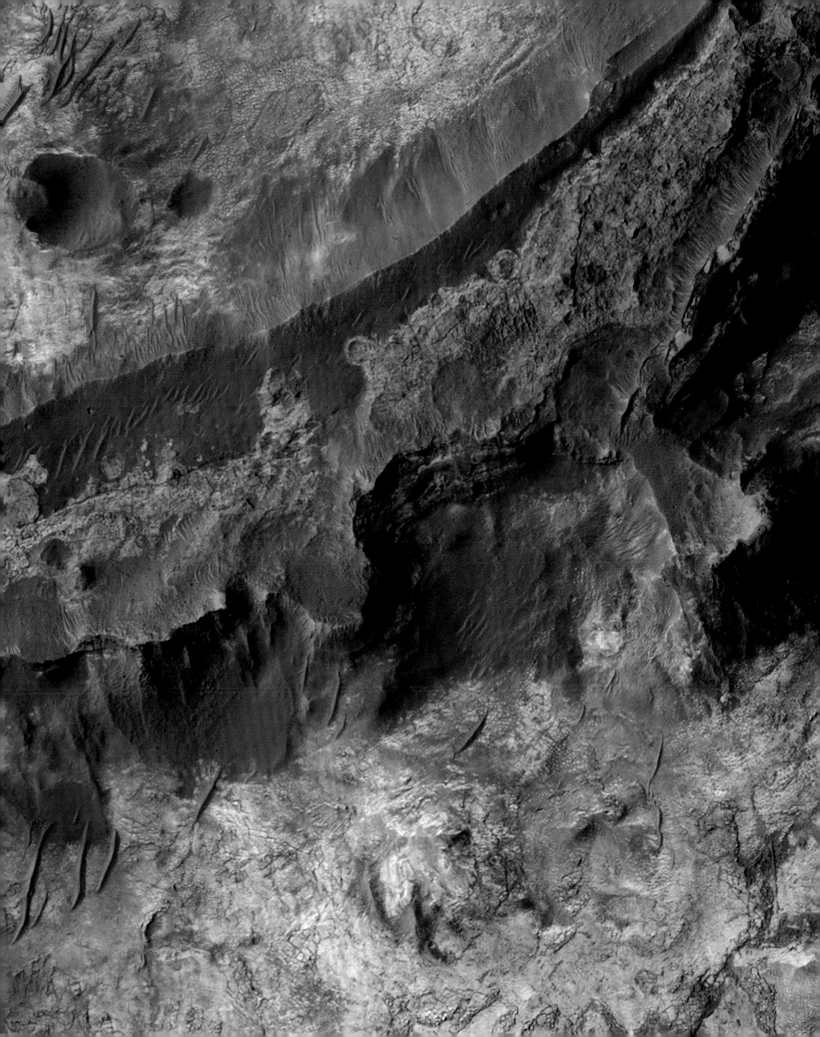

MARTIAN RIVERBEDS

NASA has been operating the *Mars Reconnaissance Orbiter* (MRO)/High Resolution Imaging Science Experiment (HiRISE) camera from a perch some 190 miles (300 km) above the Red Planet since 2006. This camera uses a 20-inch (50 cm) diameter telescope to take stunning photos that can resolve surface features in unprecedented detail—only a few feet wide—comparable to aerial photos used by geologists to guide their work on our own planet. The gorgeous and artistic example on pages 60–61 reveals an astounding diversity of color, line, and form. The scene, which is only about 0.6 miles (1 km) across, is from a region of ancient Mars known as Mawrth Vallis. Three to four billion years ago, when the climate of Mars was more like that of the Earth, a river flowed here. The riverbed was filled with rocks being moved downstream by the water, and over time many of the rocks became cemented together by clays, salts, and other hydrated minerals. After the climate changed and the deep river channel dried up, erosion by sand and wind wore down the region but left the tougher riverbed rocks standing tall in what is called "inverted topography." It is a photo filled with geologic irony—what was down is now up, what was wet is now dry, what once flowed is now stagnant.

PREVIOUS PAGES: HiRISE image of Mars ridges, or inverted channels, taken on September 21, 2021.

POLYGONAL TERRAIN

It is impossible to tell the scale or context in this abstract scene, opposite, or even to know what the subject is. To me, the view evokes the cracked surface of some styles of Japanese pottery or maybe a microscopic view of a honeycomb. It's not at all obvious that this is another stunning view of Mars from the NASA MRO/HiRISE camera team. This photo, from high northern latitude, shows what geologists call "patterned ground" or "polygonal terrain" because the darker dusty surface is broken up into a pattern of nested polygons, outlined by brighter frost. The processes that form such features on Earth—cycles of expansion and contraction from wetting and drying or freezing and thawing—behave similarly over a wide range of scales, from tiny mud cracks in dried-up puddles to polygons hundreds of feet wide in the Arctic tundra to more than half a mile wide in dried-up lake basins. A similar range occurs on Mars, which has dried up considerably since its earliest, more Earth-like planetary history. The polygons here are typically around 350 to 500 feet (106,152 m) across, similar to polygons in the Arctic tundra. But there's no need to know any of that when just enjoying this wonderfully complex, multifaceted, and fractal kind of scene.

OPPOSITE: NASA HiRISE image of the surface of Mars's northern latitude from April 1, 2012.

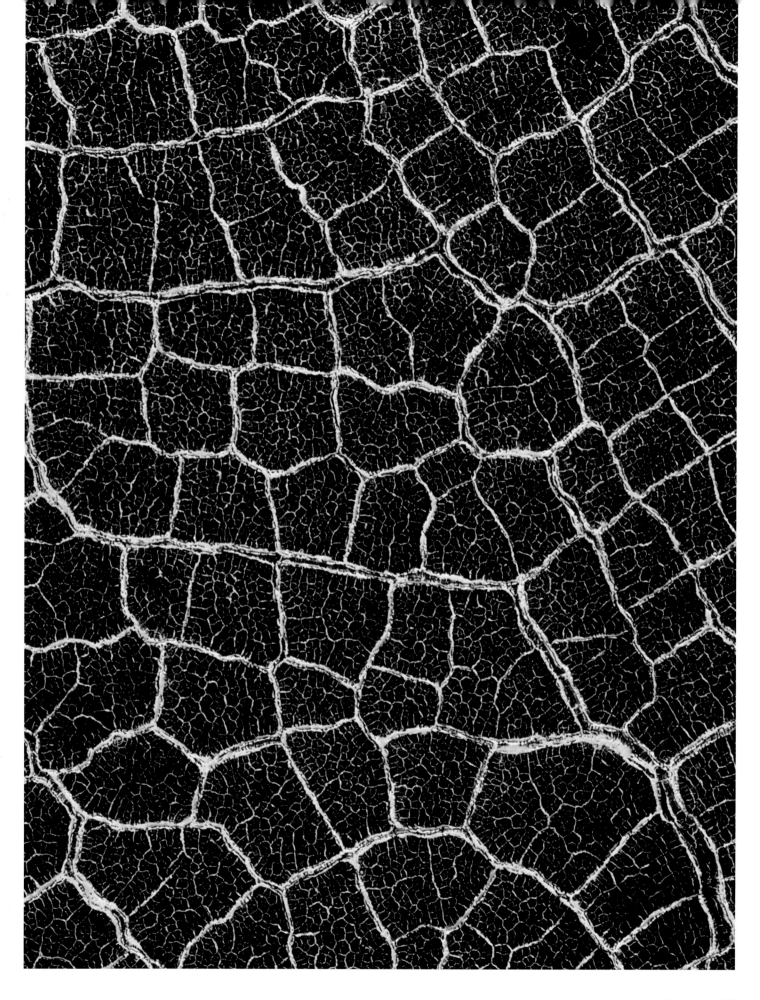

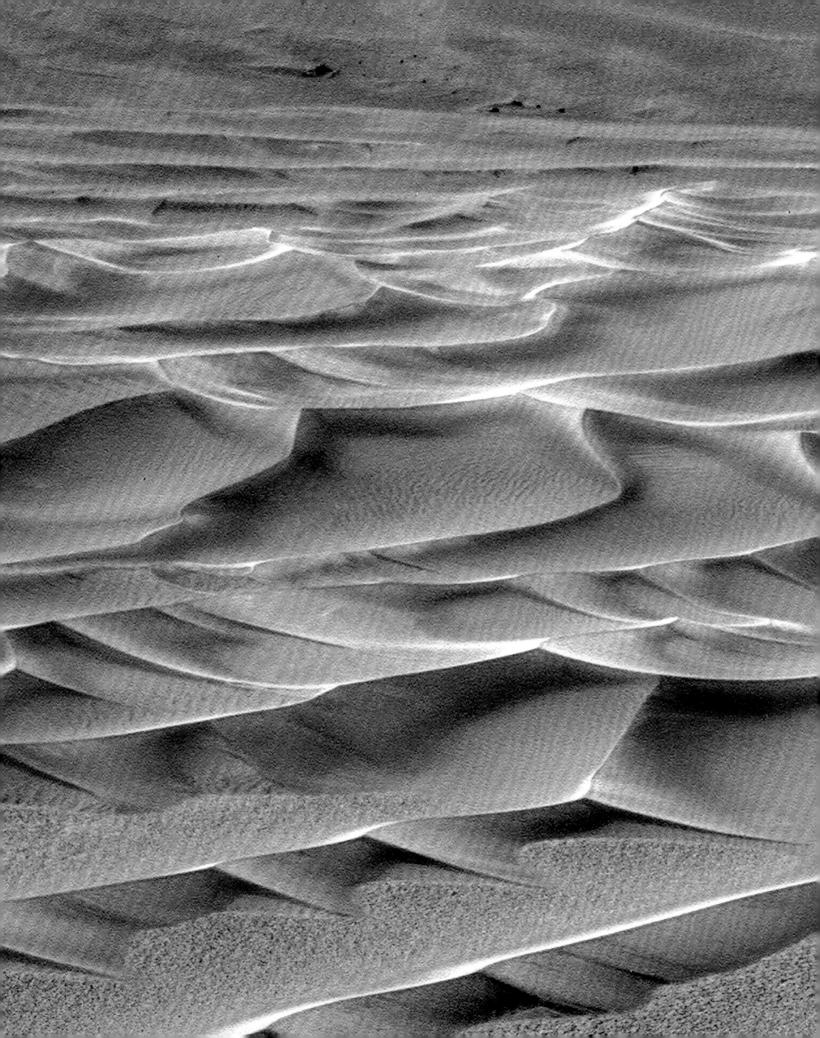

GREAT DUNE SEA

Are these angry waves on some vast alien ocean? Or maybe snowy peaks topping strange technicolor alien mountains? Neither, though this rather abstract scene is indeed alien. This false-color photo, made using blue, green, and infrared filters, is actually a view of a field of sand dunes on Mars, filling the bottom of a large hole in the ground named Endurance Crater. That crater was formed long ago when a small asteroid or comet slammed into the Red Planet. Since then, the crater has been slowly getting eroded away by wind and sand blowing across the vast plains of the area known as the Meridiani Planum. Craters such as this are like lobster traps for sand—the grains are blown in by the wind but then they are trapped in the hole forever. Over time, the grains build up into deep dunes that grow, slosh, and break like waves in slow motion. The color here highlights different iron-bearing minerals in the sand: from relatively unweathered minerals in blues and greens to highly oxidized ones in red. Part of the charm of this photo is that there is no sense of scale—only form, shadow, and wonderfully garish color.

NASA Mars rover *Opportunity* image of the dunes of Endurance Crater from August 23, 2004.

MARS SELFIE I

Selfies have gotten better over time. Instead of have having to stretch out your arm to hold your cell phone back, you can buy a long selfie stick to extend your reach and your field of view much farther. Space selfies have also evolved over time, like this one from NASA's *Curiosity* rover, a larger and more advanced model compared to earlier rovers. Now there's a digital color camera mounted to the end of the rover's own arm, programmed to perform a sort of tai chi set of slow movements. It can take 92 separate photos with the fields of view covering the rover's head, eyes, neck, body, and wheels, plus its surroundings. Careful photo editing and choice of compositing afterwards result in a seamless view that mostly excludes the arm. The impression is that *someone else was there* and took that picture of the rover. Or, because selfies are designed to personalize: I am there, standing on Mars, with this incredible nuclear-powered, laser-zapping, electric-car robot that our planet sent there. This particular version has been further converted into a so-called "stereographic projection" out to the horizon that appears to encompass the whole planet in one shot. A robotic mountain climber, and king of the Red Planet!

Mars rover *Curiosity* selfie from Gale Crater, taken on August 5, 2015.

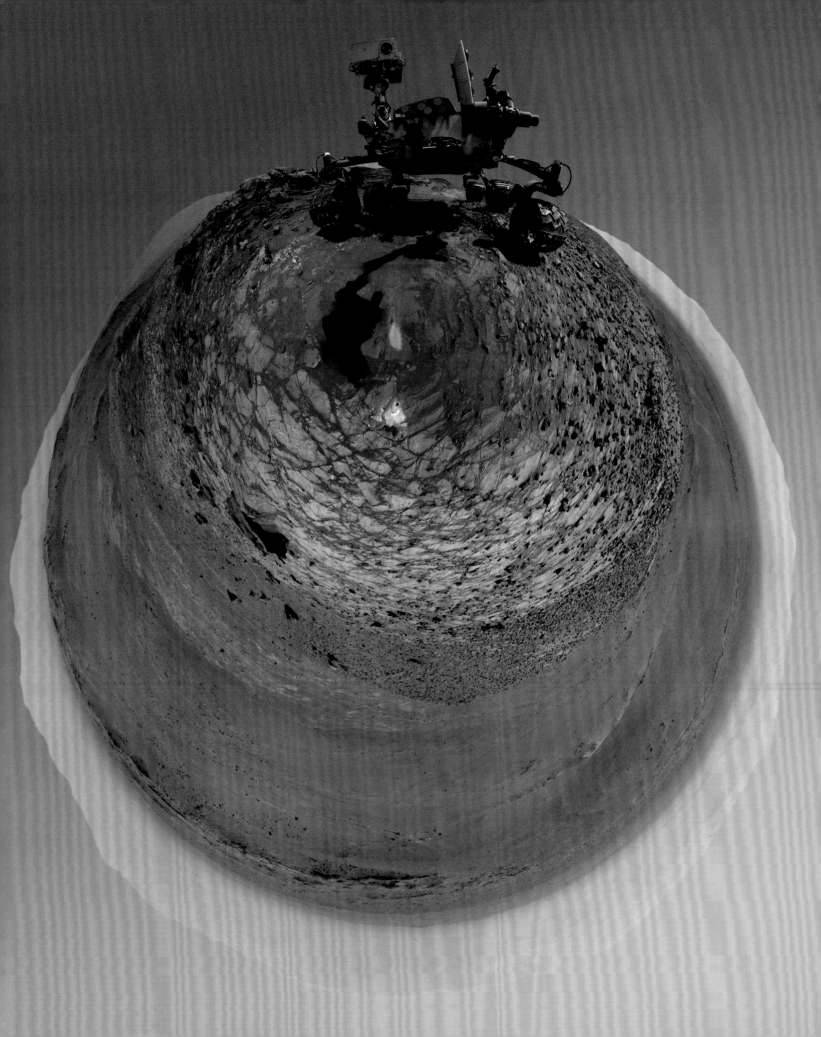

MARS SELFIE II

Space satellites that fly past or orbit other worlds usually have their cameras positioned so they have an unobstructed field of view looking out into space, away from pesky spacecraft parts that could block the view or scatter stray light into the lens. While prudent, that misses a photographic opportunity to frame a view of an alien world and give a sense of depth or height to the composition. In this lovely photo from the European Space Agency's *Rosetta* space probe mission, the team found a way to capture such artistic photo elements by carrying along a second "photographer." *Rosetta* was the first space probe to rendezvous with a comet and the first to deploy a lander module onto the surface of a comet. That lander, called *Philae*, was tucked into the main spacecraft during the journey to the comet, which included a flyby of Mars to get a boost from that planet's gravity. *Philae* carried cameras of its own that could see out into space from its nest, and it took this cool photo when the two spacecraft were just 150 miles (241 km) above the surface of Mars. The main spacecraft's solar panel blocks part of the view, but also gives the scene a sense of depth and framing that is rare in planetary flyby images.

Self-portrait taken by the *Rosetta* space probe during its flyby of Mars on February 25, 2007.

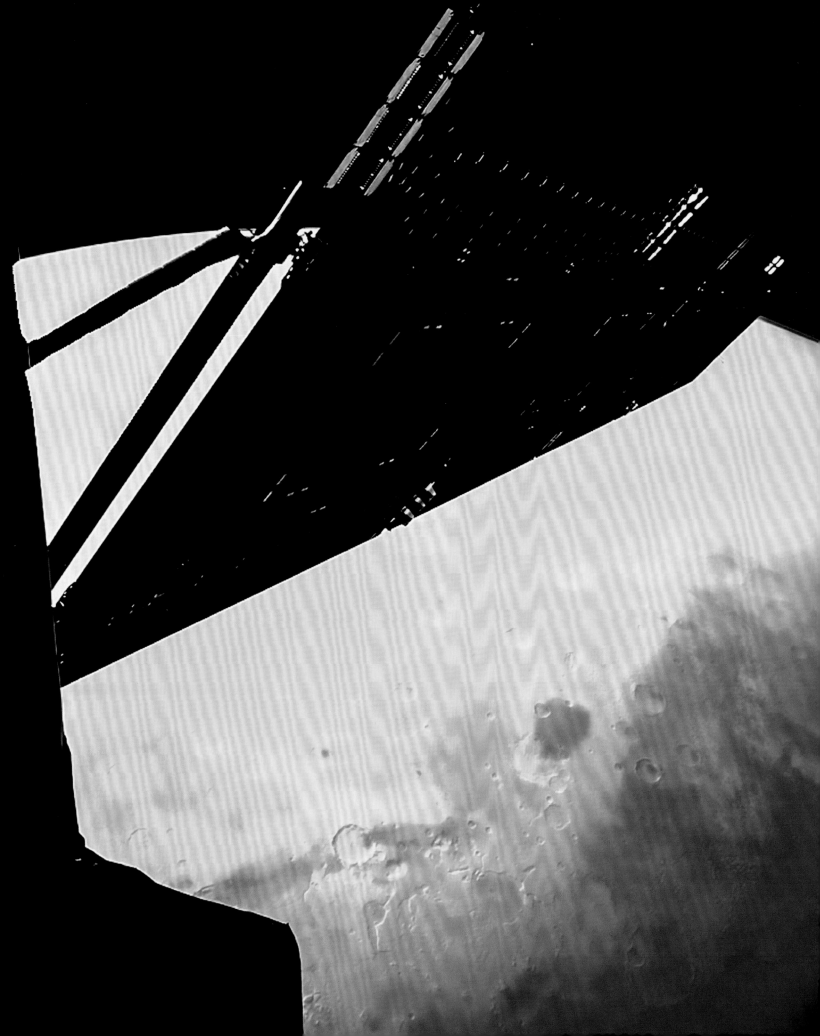

LANIKAI

Modern Mars is a dry and sandy world. Sand grains hop across the surface, blown by windstorms, and crash into rocks—creating more sand grains in the process. Enormous dunes and seas of sand slowly migrate across the Red Planet, wearing boulders and even mountain ranges down to dust. One of the goals of Mars rover missions is to study that sand and what it can tell us about those long-gone ancient landforms and their environment. NASA's *Opportunity* rover spent most of its life on Mars among these sands, and the team took advantage of rare opportunities to artistically document them. This close-up shot of a small sandy ripple, for example, is a merge of a black-and-white photo from the rover's microscope and a false-color infrared photo from the Panoramic Camera imaging system, or Pancam (see page 72). The landscape here—informally called "Lanikai," after the Lanikai Beach in Hawaii—is only about 1⅕ inches (3 cm) across. The largest sand grains are about ¹⁄₁₆ inch (1.6 mm) across, and they are coated with fine red dust grains 100 times smaller than a human hair. United States Geological Survey (USGS) geologist and microscopic imager team leader Ken Herkenhoff waxes philosophical about the view: "It takes many windstorms to create the alluring mosaic pattern seen here, so we are fortunate to have captured this artistic view of the evolving Martian surface."

A merged, close-up image of Martian sand at "Lanikai," taken on March 17, 2004, by the NASA rover *Opportunity*'s Microscopic Imager and Pancam.

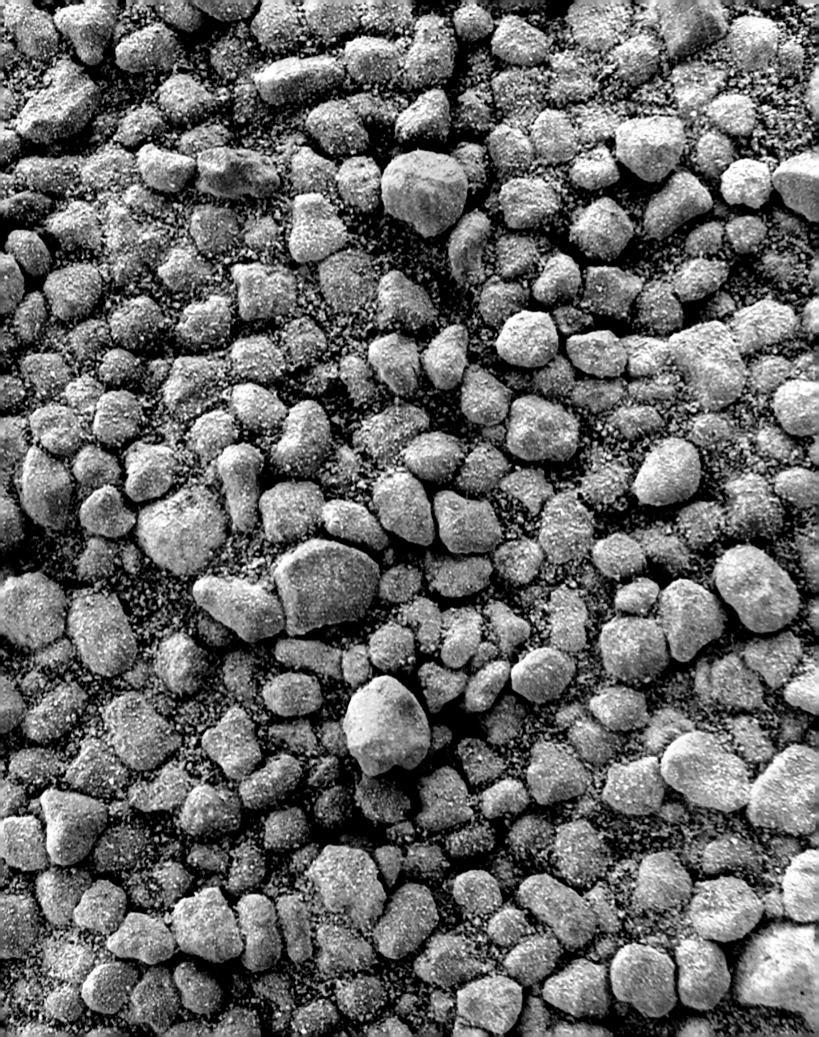

CORE OF THE HOLE

What could be so photographically exciting and artistic about a hole in the ground? Perhaps quite a bit, actually, if that hole were drilled by a robot working on our behalf hundreds of millions of miles away on another planet. This particular hole, below, is only about 1 inch (2.5 cm) wide and 5 inches (12.7 cm) deep, and it was drilled into a rock on Mars by the NASA *Perseverance* rover. The hole was made with a coring bit, designed to capture a cylindrical slug of rock and stash it inside a special sample tube inside the rover. Later, those tubes will be launched off the Red Planet by another mission, captured by a Mars orbiter, and maybe by the early 2030s rocketed back here to a parachute landing and then to laboratories on Earth. But the plot thickens: When this core was drilled, it came up empty. The rock crumbled and tumbled out of the bit. The team tweaked the process and tried again on a different rock. Success! And now eight beautiful core samples have been cached so far, with a goal of maybe twenty more to collect and bring home. While some see a hole in the ground, I see the potential for what's missing to be found. What's unknown will be discovered. But only with patience, persistence, and perseverance.

PANCAM AVATAR

The whole concept of the selfie has such great power and potential in photographic art, and no less so in the art of space imaging. The idea of turning a camera on yourself—toward your face, body, or even your planet—has the potential to yield a remarkable study in perspective, context, and (literally) self-reflection. Where am I? What am I feeling or doing? How am I perceived by others? Many of us imagine the creators of selfies thinking such things, even if those creators are silicon-based robots just following their programming. I was fortunate to be the lead for the Panoramic Camera (Pancam) imaging systems on the NASA Mars rovers *Spirit* and *Opportunity*. A simple pair of 43-mm f/20 fixed-focus and multifiltered CCD (charged-coupled device) cameras were mounted on a simple tilt and spin mast on each rover. We realized early in the missions that we could point the cameras straight down, spin them 360° around, and get a cool selfie of the rover and its surroundings that wouldn't show the mast at all, such as the photo opposite. The effect is like hovering over the spacecraft, riding along in a balloon with an otherworldly avatar. I love the sense that photos like this give me of exploring the planet's ancient sands and fractured rocks along with the rover.

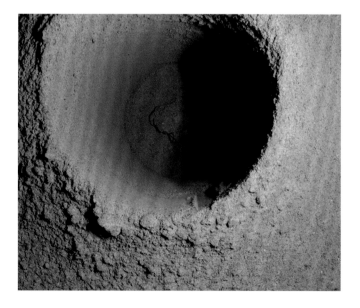

LEFT: NASA Mars rover *Perseverance*'s nighttime, LED-illuminated photo, taken on August 7, 2021.

OPPOSITE: NASA Mars rover *Opportunity* selfie from Meridiani Planum, completed on December 5, 2005.

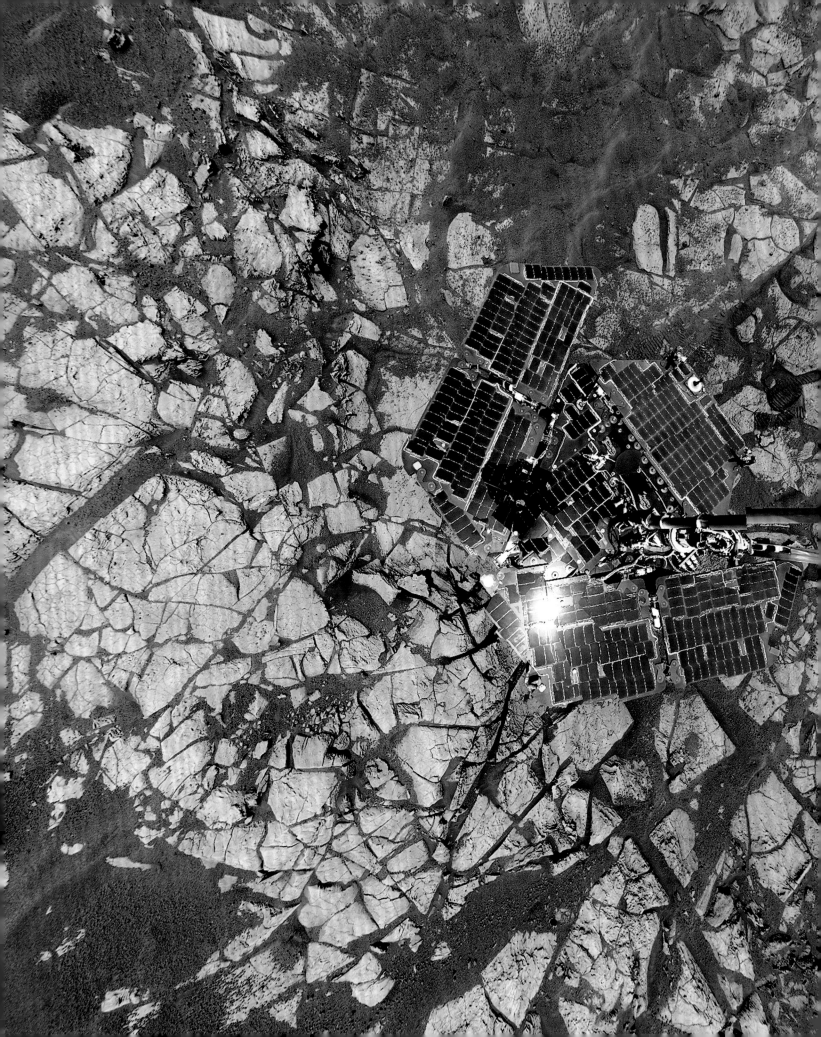

MARS IN SCALE

Mountain climbing is hard enough, but imagine doing it virtually using a robot in a harsh environment hundreds of millions of miles away. That's been the job of the NASA *Curiosity* Mars rover team for the past six years of its ten-years-so-far mission in Gale Crater. A giant mound of layered sedimentary rocks fills the center of the crater. The mound, Aeolis Mons—dubbed Mount Sharp—rises some 18,000 feet (5,386 m) above the crater floor. From orbital mineral measurements, the rocks appear to record the history of the planet changing from a warmer, wetter world early in its history to the cold and arid planet of today. The rover team is trying to tease out the details of that history on the ground by slowly climbing up through and analyzing Mount Sharp's layers. Artist and space image-processing expert Seán Doran created this mosaic of color Mastcam images from the foothills, in a region known as the Murray Buttes. The scene is remarkable and the buttes are 30 to 50 feet (9-15 m) tall—but on its own it's impossible to tell the scale. So Seán manually inserted an astronaut walking in the scene. In this case, augmenting the unfamiliar with the familiar enhances the *wow* factor in this impressive landscape photograph.

NASA Mars rover *Curiosity* photo of Mount Sharp from August 25, 2016, with an astronaut superimposed on the scene by space-imaging artist Seán Doran.

HiRISE ENIGMAS

Imparting a sense of scale is often a critical component in the creation of art, providing context for the work and its subjects, as well as a framework within which to interpret meaning. Just as importantly, uncertainty or ambiguity in scale can be used intentionally by an artist to surprise or confuse viewers or even just as a visual trope to point out universal similarities of patterns—perhaps especially in depictions of natural scenes. For example, the scale of the scene on the top of the opposite page and the medium used to create it are completely ambiguous. Is it a microscopic photograph? A painting of snails or sea slugs? Actually, it's a rendering by space artist Seán Doran ("using limited AI upscaling, blended with image processing in Photoshop," he writes) from a digital photo of high-latitude sand dunes on Mars taken by the NASA *Mars Reconnaissance Orbiter* mission's HiRISE camera. The largest dune here is about 10 football fields long, and typical dunes range from one to ten stories tall. Visible and infrared filters have been combined in this false-color composite to create shades of white, pink, and black that correspond to frosted, dusty, and less dusty areas of sand.

Another spectacular example of a high-resolution Mars landscape by space image-processing maven Seán Doran provides a dramatic and vivid demonstration of regularity of form in nature. This false-color photo, opposite center, shows a field of small greenish sand dunes scattered across the fractured floor of an ancient impact crater. Scale is impossible to discern here without common (on Earth) cues like trees, streams, and roads. But to give this scene context, the smallest semicircular dunes are around the same size as a football field. Geologists refer to the distinctive notched nature of these dunes as *barchan* (Russian for "crescent-shaped"); their shallow slopes are windward, and their pointy "horns"

and concave notch form on their leeward side. Dunes are created by the wind-driven piling-up and slow migration of sand. This is a common process on Mars and in arid regions on Earth, but there is a big difference between the sand on the two worlds. Earth's sand is mostly made of quartz, a bright mineral abundant on our continents, while Martian sand is made of basalt, a dark volcanic mineral erupted from the planet's mantle; this similarity in form, but stark difference in composition, is an important and intriguing aspect of Seán's photo.

When David Bowie wrote about Ziggy Stardust jamming with the Spiders from Mars, he probably never imagined that they'd be playing music on the south polar cap of the Red Planet. Mars does indeed harbor such spiders, at least metaphorically. Geologists call the features seen here in this NASA *Mars Reconnaissance Orbiter*/HiRISE photo *araneiform* (Latin for "spider-like") terrain seen on the bottom of the opposite page. As is often the case in astronomical imaging, there is no sense of scale or context here, either for the spider-like features or the color of the landscape, helping to enhance the otherworldly artistic appeal of this scene. The appeal also extends to the otherworldly physics of what is going on here. Mars winters are so cold that dry ice (CO_2) condenses out of the atmosphere and forms polar caps. In the springtime, as the caps sublimate from dry ice back to vapor, plumes of CO_2 gas flow under the ice, concentrating dust and water ice grains in channels that merge around plumes where cracks in the ice release the gas. When the dry ice is gone, only the spider-like bright ice- and dust-filled channels remain imprinted on the terrain. There is no comparable process on Earth for such sublime Martian sublimation.

TOP: A digital rendering of a NASA *Mars Reconnaissance Orbiter* (MRO)/HiRISE image depicting a high-latitude Martian sandscape on March 20, 2008, created by Seán Doran.

CENTER: NASA MRO/HiRISE photo of Martian sand dunes from September 1, 2013, rendered by Seán Doran.

BOTTOM: Spider-like channels on Mars's south polar cap, taken by NASA's MRO/HiRISE on January 12, 2011, and rendered by Seán Doran.

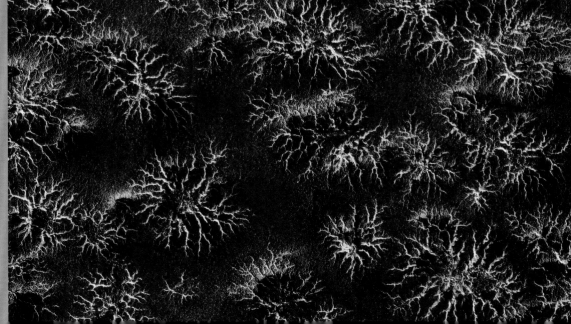

KODIAK BUTTE

Like a ruddy iceberg in a stormy sea of boulders, a rocky butte named Kodiak helps frame this Mars rover–enhanced color photo and create a tangible sense of depth and perspective. Near-field, mid-field, and far-field features show contrasts in color, texture, and topography that give the viewer a sense of seeing the scene in three dimensions. Because there is (as of yet) no interplanetary internet, and because rovers only operate during the warmest part of each day, only a small number of images can be relayed back daily from Mars. Thus, mission teams typically can't be choosy, but must instead take whatever minimal set of photos they can get to document the alien landscape and prepare for future driving or science experiments. More rarely, however, teams might have the luxury of being able to think like photographers—framing a scene, choosing the time of day to control the lighting, or increasing the fidelity by decreasing the compression. The butte itself, which is almost two football fields long and four stories tall, is adorned with intricate crisscrossing layers, belying its sedimentary origin and helping rover scientists piece together the history of this part of the Red Planet.

NASA Mars rover *Perseverance* enhanced-RGB photo of Kodiak Butte from April 24, 2021.

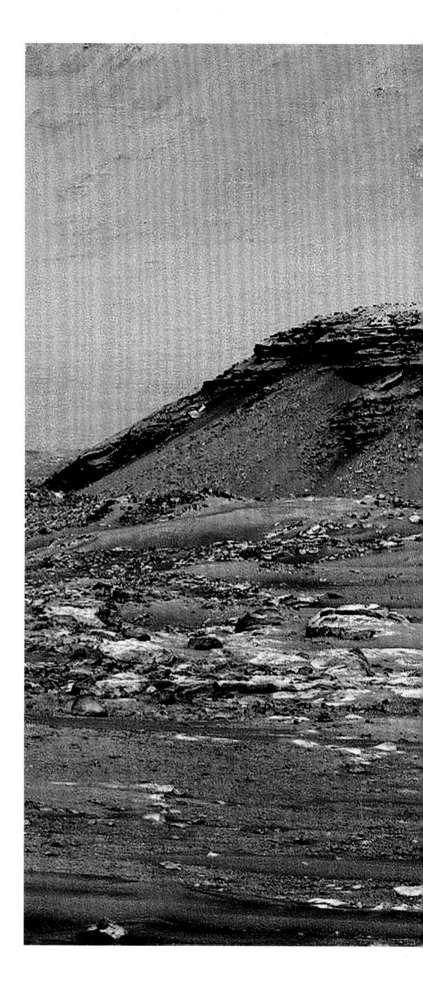

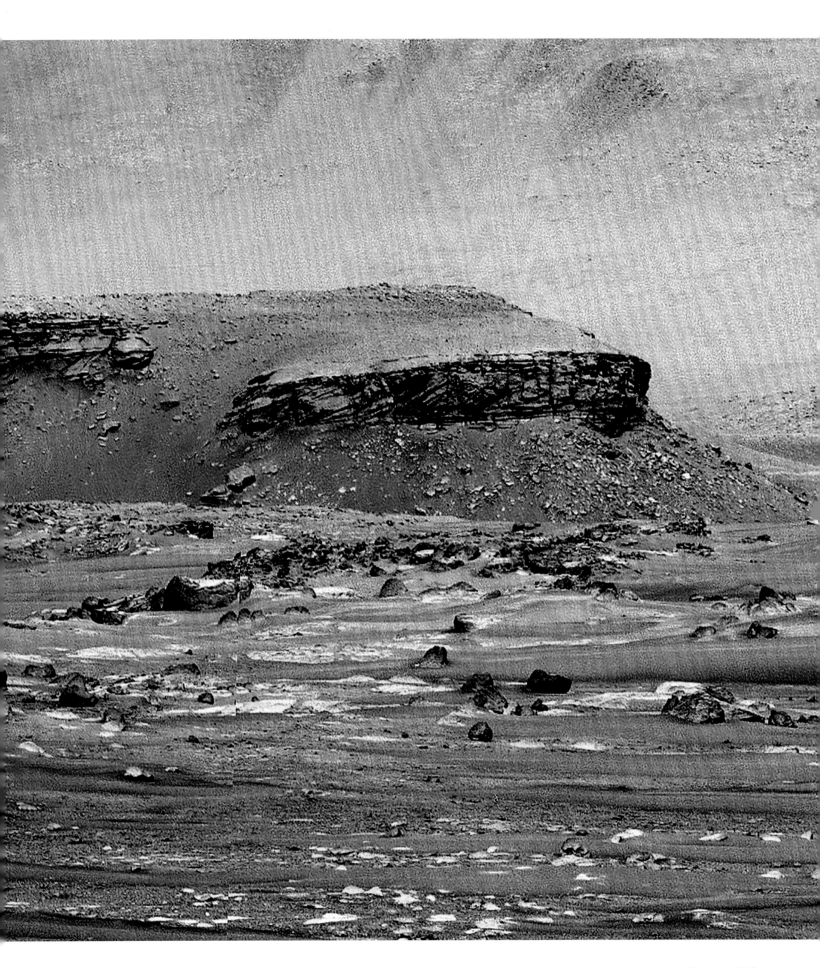

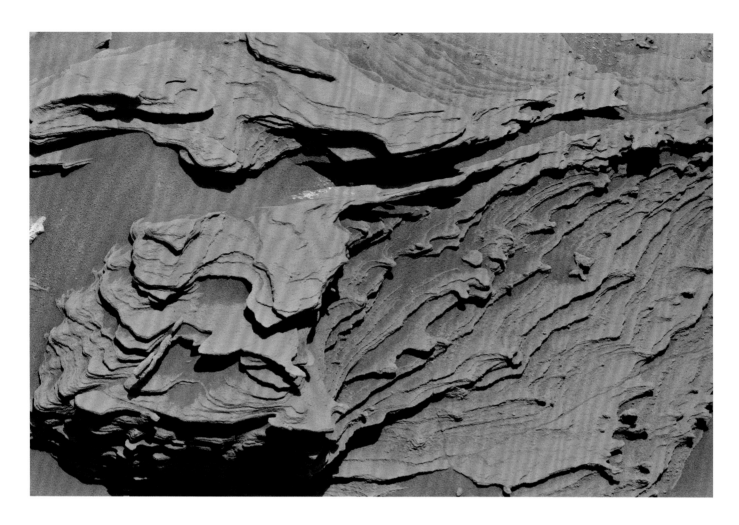

PEELING BACK THE HISTORY OF MARS, ONE LAYER AT A TIME

The symmetries and rhythmic layering of surfaces in this sublime photo make it seem like one of those three-dimensional wooden jigsaw puzzles. However, it's actually a puzzle of a completely different kind. This is a stack of dusty and ancient Martian sedimentary rocks, photographed by the NASA *Curiosity* rover team while driving on the floor of Gale Crater. Gale is a 100-mile (161 km) wide basin that hosted a deep freshwater lake during a much earlier, more Earth-like time in the Red Planet's history. These layers, formed as fine sand and silt, slowly settled to the bottom of that lake, becoming lithified mudstones. Six individual natural-color Mastcam scenes were merged by Paul Hammond, an amateur image processor and self-described "space-nerd since

the late 1950s," to create this photo. "The layers reminded me of the rover's mission," Paul told me, "climbing up from the crater floor and exploring newer, ever younger rocks as it climbed and sampled along the way." But how much water was in this lake, and when and for how long? This is part of the puzzle the rover team is still working to solve, now more than 10 years into their mission. Paul's title for the composition here is thus quite apt: *Peeling Back the History of Mars, One Layer at a Time.*

ABOVE: NASA Mars rover *Curiosity* photo of a stack of sedimentary rocks on the floor of Gale Crater, taken on May 26, 2016, and merged by space image-processor Paul Hammond.

SURFACE

This photograph, taken with a camera on NASA's Mars rover *Sojourner*, is a wonderful example of a resurrected and artistically reprocessed photo from philosophy professor and space-imaging expert Ted Stryk. *Sojourner*, a six-wheeled microwave oven–sized robotic car, was the first rover on Mars, carried along with the Mars *Pathfinder* lander mission in the summer of 1997. The image was photographed by the rover's low-resolution color camera just a foot (30.5 cm) above the surface, and it shows the rover's spikey 3-inch (7.6 cm) wide right rear wheel and part of its spectrometer instrument nuzzled against the rugged surface of a small boulder named "Chimp." It's

a historic shot, one of the first color photographs ever taken by a rover on another planet. And it also provides a unique and historic perspective. "The closeness to the surface is a metaphor for where we were in exploring Mars at the time," Ted told me. "We had been stationary [Viking]. With *Sojourner*, we started crawling. Not unsupervised yet—we had the *Pathfinder* lander watching over her—but still, we were moving on the surface." The low resolution of the photo also gives the scene an impressionist or pointillist feel; these are just the pieces of a larger, more detailed picture yet to be formed, built by the many rovers that would follow . . .

Historic NASA Mars rover *Sojourner* partial selfie with the Chimp boulder, taken on August 29, 1997, and reprocessed by space-imaging expert Ted Stryk. The photo is a little fuzzy and distorted because of the low-resolution of the rover camera's then novel miniaturized digital sensor (just 768 x 484 pixels) and the wide field of view of the optics (more than 90°). Still, it is historic in that it is one of the first color photos ever taken by a Mars rover.

PHOBOS AND MARS

I am drawn to space photographs that show sharply contrasting but closely associated astronomical bodies. So is Ted Stryk, who came of age in the 1980s with missions like Voyager and the Soviet *Phobos 2* probe that was designed to study Mars and eventually land on its moon Phobos. "Both missions captured my imagination," Ted told me. "It was the last possible time to become aware of space exploration with two primary players, one of which was the Soviet Union. I would ride my bike to the libraries in town several times a week to see if there were any images in magazines and newspapers." As a teenager, Ted found and reprocessed the original images to create this scene. "While *Phobos 2* would ultimately end prematurely," Ted recalls, "this was not before it sent back some spectacular images, the most striking of which showed Phobos and Mars in color, together." Bright Mars—the Red Planet—a rusty, dusty world with a watery past, frames dark and monochrome Phobos, an airless, potato-shaped, asteroid-like body the size of Lake Tahoe. The tiny moon looms large in the shot because it is close, and the overlap of the pair adds a neat element of depth to this beautifully arranged shot.

Soviet *Phobos 2* Mars orbiter photo from February 28, 1989, reprocessed by Ted Stryk.

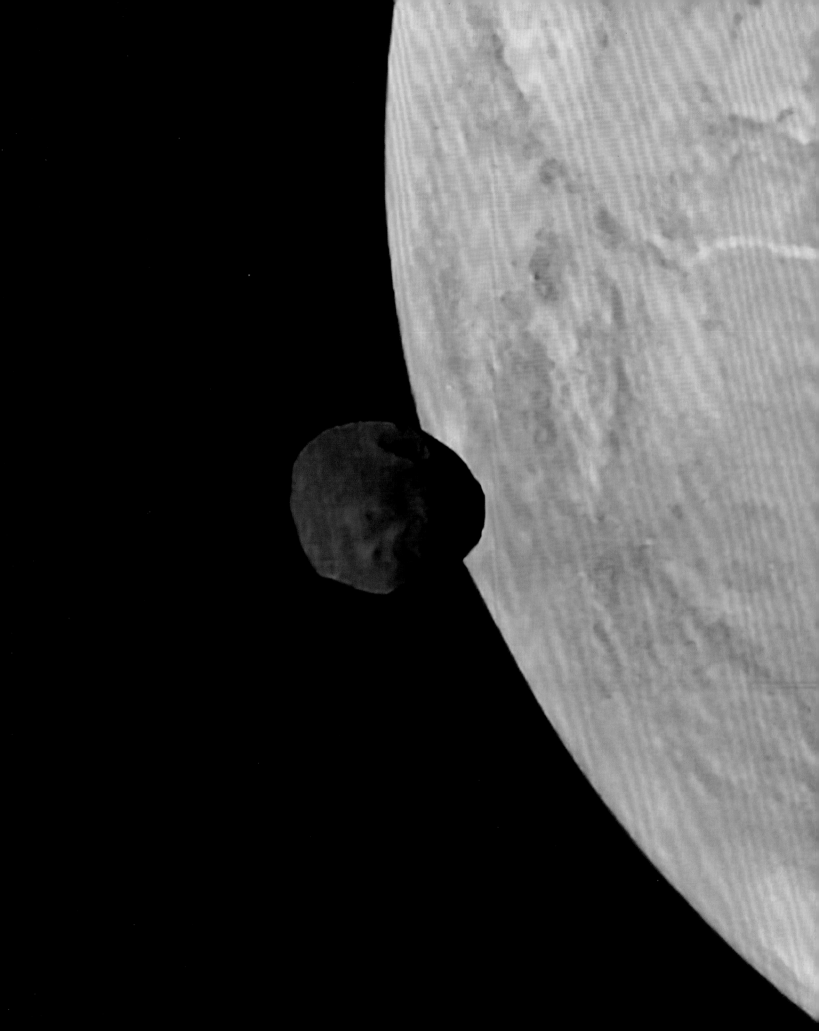

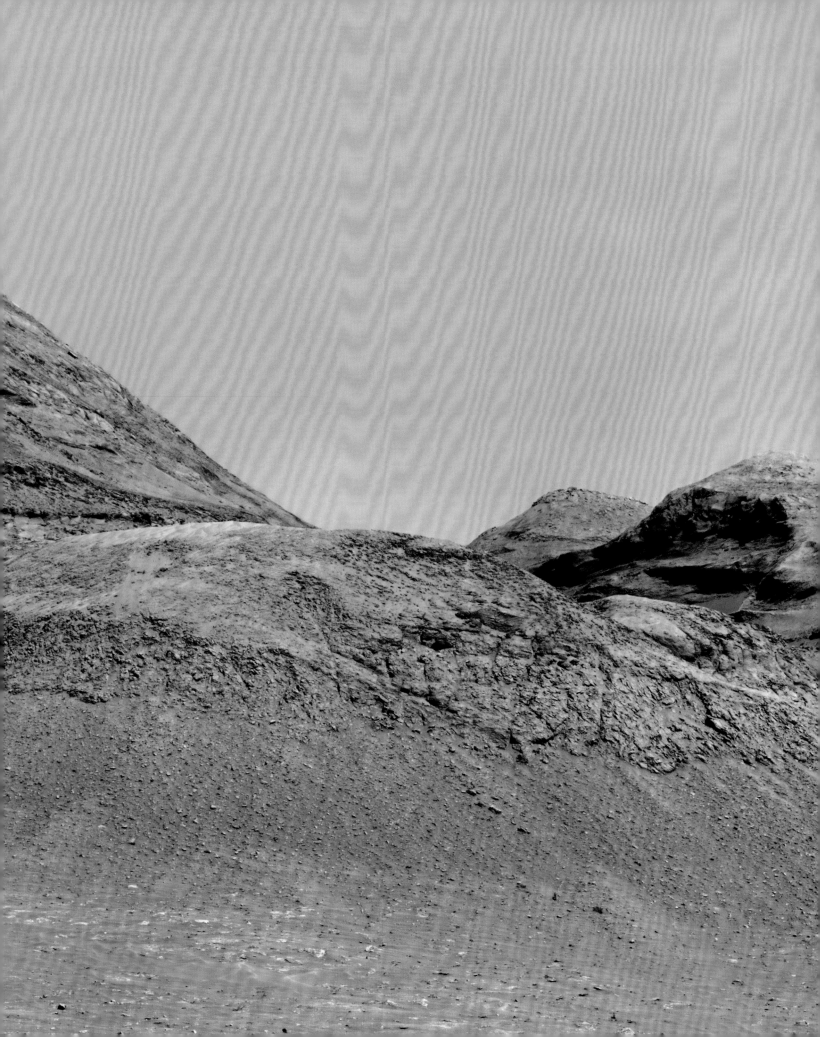

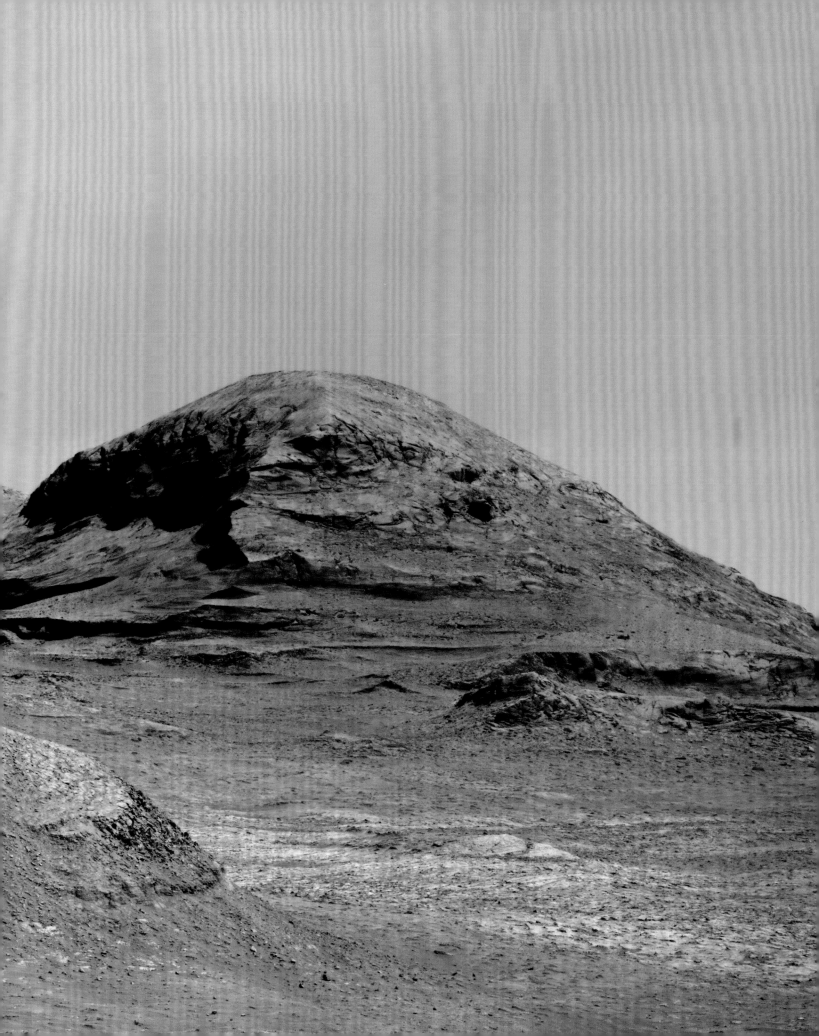

MOUNT SHARP

Sometimes a landscape is *just so beautiful* that it can't help but be regarded as art. Yosemite in the moonlight. Sunset on a Hawaiian beach. Jagged peaks in the Alps. And the landscape shown in the image on pages 84–85—an ancient extraterrestrial mountain pass winding through worn-down rocks older than almost anywhere on Earth. This is Mount Sharp in Gale Crater on Mars (see also page 80 and below), high up the slopes, nine years into the NASA *Curiosity* rover's climb. The image's enhanced color gives the scene an Earth-like feel. Jan van Driel, an almost 80-year-old space enthusiast from the Netherlands, made this stunning Martian-mountain mosaic. He explained

why: "For me it symbolizes the small rover between those hills and she is not afraid to drive there in that rough terrain for almost 10 years now, guided by controllers on the ground here, at times 400 million kilometers [249 million miles] away." The landscape is dramatic, evocative, and compelling to me as well. I can't help but believe that this place will one day be part of a planetary natural park on Mars, and that people—our descendants—will enjoy this magnificent view previously available only to robotic eyes. In the meantime, we can dream about and work toward that day. "It is one of my favorite images," Jan told me. "I have it as my desktop background."

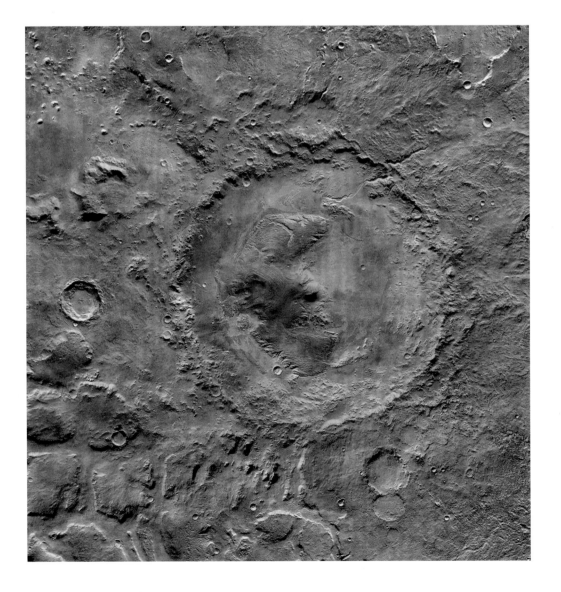

PREVIOUS PAGES: Enhanced-color mosaic of Mount Sharp by space image-processor Jan van Driel, based on NASA Mars rover *Curiosity* photos taken on June 3, 2021.

RIGHT: A mosaic of Gale crater photographs from orbit taken by the THEMIS infrared camera team on NASA's Mars *Odyssey* mission and released in June 2015. The different hues here map out different mineral compositions of rocks, sand, and dust in the crater and on Mount Sharp.

FAREWELL TO MARS

The depth and perspective of this photograph makes it look like some sort of computer graphic still from the 1982 movie *Tron*. But the Mars looming in the background here is the real thing. This is a historic photo from a relatively low-resolution, wide-angle camera on the NASA *MarCO-B* spacecraft. *MarCO* stands for "Mars Cube One." *MarCO-B* and its sister, *MarCO-A*, are a pair of "CubeSats," each only the size of a cereal box, that were launched to Mars with NASA's *InSight* lander in 2018. The probes successfully relayed signals from the lander as it descended to the surface, using their flat radio antennas—the gridded surface seen here in the foreground. The relayed signals allowed NASA controllers and space enthusiasts around the world to follow the successful landing events almost in real time. *MarCO-A* and *MarCO-B* are the smallest independently operating spacecraft yet sent into deep space. They have all the major systems and subsystems of larger "normal" spacecraft, but because they are miniaturized, they are much less expensive to build and launch. The photo here is both historic and portentous. Just as *Tron* represented the wave of the future in computer graphics, CubeSats and other small versions of traditional space probes represent the wave of the future in space science and planetary exploration.

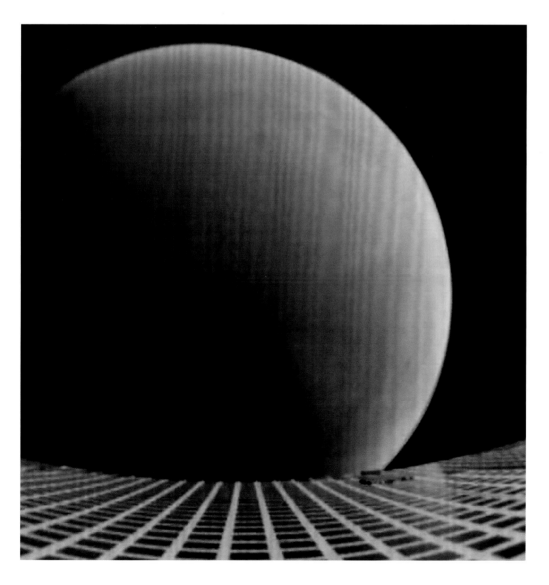

NASA *MarCO-B* mission photo of Mars—with the spacecraft's flat radio antenna in the foreground. The photo was taken on November 26, 2018, shortly after *MarCO-B* and its twin *MarCO-A* successfully relayed data to Earth from the successful landing of NASA's *Phoenix* lander on the Red Planet. The spacecraft's tiny off-the-shelf miniaturized color camera yields a relatively low-resolution image (just 752 x 480 pixels), and its fish-eye camera lens smears the view of the spacecraft's flat-panel radio antenna across the bottom of the scene.

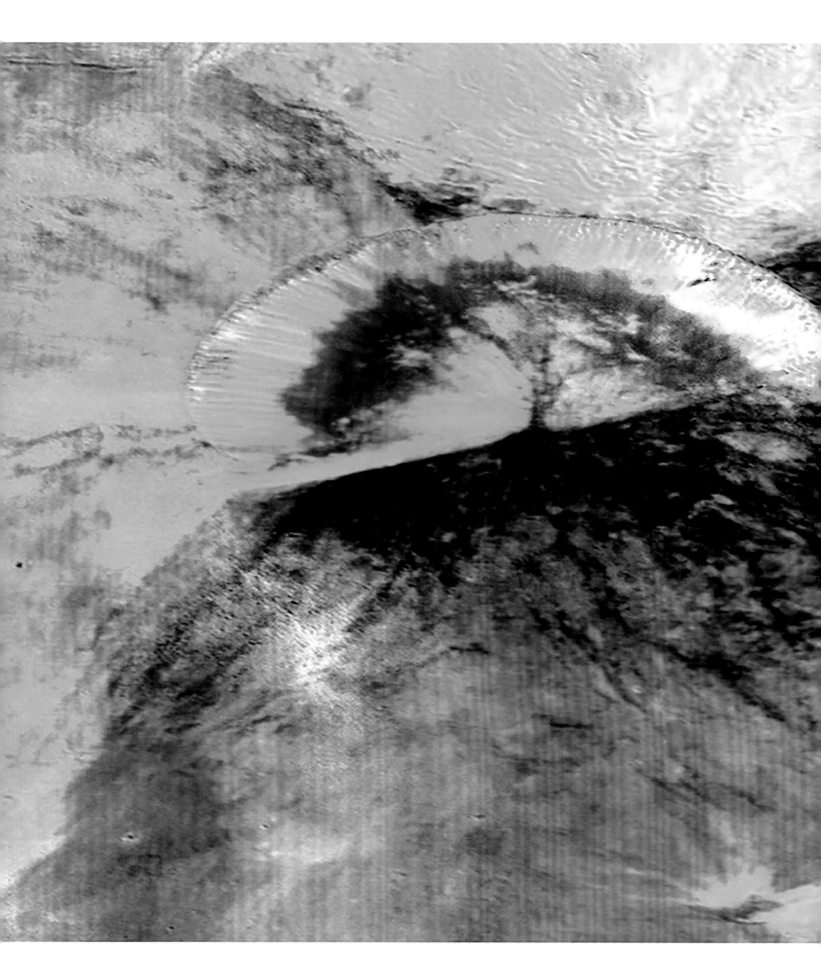

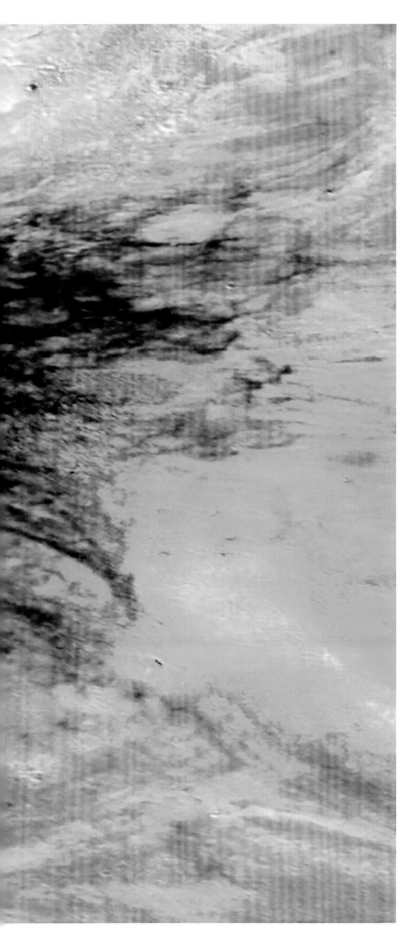

VESTA CRATER I

The natural world is a palette upon which geology, chemistry, and mineralogy create art. This is not just the case on our own planet, but on other worlds as well. Even small, airless bodies like asteroids can exhibit spectacular variations in color, if we only open our eyes to the spectrum of possible hues. This stunning infrared, false-color rendering, for example, shows part of the surface of the asteroid Vesta, which was one of the targets of the NASA *Dawn* asteroid orbiter mission. The view shows an 11-mile (17.7 km) wide circular impact crater named Antonia. The small asteroid or comet impact that created the crater also dug up and spread around lots of fine-grained rocks and sand, here depicted in light blue and teal. Darker blue colors map out coarser rocks and boulders that buried half of Antonia during landslides shortly after the crater was formed. Red and yellow hues indicate the presence of more crystalline, iron-bearing, silicate minerals. Even though Vesta appears rather bland and gray in human color vision, using technology to extend our visual senses can yield glorious and vivid artistic renderings.

NASA *Dawn* orbiter color-composite image of Antonia Crater on the asteroid Vesta, taken in October 2011.

VESTA CRATER II

I am strangely attracted to certain kinds of art that have
been violently produced or that document cataclysm—
imagery that evokes extreme force, upheaval, tension,
and distress. Paint literally thrown onto a canvas by the
likes of Jackson Pollack. Andy Warhol's *Death and Disaster*
series. Historical landscape photos of cities racked by
natural disasters. Such scenes may be difficult to view,
especially when depicting events that are rarely or never
encountered under normal circumstances. I get the
same sense when viewing photos of extreme natural
phenomena in space. This photo, for example, portrays in
garish false color the natural scars caused by the violent,
high-speed collision of a small world with a bigger one.
The bigger world here is Vesta, the second-largest asteroid
in the Main Belt between Mars and Jupiter, and one of
the targets of the NASA *Dawn* asteroid orbiter mission.
The "splosh" crater created in the impact, called Aelia, is
about 3 miles (4.8 km) wide, and the garish colors here
represent a variety of iron-bearing minerals, derived
from different visible and infrared filter images. The blue
material, for example, was dug up from the subsurface by
the impact. The intense energy and violence that created
this scene are well beyond our normal human experience.
Which, to me, is part of the appeal.

NASA orbiter *Dawn* color mosaic of Aelia Crater on Vesta, from
images taken in September and October 2011.

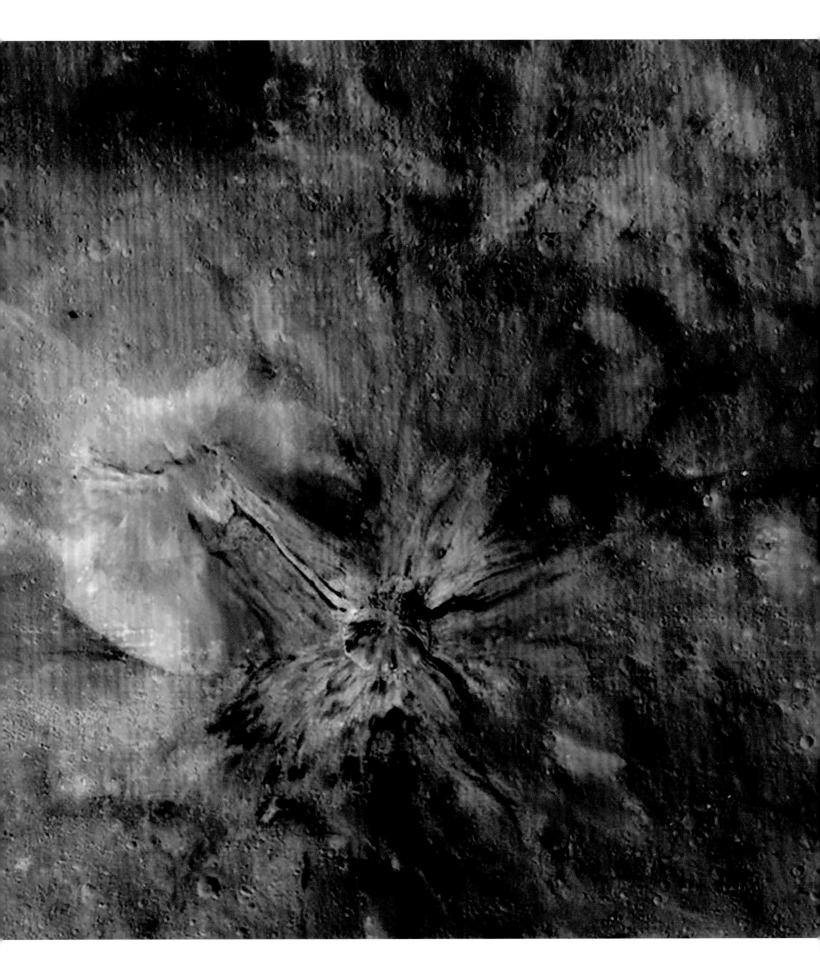

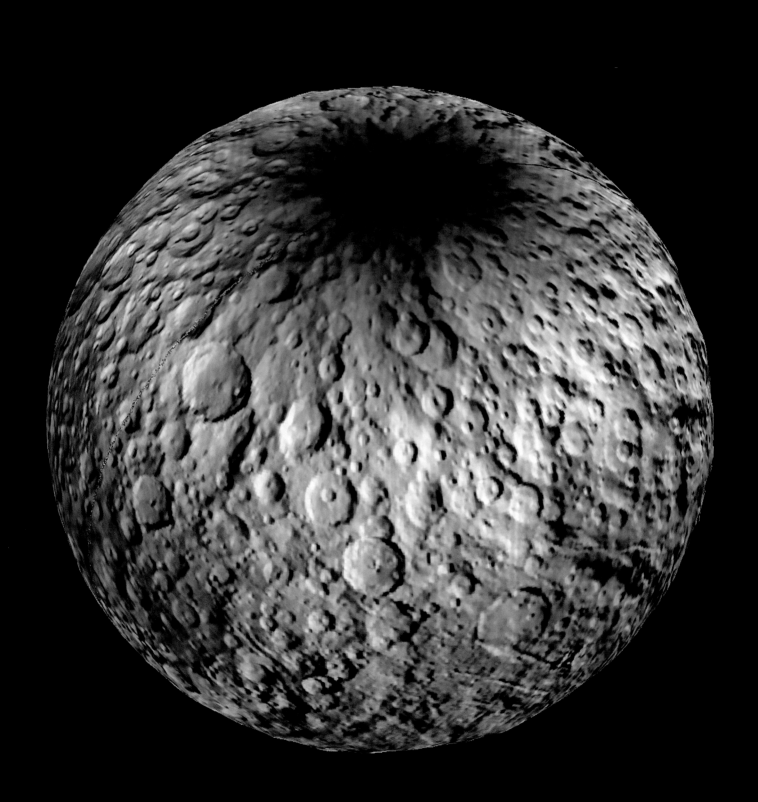

CERES ICE

This is a composite photo of Ceres, the largest asteroid (actually, a small planet) in the Main Belt between Mars and Jupiter, and one of the targets of the NASA *Dawn* asteroid orbiter mission. It's a composite of a "normal" black-and-white image of the dwarf planet's geology from reflected sunlight (photons), merged with color information from an unfamiliar source: reflected neutrons. Space is permeated by high-energy particles ("cosmic rays"), created by stars, supernovas, black holes, and the like. When those particles strike the surface of a planet or moon or asteroid, the collisions create or release other particles, like gamma rays and neutrons, within a few feet of the surface. Freed neutrons can be reabsorbed by surface materials, especially hydrogen, before escaping. The blue colors here show places where neutrons aren't escaping, presumably because of the hydrogen in water ice. The redder areas show dry places where neutrons freely escape. So what looks like a small planet with a bad haircut is actually a map of an asteroid with polar caps—buried ones, at least. It's cool and nerdy physics and chemistry converted into and communicated via colors that we can perceive. I like that sometimes science requires artistic interpretation.

NASA orbiter *Dawn* color composite of Ceres, from data acquired between 2015 and 2018.

CERES SALT MOUNTAIN

I think of space photographs that depict unique scenes or events (first time to do *x*, *y*, or *z*; biggest one of those ever seen; and so on) as intrinsically historic, in that they document achievements in human and robotic exploration and experience, and set a benchmark for the future. When documenting the new and unexpected, an additional dimension of meaning can be added when the mundane becomes the exceptional, or so-called common wisdom is flipped on its ear. This is the case for the view here, which is a high-resolution photo of a tiny part of the asteroid Ceres taken by the NASA *Dawn* asteroid orbiter mission team. This feature—a "bright spot" called Cerealia Facula (*facula* is Latin for "little

torch")—is about the size of Washington, DC, and occurs in the center of an impact crater that is just a bit larger than the state of Rhode Island. Cerealia is much brighter than anywhere else on Ceres— mission scientists spotted it like a beacon from very far away and it was a mystery until they could get the spacecraft much closer. The surprise was that it's not a mountain of ice, but instead a mountain of salty sodium carbonate and ammonium chloride. The little planet Ceres is full of surprises.

The Cerealia Facula bright spot on Ceres, a composite of images from the NASA orbiter *Dawn*, acquired in the summer of 2018.

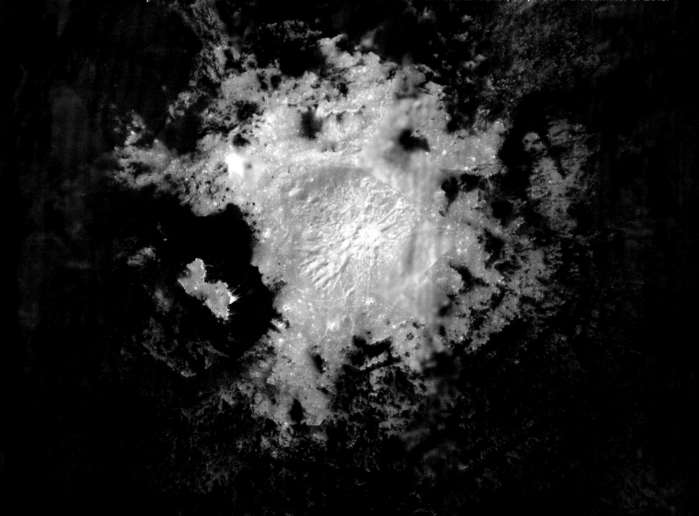

BENNU

Landing on a new world is an exciting event. We generally send robots on one-way trips to their permanent new off-world homes. People have only spent up to a few days at a time living and working on another world—just on the Moon, so far. Some of our extraterrestrial robotic landings have only been momentary events, however: The robots make contact, maybe grab a sample or make a measurement, and then leave quickly. Mission scientists, like aircraft pilots, call them "touch-and-go" landings. Several missions have now done these maneuvers to capture samples from small asteroids, including NASA's probe called *OSIRIS-REx* (for "Origins Spectral Interpretation Resource Identification Security Regolith Explorer"). The mission was sent to a tiny near-Earth asteroid named Bennu—a lump of rocks only around five football fields wide—to pick up samples of primitive planetary "building block" material and bring them back to Earth. This photo captures the fleeting and historic moment that the probe's sampling arm touched the surface of Bennu and vacuumed up some rocks and soil. Then it bounced back into orbit around that little world. Those samples will be parachuted back to Earth in the fall of 2023, and I can't wait until we can all see those planetary building blocks with our own eyes.

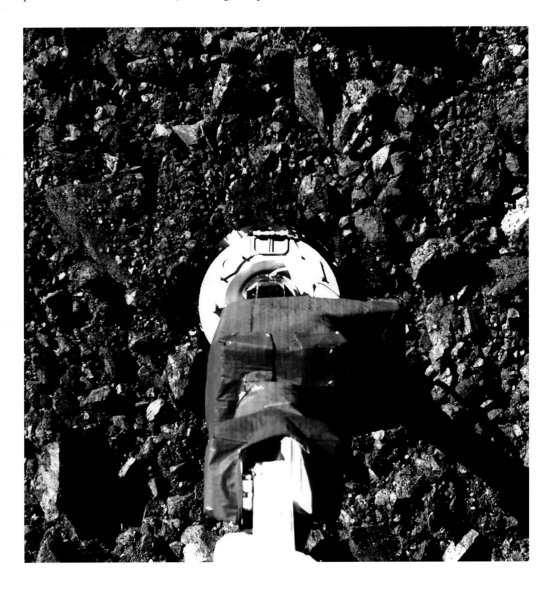

NASA probe *OSIRIS-REx* mission photo of Bennu asteroid from October 20, 2020.

ZAGAMI SECTION

Rocks fall from the sky all the time, like the 40-pound (18 kg) one named Zagami that landed about 10 feet (3 m) from a farmer in northern Nigeria in 1962. Some of them make their way into laboratories, where meteorite researchers like Lottie Herkenhoff photograph and study them. Lottie uses a 35-mm film camera, a petrographic microscope, and a special kind of filter called a quarter-wave plate that dramatically enhances the colors of mineral and glass grains that polarize light. "While taking mineralogy in college, I was awestruck by the psychedelic hues and abstract art in thin sections of rock," Lottie told me. She started photographing super-thin sections of different meteorites, only as thick as a human hair, so that light could pass through them. The result for Zagami is garish and spectacular, and also scientifically meaningful. For example, the smoother pink areas in this 2-mm-wide piece of the meteorite are telltale signs of maskelynite, a glassy and violently shocked form of the common mineral feldspar. Zagami is not only photogenic; it is extremely special and rare. Tens of millions of years ago, an asteroid struck Mars, accelerating shocked chunks of the surface into space. One of those pieces of the Red Planet would land in that farmer's field. Lottie now shares her favorite meteorite photos in art exhibits: "I am soothed and inspired by the idea of 'science as art.' Every time I look at one of my prints I see something new."

Color-enhanced thin section of the meteorite Zagami, photographed by artist and meteorite researcher Lottie Herkenhoff in 2004.

MURCHISON X-RAY

Another beautifully artistic extraterrestrial photo is this intense false-color view of a meteorite called Murchison. People saw a fireball streak across the morning sky above Murchison, Australia, in 1969, and more than 220 pounds (91 kg) of meteorite remains were quickly collected from the area. Labs around the world then discovered it to be one of the most remarkable space rocks ever. These rocks are ancient, solidified pieces of the original cloud of gas and dust that formed our solar system 4.5 billion years ago. And they are loaded with amino acids, dozens of different kinds, including many found on Earth and known to be critical to life on our planet. While nothing is or was *alive* in this space rock, the fact that it proves that the building blocks of life fall to Earth from the sky, like cosmic seeds, was revolutionary. Indeed, this vibrant microscope photo of a thin piece of Murchison reminds me of seeds in a garish loaf of grainy bread. It's not a visible or even infrared photo, though—this one is from X-rays, made from an electron beam zapping the surface. The resulting colors map magnesium (reds), calcium (greens), and aluminum (blues). The art here is both visually stunning and profoundly meaningful in the search for our origins.

Murchison meteorite X-ray microscope photo by Alexander Krot, an expert on the petrology of meteorites at the Hawai'i Institute of Geophysics and Planetology.

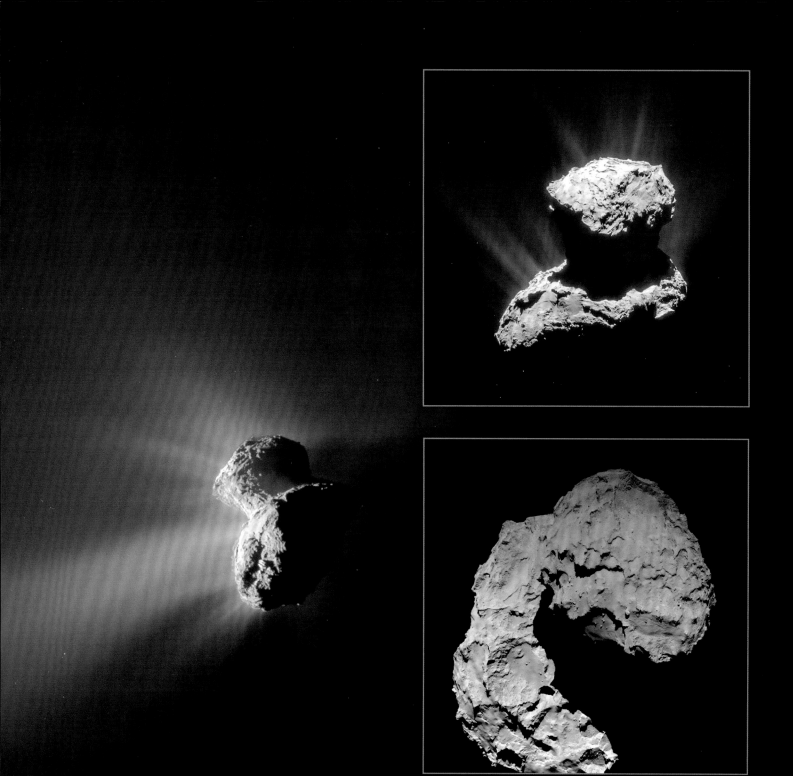

SHADOW AND LIGHT

When Soviet astronomers Klim Ivanovich Churyumov and Svetlana Ivanovna Gerasimenko discovered a new and faint fuzzy blob in the sky on their photographic plates in 1969, little could they have imagined that 45 years later a European Space Agency (ESA) probe would begin a daring and dramatic mission to study, orbit, and land on what would eventually just be dubbed Comet Churyumov-Gerasimenko or "Comet CG" for short. ESA named the mission probe *Rosetta*, in recognition that comets are among the keys to understanding the history of our solar system. From a great distance, telescopes and even spacecraft can't see the small icy nucleus of a comet because it is hidden by the hazy gas and dust being released from its surface by the Sun's warmth. But up close, deep within that shroud, spectacular details emerge, as in this *Rosetta* Navcam photo taken from only around 10 miles (16 km) away (opposite, top right). The nucleus has two lobes, one around 2 miles (3.2 km) wide and the other around 1½ miles (2.4 km) wide, connected by a narrow neck. Jets of gas and dust stream out of cracks and holes exposed to the sunlight. It is a glorious, weird, dynamic, and ever-changing landscape. And mortal: Comets lose a little bit of themselves every time they swing by the Sun, eventually breaking up and turning to gas and dust.

Artists like M. C. Escher have famously experimented with the dramatically changing perception of shapes and forms, depending on the perspectives from which they are viewed or illuminated. The same strong sense of perceived reality can also vary significantly in nature, like the way the full Moon seems like a flat plate in the sky, or how Saturn's rings essentially disappear when viewed edge-on. Viewing-angle effects are even weirder for unfamiliar and irregularly shaped objects like small asteroids or comets. This view of *Rosetta*'s mission target (opposite, bottom right), Comet CG, for example, belies the comet's true nature as a two-lobed body, connected by a thin neck. But I mostly like this particular view of CG because of its metaphorical appeal. Instead of a neck, this rendering of the comet shows a spine. Instead of two heads, there is one. The overall impression is fetal, nascent, embryonic. And there's the metaphor: Comets are harbingers of life, seeds of habitability, bringers of ocean water and atmospheric gases to growing worlds early in a solar system's history. Comets host the ingredients needed for life, but that life is not yet fully realized, not yet fully formed, not yet born.

Fog, footlights, and silhouetting are commonly used by theatrical directors and photographers as compositional elements designed to isolate a subject and maybe add a shroud of mystery. It's rare to be able to consider the artistic potential of such conceits in space photography, but this spectacular photo is a great example of how it is still possible. This ESA Rosetta mission photo (opposite, left) shows the nucleus of Comet CG embedded within the fog of its own gas and dust, what astronomers call its *coma* (Latin for "hair"). Sunlight is streaming in from the right. The photo is a combination of short- and long-exposure shots, merged using high dynamic range (HDR) techniques by planetary scientist and self-described "planetary treasure hunter" Justin Cowart. "I've always been really fascinated by comets, particularly their dynamism," Justin told me. "Getting to see that dynamic environment up close with the Rosetta mission was like a dream." His careful work pulled amazing detail out of the scene, including the delicate streamers that come out of the nucleus and the comet's shadow being cast onto the coma. "It reminded me a lot of some of the glitzy photos of 1920s and 1930s movie premieres, and I was aiming to produce something in the same ballpark."

CLIFF JUMPING

The juxtaposition of familiar forms in unfamiliar contexts is often used by surrealists or satirists to convey complex layers of meaning, judgment, or irony. Juxtaposition can also be a compositional component of space-themed art, especially when comparing other worlds to our own. A nice example comes from this spectacular view of a rugged cliff on Comet CG, processed by Stuart Atkinson, a writer, image processor, and outreach educator from England. The scene reminded Stu of a trip to Yosemite years earlier. "When I had my first view down the valley," he told me, "I almost burst into tears—it was so, so beautiful, like something from one of Tolkien's novels. And then when I stood looking up at El Capitan it was very moving." This particular 3,300-foot (1 km) tall cliff is starkly different from anything in Yosemite, though. Indeed, as this little world spins, sometimes it doesn't look like a cliff at all, instead appearing as a flat plain or a steep crevasse. Still, it *feels* like a cliff to Stu, and to me, too. A fun aspect of the juxtapositional irony here is that while jumping off this cliff would be deadly on Earth, it would actually be safe on CG, as the gravity on this tiny world is 10,000 times less than ours.

Rosetta probe photo of Comet CG from December 10, 2014, reprocessed by Stuart Atkinson.

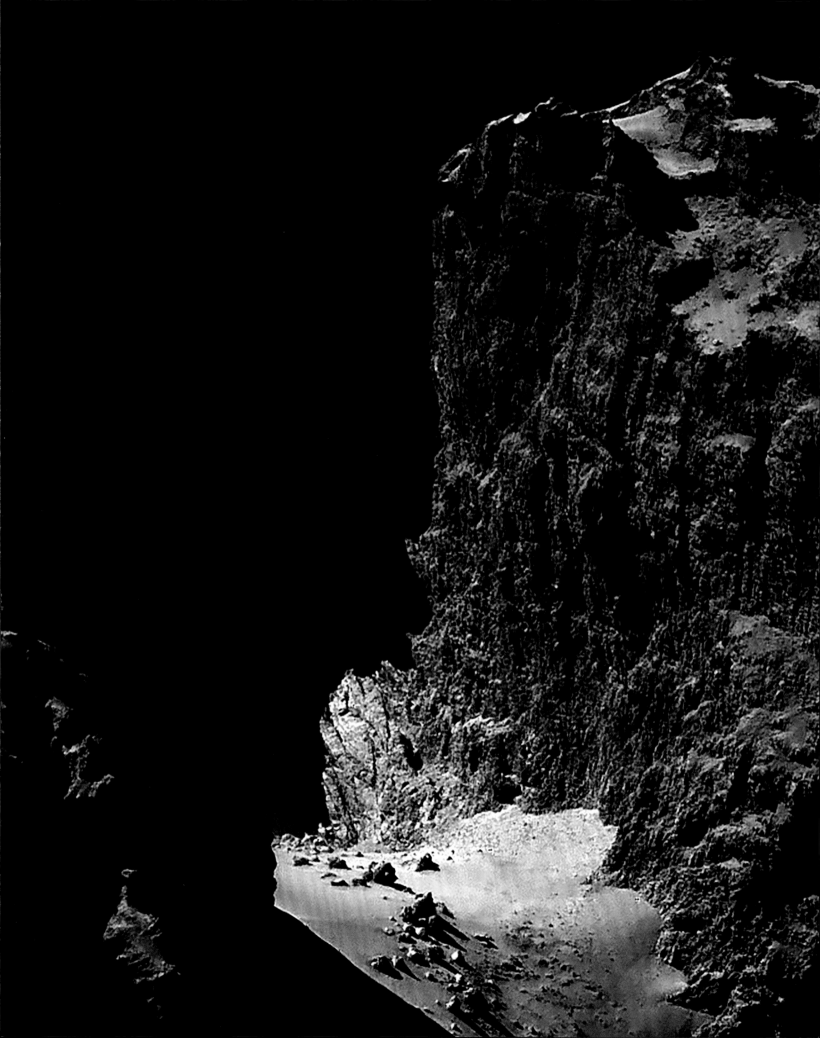

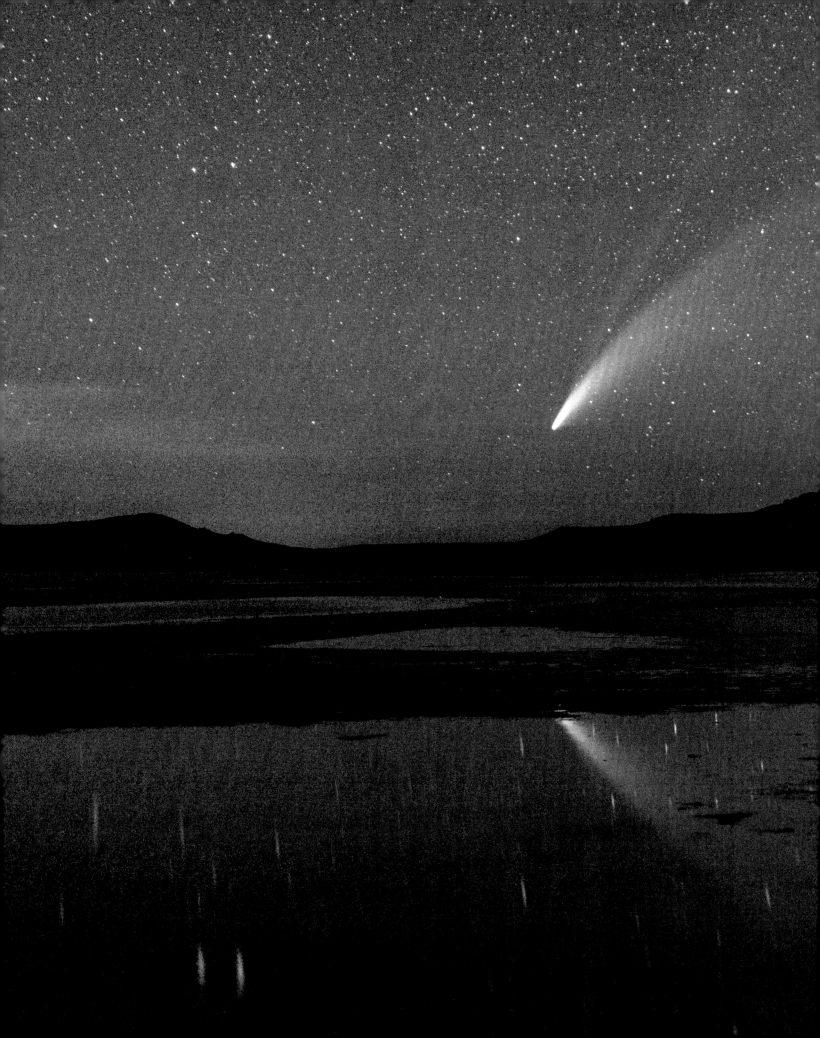

NEOWISE OVER GREAT SALT LAKE

How can something so small make such a big impact on a photograph? I wonder that to myself when looking at this gorgeous and beautifully framed photo of Comet NEOWISE. The image of NEOWISE was photographed by Jason Shepherd, an associate professor of neurobiology and biochemistry at the University of Utah, as it glittered across the sky over the Great Salt Lake. NEOWISE was discovered in the spring of 2020 and was named after the Near-Earth Object (NEO) observing program on the Wide-field Infrared Survey Explorer (WISE) space telescope that first detected it. The solid body of the comet—the nucleus—is a sort of dirty snowball only a few miles across. As sunlight warms the nucleus, it evaporates the ice, spewing the vapor out into a trailing tail of gas that glows blue when it is ionized by sunlight. The spew also releases rocky dust grains from the nucleus, forming a second, golden-colored tail that shines by reflected sunlight. Comet tails like this are millions of miles long and make for spectacular displays; the nucleus itself is completely hidden within the fog and haze of all that gas and dust. NEOWISE is a long-period comet. After swooping close to the Sun in the summer of 2020, it started its long loop back into the deep outer solar system, where it will spend most of the next 6,700 years or so until swinging back by the Sun again for its next show.

Photograph of NEOWISE streaking across the sky and reflected in the waters of the Great Salt Lake, taken on July 23, 2020, by University of Utah professor Jason Shepherd.

3

OUTER SOLAR SYSTEM WORLDS OF GAS AND ICE

Jupiter, Saturn, Uranus, Neptune, and Pluto

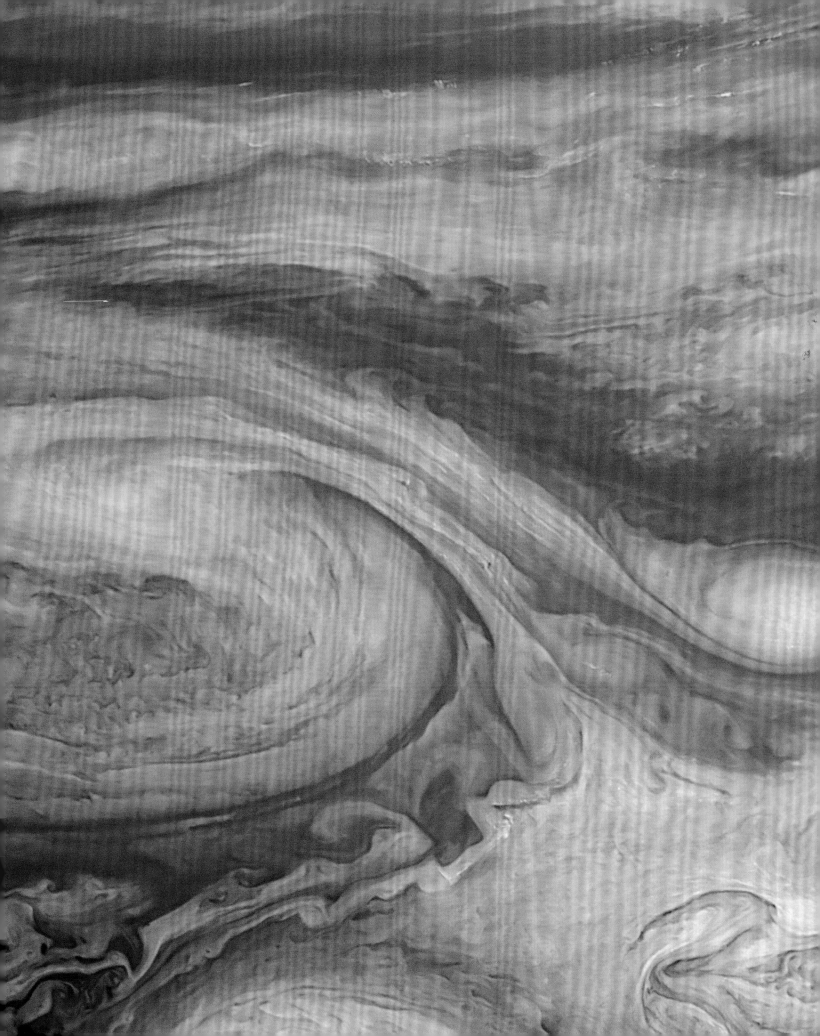

JUPITER'S EYE

It is the most iconic cyclone in the solar system, and perhaps the most photogenic. Jupiter's Great Red Spot has been around for at least 350 years, when the first astronomical telescopes started getting good enough for astronomers to see it. The storm is what atmospheric scientists call a "persistent high-pressure vortex," spinning counterclockwise with mega hurricane-force wind speeds of more than 250 mph (400 km/h). The NASA *Voyager 1* flyby of Jupiter in 1979 gave us our first up-close view, revealing a spectacular cloudscape of swirling vortices and breaking waves, all in vibrant colors. Icelandic space-image processing and computer graphics expert Björn Jónsson made the mosaic on pages 106–7 from a dozen separate photos taken as *Voyager 1* approached the giant planet. He had to use special image-mapping techniques to compensate for Jupiter's rotation as the 12 photos were being shot. While it is still enormous, the Great Red Spot has shrunken over the past century, starting about three times the diameter of the Earth, to around half that size nowadays. Will this monster of a storm eventually fizzle out? No one knows, but we're all enjoying the views in the meantime.

PREVIOUS PAGES: NASA *Voyager 1* mosaic of Jupiter's Great Red Spot from March 4, 1979, created by Björn Jónsson.

The outer solar system is dominated by the four largest planets, but mighty Jupiter is king of them all. Its colorful belts and zones, iconic Great Red Spot, and large moons provide a palette for some of the most lovely and dynamic examples of space photography. A glorious example is this wide-angle *Voyager 1* mosaic of Jupiter and its innermost large moon Io, created by British space-image processing expert and "vicarious explorer of the planets" Ian Regan. Ian told me that his self-given moniker "sums up my philosophy rather neatly, as plowing through the image archives, I sometimes feel like a space-age Indiana Jones, searching for whatever hidden gems are lurking in some long-forgotten NASA server or folder, and then spending hours removing the grime and accumulated dust to reveal

the wonders lurking underneath." Images from *Voyager's* 200-mm *f*/3 wide-angle camera taken close to the planet yielded wonderful studies in both perspective and depth of field. Ian "wondered if it would be possible to reconstruct this specific perspective of Jupiter: a global portrait taken as near to closest approach as possible." He needn't have worried: The view is spectacular. And Io's shadow projected onto the planet's cloud tops also imbues this scene with a particularly strong three-dimensional feel.

NASA *Voyager 1* photo of Jupiter and Io from March 4, 1979, processed by Ian Regan.

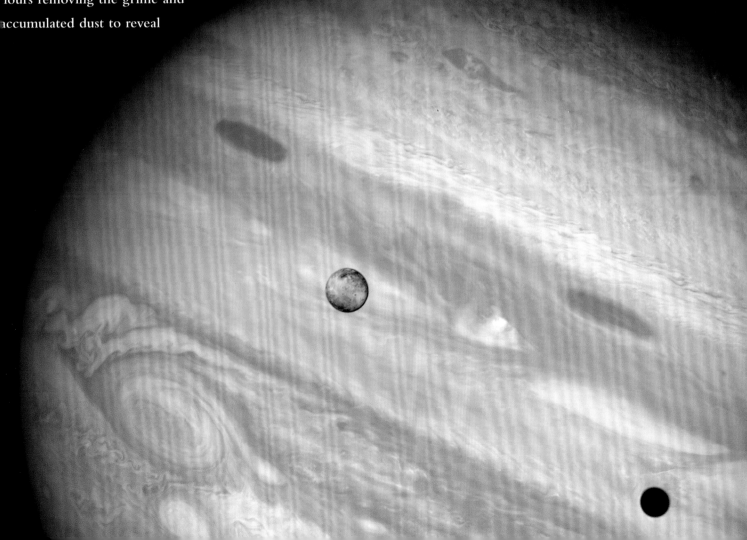

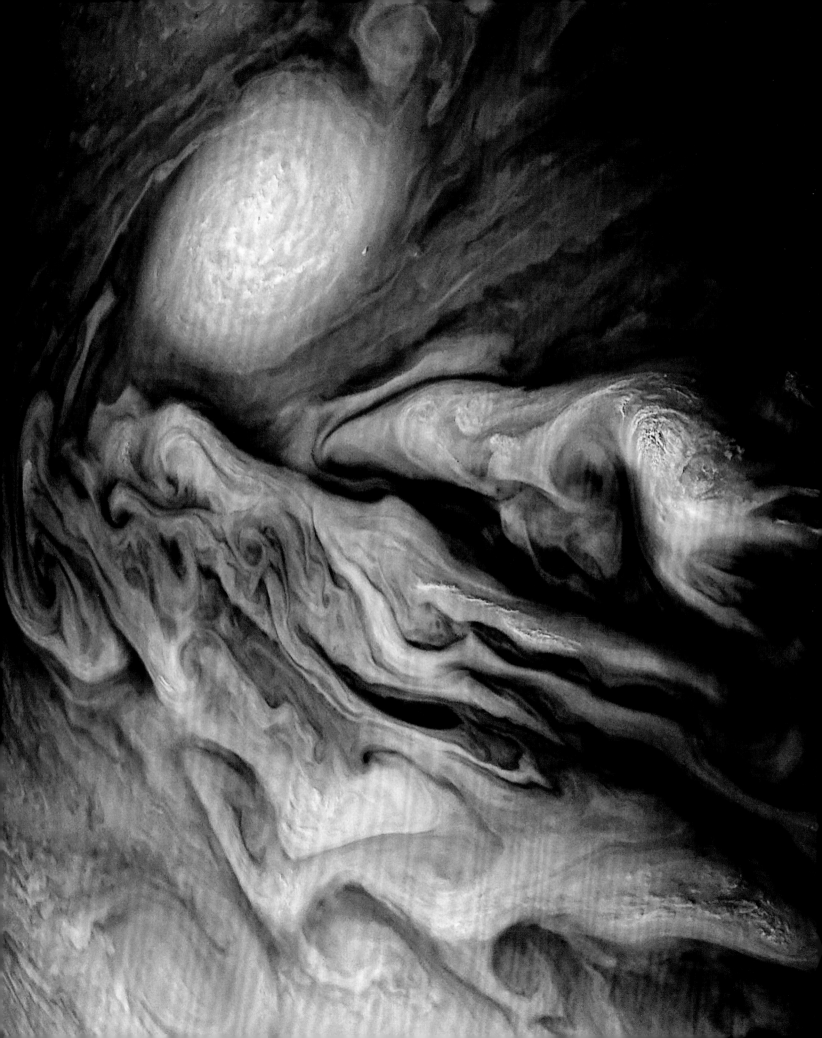

CLOUDS OF JUPITER

It might be easy to believe that this scene was painted by the likes of Vincent Van Gogh or Edvard Munch, with its ghostly patterns of streaming color and swirling vortices. But it's actually a stunning close-up photo of the clouds of Jupiter, a digital satellite weather image taken by the NASA *Juno* space probe in orbit around the solar system's largest planet. The vibrant colors are a visual delight, but also a lesson in chemistry: Brownish and reddish hues are caused by sunlight reflecting off clouds and hazes made from ammonium hydrosulfide; light bluish and white clouds indicate the presence of clouds of pure ammonia high above the brownish haze. Circular and oval forms are enormous storms—Jovian hurricanes and cyclones—the largest here comparable in size to the Earth. *Juno* is a spinning spacecraft in a highly elliptical orbit. During close approach every 53 days, its 11-mm wide-angle camera sweeps its view from limb to limb as the spacecraft spins, yielding a distorted but artistic perspective. The view is powerful, abstract, and surreal, but one is also keenly aware that it is only ephemeral art. The photo captures an irreproducible snapshot in time, a fleeting glimpse into a constantly churning cosmic cauldron of light and color.

NASA *Juno* mission photo of Jupiter, taken on October 29, 2018, from a distance of only about 8,000 miles (12,900 km) above the clouds.

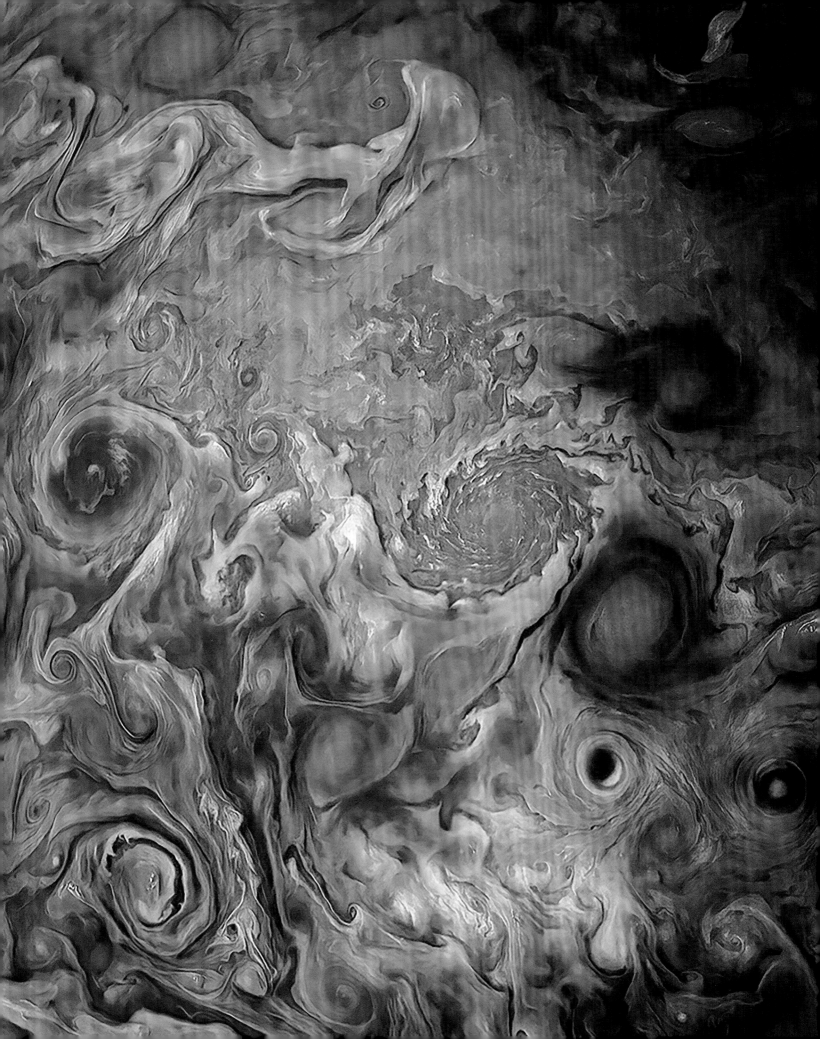

DYNAMIC CURRENTS

Some of the most compelling art, whether photographic or painted or in other forms, taps into the ability to create a sense of dynamic motion from physically static pieces. Iconic examples can be found in paintings by Marcel Duchamp and Jackson Pollock or the stop-action photography of Eadweard Muybridge (see page 24). Space photography and digital media expert Seán Doran has joined this cohort of dynamists by producing stunning and vividly fluid new views of planetary and astronomical scenes from space satellite images. Here, Seán captures a part of the upper atmosphere of Jupiter as photographed by NASA's *Juno* orbiter camera during the closest approach to the planet on the mission's fifteenth orbit. The original "natural-color" image is rather muted, but the wide dynamic range of the digital data gave room for Seán to experiment with color and textural renderings. Here, for example, he accentuates and evokes blue and white fluid currents in Earth's oceans and atmosphere that bring the clouds and storms alive. "I cut my teeth on *Juno*," he wrote to me. "This is my favorite image from the many I have produced. Creating these images is a trial by error in every case. . . . I make mistakes until something nice appears."

NASA *Juno* mission image of Jupiter, taken on September 7, 2018, from a distance of only about 10,500 miles (17,000 km) above the clouds, processed by Seán Doran.

MOONS OF JUPITER

Jupiter's four large moons are called the "Galilean satellites" because they were discovered by Italian astronomer Galileo Galilei back in 1610. They are each planets in their own right, helping to make the Jupiter system really a sort of mini solar system. Among the most interesting, enigmatic, and photogenic of those moons is the second one out, Europa. Just a little smaller than Earth's Moon, Europa is covered in ice. As shown in this rather abstract, high-resolution photo (opposite, top) of its surface from the NASA *Galileo* Jupiter orbiter mission (also named after the astronomer), that icy surface is heavily fractured and broken up into countless plates that appear to have shifted relative to each other since the cracks originally formed. The similarity to sea ice on Earth is striking and not coincidental: Below that thin icy crust, planetary scientists believe that Europa harbors a global salty ocean that might have two or three times as much water as all of Earth's oceans combined. Beyond the wonderful interplay of lines showcased here, part of the artistic appeal of this photo is the magnitude of what it might imply. Is there really a deep ocean under this otherworldly sea ice? And, if so, what creatures might lurk in those ancient, dark, and salty depths?

I think of Jupiter's largest moon, Ganymede, as a planet all its own that just happens to be orbiting another one. It's the largest moon in the solar system and is larger than the planet Mercury. Ganymede, like Europa and most other large outer solar system worlds, is covered in ice. That ice acts like rock at the super-frigid temperatures of these places so far from the Sun. That helps preserve features like craters, ridges, and valleys on icy bodies like this, just as on truly rocky surfaces on the planets and moons closer to the Sun. This NASA *Galileo* Jupiter orbiter photo of Ganymede (opposite, bottom) is also a great example of landscape photography elevated to art (in my opinion) because of just the right lighting conditions. Specifically, this shot was taken when this part of Ganymede was near the *terminator*—the boundary between day and night. The Sun is low in the sky and shining on the scene from the top down. The low angle of illumination brings out details and enhances the differences in textures between the older, darker plains and the lighter *sulcus* (Latin for "groove" or "furrow") terrain. I especially like the way the fresh and faded, pockmarked circular craters evoke the pattern of raindrops on water— an impossibility on this airless, frozen world.

OPPOSITE TOP: NASA *Galileo* orbiter mission photo from February 20, 1997, of Europa's surface.

OPPOSITE BOTTOM: NASA *Galileo* orbiter photo of the surface of Ganymede from May 7, 1997.

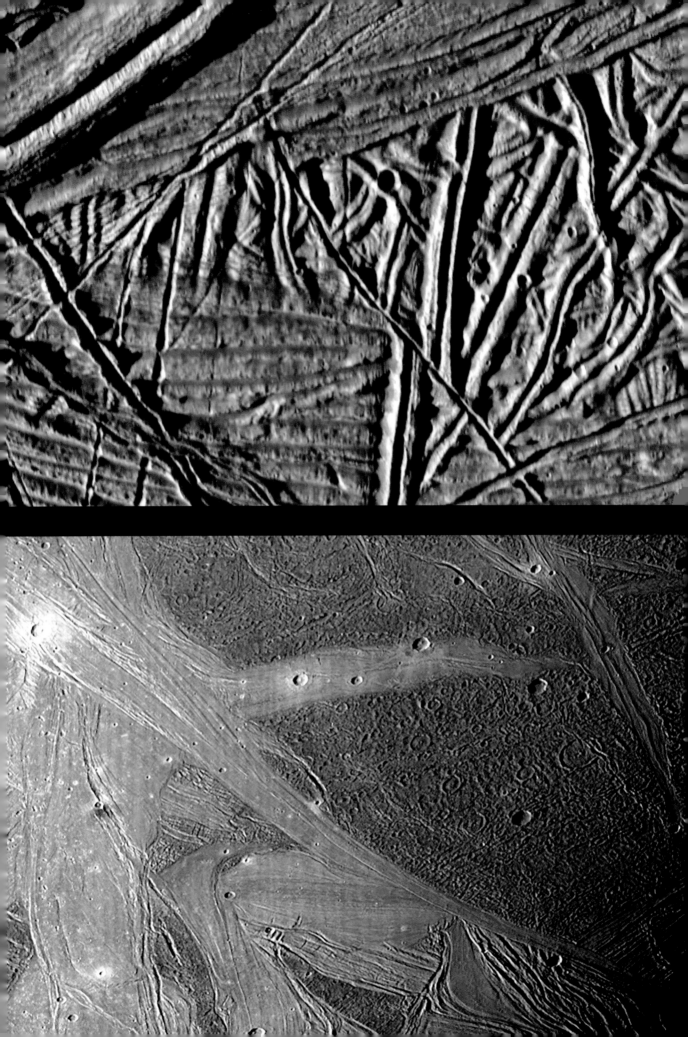

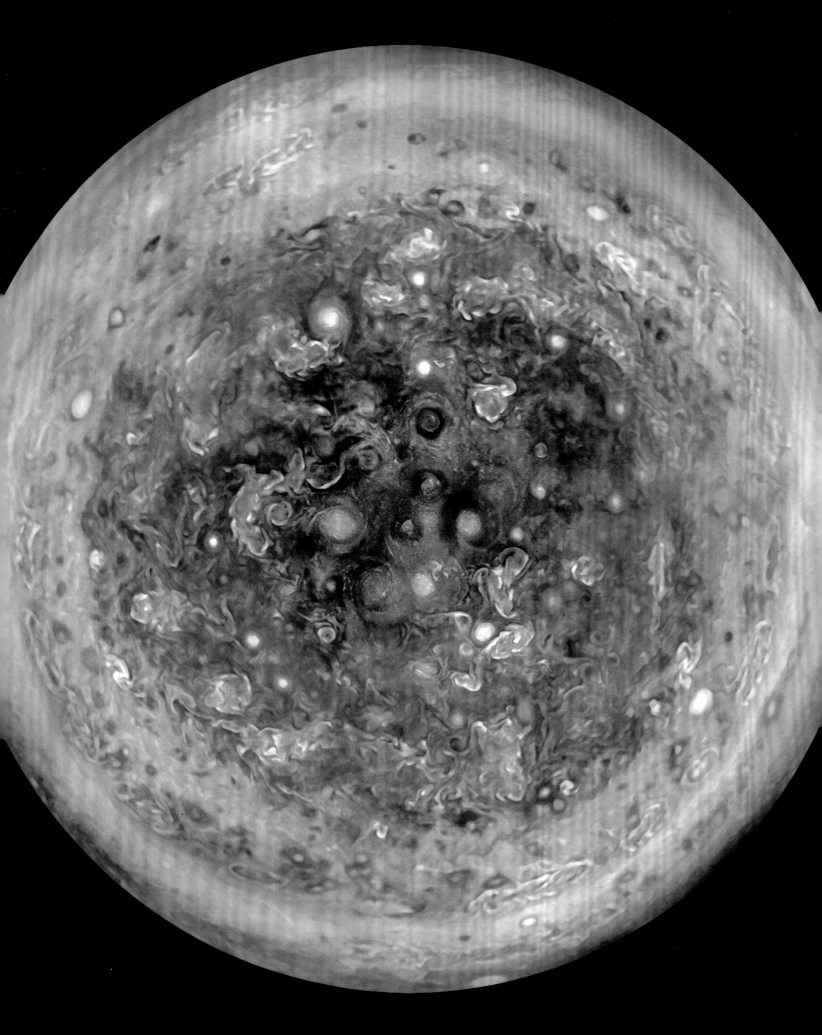

JOVIAN SOUTH POLE

We've grown used to seeing images of Jupiter from telescopes and space missions that show beautifully colored horizontal cloud layers, one above the other from north to south and covering the planet from end to end, east to west. So it was jarring to me to see some of the first photos from NASA's *Juno* Jupiter orbiter mission, because they showed lots of features organized into circles instead of straight lines. *Juno* is a polar orbiter in a big elliptical orbit that takes it from about 5 million miles (8 million km) away to just 2,600 miles (4,200 km) above the planet's south pole, every 53 days. From that unique high-latitude vantage point, rendered in image processing as if staring down on the pole, we can see for the first time the gas giant's glorious clouds and storm systems spinning around the planet's axis of rotation. The photo—and, it turns out, Jupiter's polar weather—is a study in both symmetry and chaos. Individual, small (but up to 1,000 miles [1,600 km] wide!), circular storm systems shed cloud bands farther to the north. The cyclones dance, collide, and some merge over time, with the whole lot of them spinning dervish-like around and around and around. What a wonderful and surprising example of cloudscape art.

NASA *Juno* orbiter montage of images taken above Jupiter's south pole in 2016 and 2017.

SATURN, TITAN, AND DIONE

Framing. Depth of field. Perspective. Motion. This dramatic photo from NASA's *Cassini* Saturn orbiter mission has all of those classical artistic elements going for it. Plus timing. I'm guessing, but I'm almost certain this image was not taken by accident. That robotic spacecraft was launched in 1997, was captured into Saturn's orbit in 2004, and spent more than 13 years photographing "the crown jewel of the solar system" and its panoply of rings and moons. I know that many members of the *Cassini* team prided themselves on being able to predict and plan to photograph stunning events like the one captured here: a conjunction of multiple astronomical objects, as seen through the eyes of the spacecraft. This natural color view shows Saturn's giant moon Titan—larger than the planet Mercury and shrouded in a hazy atmosphere of smog—in the foreground. The small icy moon Dione, which would fit comfortably between New York City and Chicago if we could magically bring it here, is peeking out from behind Titan. And the two are set against the dramatic backdrop of Saturn's rings, seen edge-on, and the shadows of the rings projected onto the massive, yellow-hued atmosphere of the gas giant planet. What a view!

NASA *Cassini* orbiter mission photo of Saturn and its moons, Titan (in the center) and Dione (small, to the right), from May 21, 2011.

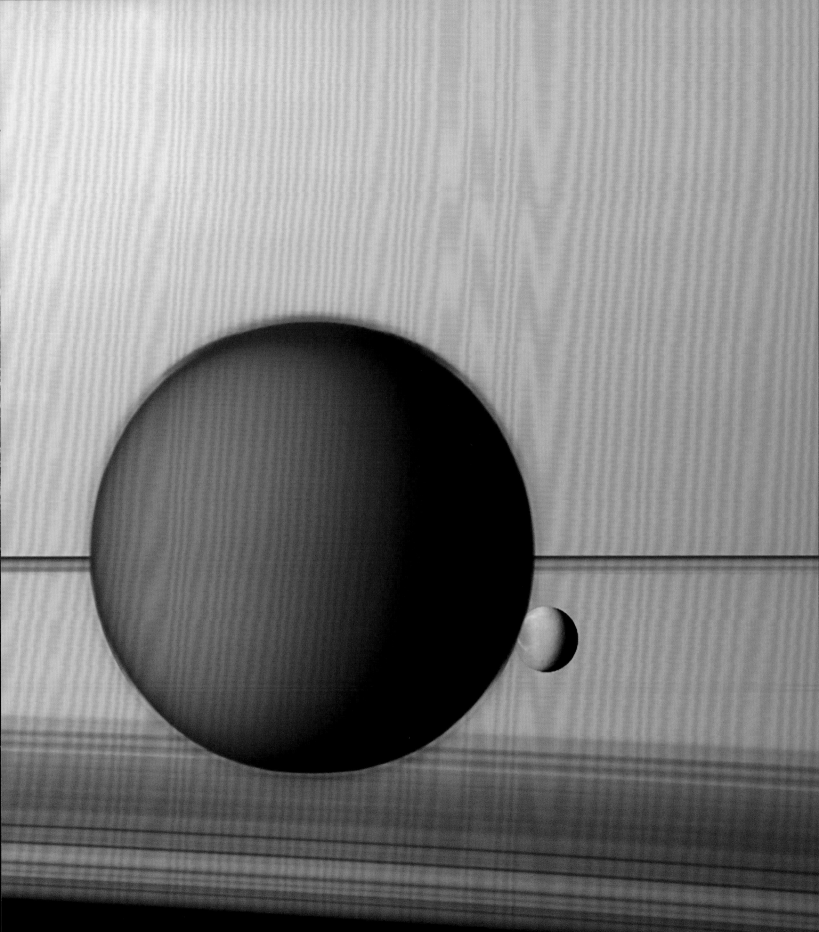

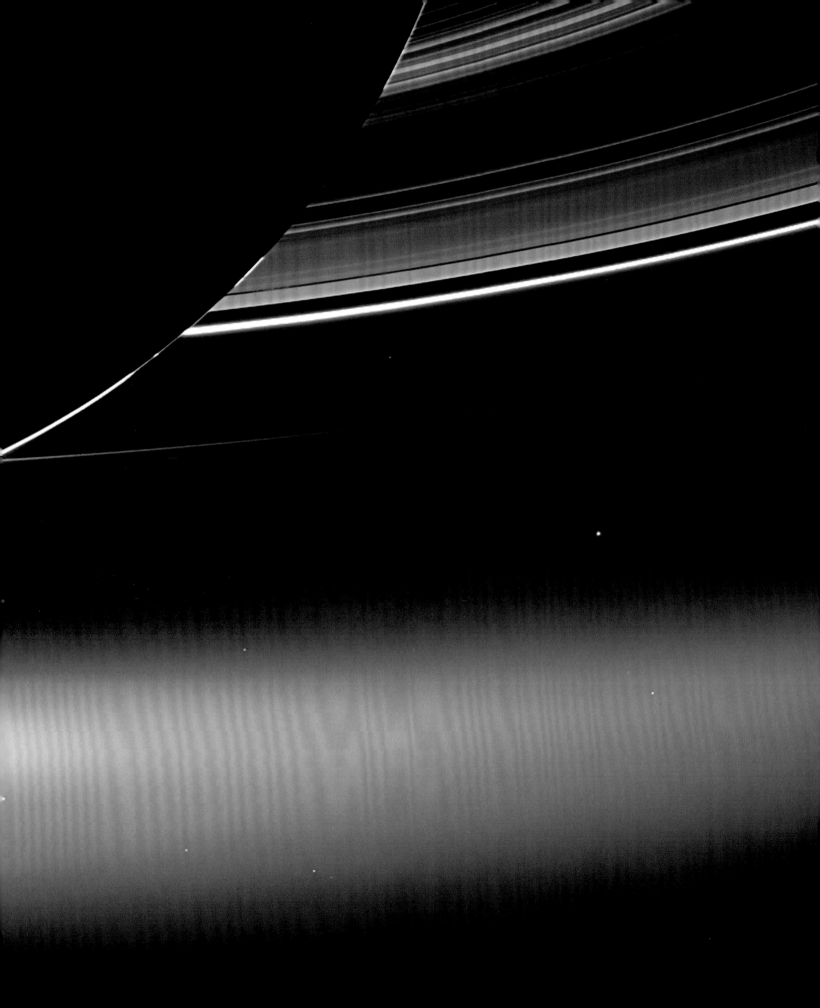

as a tiny, bright bluish dot under Saturn's ring, to the right of the center—from July 19, 2013.

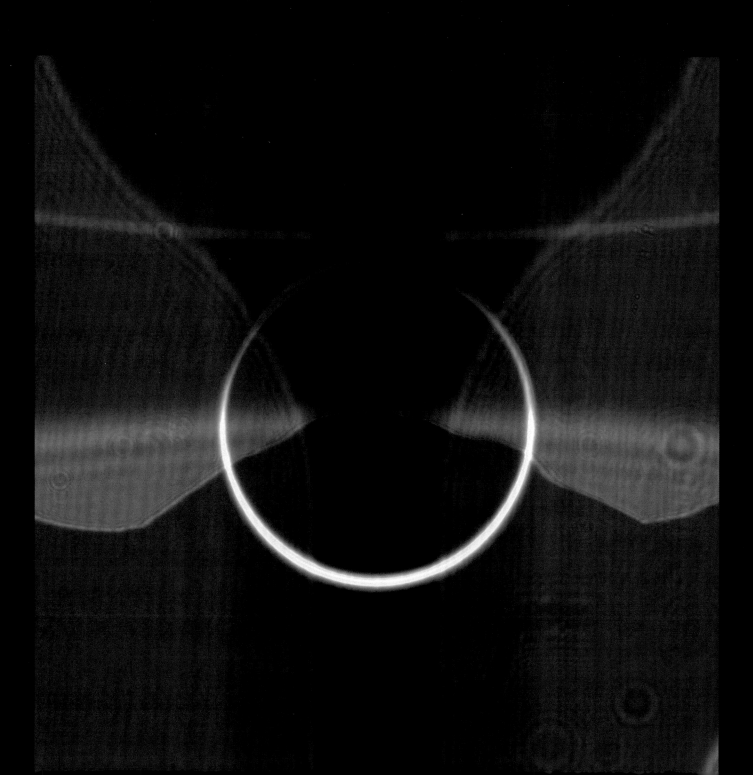

TITAN SHADOW

Not all space photographs are perfect. Some are accidentally underexposed or saturated or show an unintended view, and some are taken to specifically try to highlight and develop solutions for potential camera or viewing problems. Planetary scientist and space-imaging expert Justin Cowart is always looking for what he calls such "back catalog" photos in NASA's collection. This view of Saturn's giant moon Titan that he processed, opposite, is a dramatic and, to me, artistic example. "I noticed the image-processing community was mostly tackling the mission's highlight reel, working with really nice, clean data," Justin told me. "At the time I was really keen to try to make something out of the grunt work photos—low-resolution, support observations, routine monitoring photos, etc.—which weren't obvious choices for processing." This particular view is from a long-term set of images of Titan designed to characterize its thick atmosphere. But it required looking almost right into the Sun to get this beautiful crescent shot. That piped a lot of scattered light into the camera system. While such effects can often ruin a photo, in this case it works. "What I think makes this one particularly compelling," Justin notes, "is how it's framed within the lens glare and internal reflections of the camera."

OPPOSITE: NASA *Cassini* orbiter mission photo of Titan from June 29, 2007, processed by Justin Cowart.

RINGS OF ICE

Some space photographs qualify as art partly because they portray their subject in abstract or nonintuitive ways, perhaps befitting the alien environments and perspectives that they offer. The quizzical photo on pages 124–25 is no exception. Is this a microscope photo of grooves on a vinyl record? An aerial photo of a freshly tilled field with an imagined tractor just off the screen? Not even close. This vivid extraterrestrial scene is actually part of some of the highest-resolution photos ever taken of the rings of Saturn. Near the end of its mission, NASA controllers directed the robotic *Cassini* Saturn orbiter to pass closer and closer to the rings as part of its eventual fiery plunge into the planet's atmosphere. The close-up view here shows stunning evidence that the ring system—which overall is more than four times the diameter of the Earth—is actually made of countless individual narrow rings, some only 25 miles (40 km) wide. How and when Saturn's ring system formed, how such small ring segments formed and are held together, and what gives the mostly icy rings their yellow to tan to ruddy colors remain topics of intense study and debate, fueled by provocative views like this.

FOLLOWING PAGES: NASA *Cassini* orbiter image of Saturn's rings from July 6, 2017.

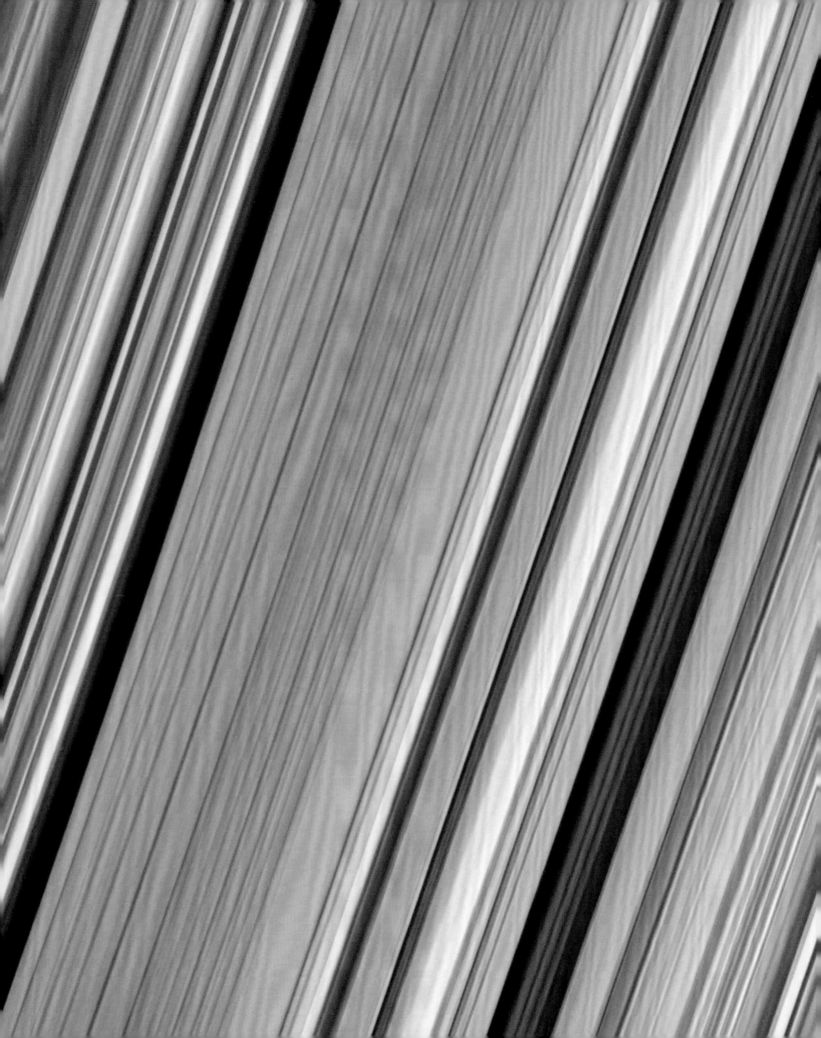

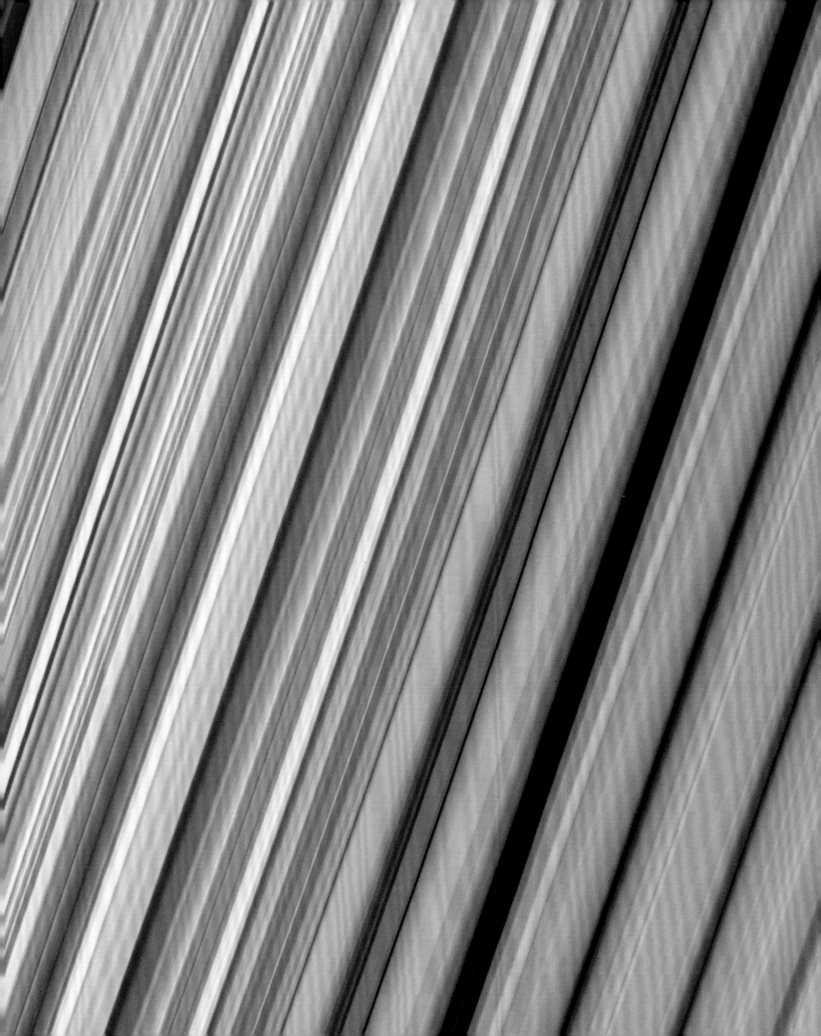

B-RING SHADOWS

Through a telescope, Saturn's rings look like a thin disk. They're actually made of countless chunks of dust-sized to house-sized ice, all independently orbiting the planet. But that enormous collection of tiny icy moons is still extremely thin—only the height of a three-story building. So it's rare—and stunning—to see what looks like evidence of mountains in those thin rings. But that's just what this amazing NASA *Cassini* photo shows. Linda Spilker was the NASA/JPL project scientist for *Cassini* and shared this photo with me. She and her colleagues knew that Saturn would experience a once-every-15-year equinox during the mission, meaning that the Sun would shine almost edge-on to the rings. "For the first time, we could search for three-dimensional regions in the rings, and we found them," she told me. How? With the Sun nearly edge-on, bigger chunks of the rings can suddenly be recognized because they cast super-long shadows. Linda explained that it would be like seeing the miles-long shadows of the Egyptian pyramids from space at sunset, even if the pyramids themselves were too small to see. She is still excited about having had such a rare photo op: "I've been studying Saturn's rings since the early 1980s, and the long shadows in this particular image fascinated me!"

NASA *Cassini* orbiter image of the Sun creating shadows on three-dimensional regions of Saturn's rings, taken on July 26, 2009.

HYPERION

I can think of a large number of adjectives to describe the surfaces of solar system bodies seen in space probe photos over the decades: rocky, icy, smooth, rugged, cratered, fractured—the list goes on and on. *Spongy* was never on that list, however, before my first glimpse of Saturn's strange and weirdly beautiful moon named Hyperion. Hyperion is a small world that would fit snugly between New York City and Boston. This enhanced color photo, opposite, from the NASA *Cassini* orbiter mission team, was timed for a close flyby of this moon by the spacecraft, allowing a much better resolution view than ever before seen. The opportunity did not disappoint! Hyperion has an unusually low density for a moon of this size—half that of water ice—and thus must have a super-high internal porosity. That might explain its strange texture: When asteroids or comets crash into Hyperion, the energy goes into compressing the porous surface and subsurface, not into excavating and ejecting material. The effect is similar to running on the beach, compressing the sand and getting less "bounce" with each step. Why this little moon is so porous, though, remains a mysterious part of this lovely and evocative photo.

OPPOSITE: NASA *Cassini* orbiter image of Saturn's moon Hyperion from September 26, 2005.

TITAN LAKES

The lovely landscape photo on pages 130–31 could easily be a satellite view of part of the lake districts in Minnesota or England or elsewhere. One imagines summer cottages, swimming holes, and bucolic picnic spots along these tranquil shores. The reality, however, is phenomenally different. This is indeed a lake district, but it's on Saturn's large moon, Titan, not on Earth. And there's liquid in those lakes, but at Titan's frigid temperatures it's liquid hydrocarbons, not water. Space-image processing expert Ian Regan worked up this scene from several years of NASA Cassini mission radar images of Titan, for use in the 2014 short documentary film *In Saturn's Rings*. Ian told me that this mosaic "was borne out of a challenge set by the producer to carefully clean and restore selected radar swathes of Titan, removing seams, reducing noise, and boosting contrast." The result is both familiar and alien. It's wild to imagine lakes, rivers, and waterfalls made of ethane, methane, and propane. "I feel proud that this is probably one of the best views of Titan's lake district that humanity will have for the next decade or two," Ian says. "Ultimately, new and better-equipped robotic scouts will take better images at higher resolutions, but such is the nature of space exploration."

FOLLOWING PAGES: NASA *Cassini* radar-image mosaic of Titan's "lake district," with data from 2006 to 2014, processed by Ian Regan.

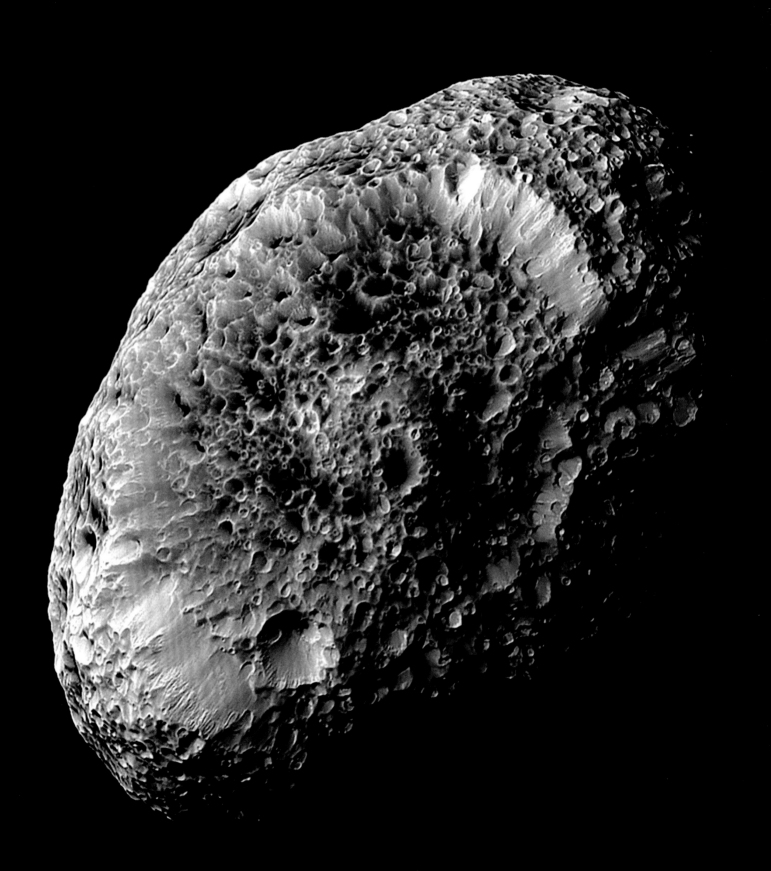

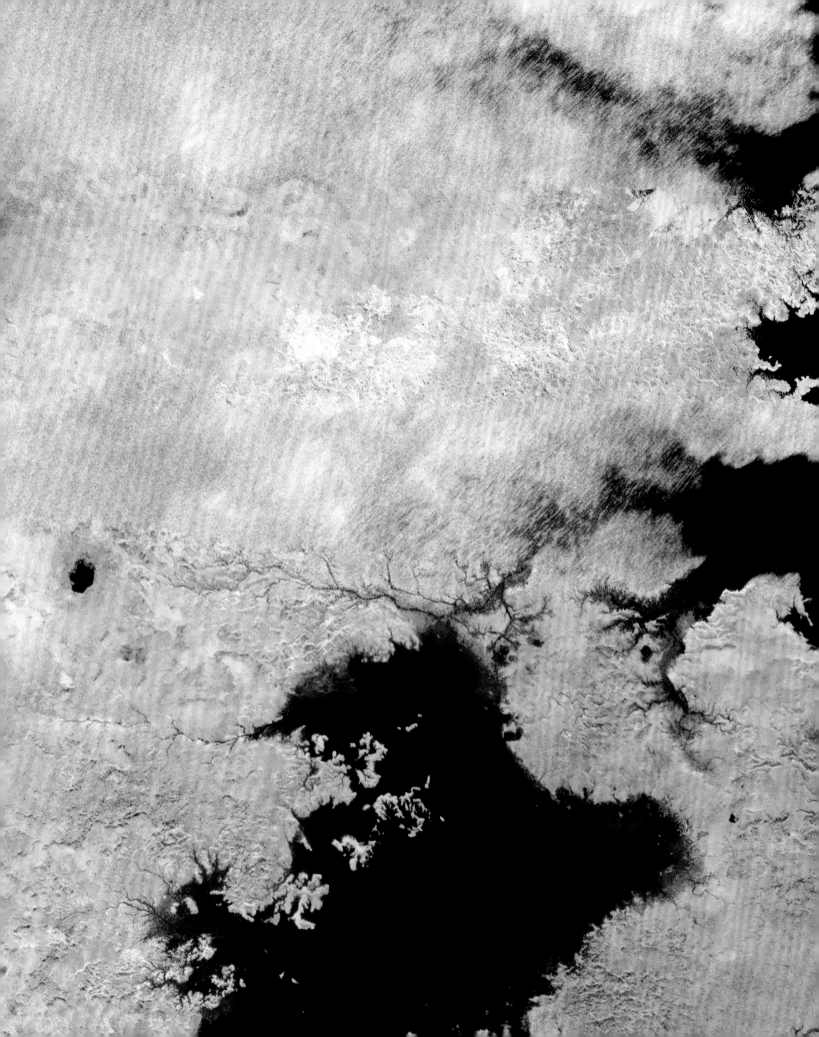

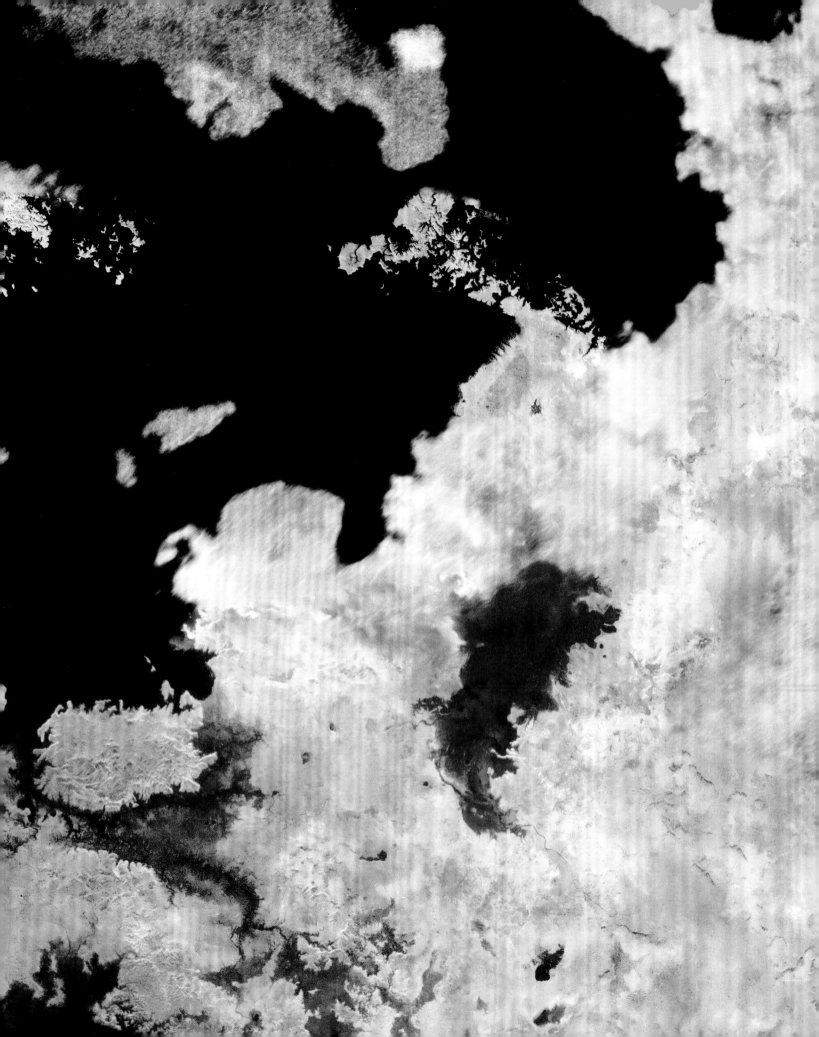

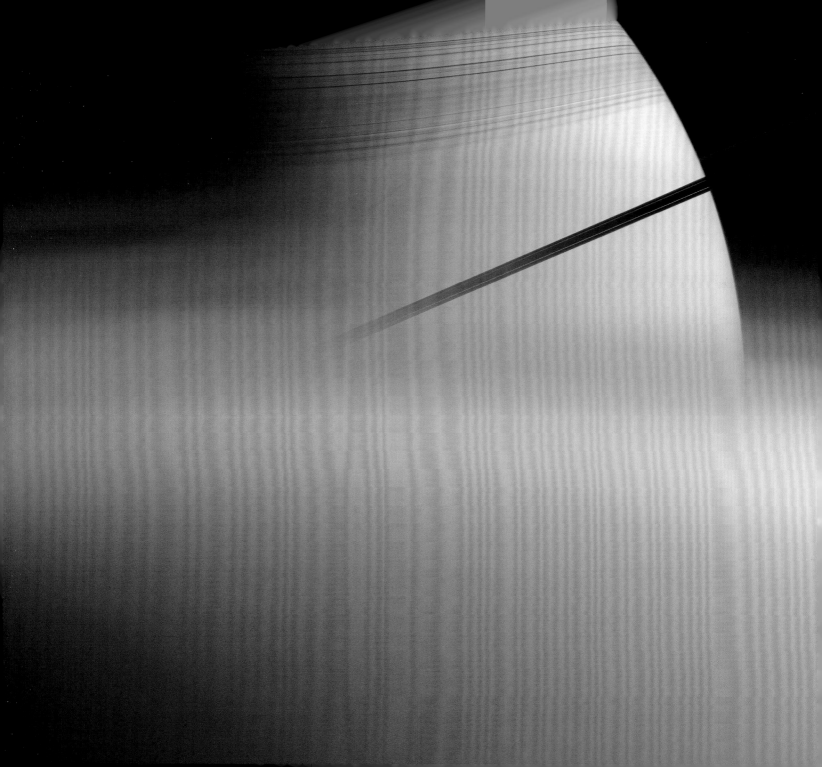

SATURN-TITAN COMPOSITE

Saturn's moon Titan has a thick, smoggy atmosphere—so thick, in fact, that from the surface you wouldn't be able to see Saturn looming in the sky. But if you imagine launching off that surface and traveling to higher and higher altitudes, at some point the skies would start to clear and the magnificent ringed planet would come into view above you. *That* is the moment captured in this superb NASA *Cassini* orbiter photo that was specially processed by Ian Regan. The scene is a little "made up," however, since the original photo was in black and white. "The problem of colorizing this image was a real skull-buster," Ian told me. "I came up with one solution (some might call it a cheat!) that involved re-creating this vantage point using other *Cassini* data." I don't personally regard Ian's color work as cheating, however, because the intention is realism and the results are traceable and quantitative. With the advent of modern digital-image processing, colorizing monochrome photos using the known colors of specific objects in the scene has become widely used in historical photography and filmmaking. For me and this spectacular piece of space art, color not only adds vibrancy but also reinforces the imaginary "you are there" feel.

NASA *Cassini* orbiter image of Saturn from above Titan, taken on March 31, 2005, and processed by Ian Regan.

PAN MONTAGE

At first glance, the photo montage on the opposite page, left, might make you wonder why pictures of walnut-shaped flying saucers are making it into an art book about space photography. But this is no UFO. Rather, the montage shows three views of Saturn's small moon, named Pan, photographed up close by the NASA Cassini mission-imaging team. The photos were processed by space-imaging expert Ian Regan, who recalled being excited back in 1990 when astronomers reanalyzed *Voyager 2* photos and discovered that small moon to be responsible for clearing out the famous "Encke Gap" in Saturn's rings. "However, the discovery image showed Pan as just a single pixel," Ian told me. "Not so much of a new world as a lone data point." So he and others were charged up when the *Cassini* orbiter was able to pass close by and photograph Pan 27 years later. "This marked the day that the discovered 'pixel' of my youth became a new world in my imagination." And a strange new world indeed: Only about 20 miles (32 km) across, with a ravioli-like form, crisscrossed with fractures, and sporting a 2-mile (3 km) high equatorial ridge, formed by infalling ice from the nearby rings. Ian reminded me of the apt quote credited to J. B. S. Haldane: "The Universe is not only stranger than we imagine, but stranger than we *can* imagine."

OPPOSITE LEFT: A montage of Saturn's moon Pan composed of images from the NASA *Cassini* orbiter taken on March 7, 2017, and processed by Ian Regan.

MIMAS

Everything in space is in motion—usually in orbit around something else. But every once in a while I encounter a space photo—like this one (opposite page, right)—that just makes me think about stillness and tranquility. The peacefully floating orb in this remarkable photo is Saturn's moon Mimas, a 250-mile (402 km) wide, heavily cratered iceball. Graphic designer and space-image processing expert Jason Major created this rendering from NASA Cassini mission images, including long-exposure, ultraviolet filter photos. The little moon was captured passing in front of Saturn's rings, and the long exposure time "helped create that out-of-focus look to the rings in the background," Jason told me. I love the way Mimas is just hanging there, like a celestial holiday ornament, dangling from an invisible thread. The perfect framing and the fuzzy background give this scene a portrait photography kind of vibe, as if a very shallow depth of field lens had been used to keep the attention on the main subject at the expense of all else. "I have always been fascinated by space and planets and all that exists outside of our little blue world," Jason writes on his blog. His fascination and talent have combined to create a beautiful piece of cosmic art.

OPPOSITE RIGHT: NASA *Cassini* photograph of Saturn's moon Mimas from November 7, 2004, processed by Jason Major.

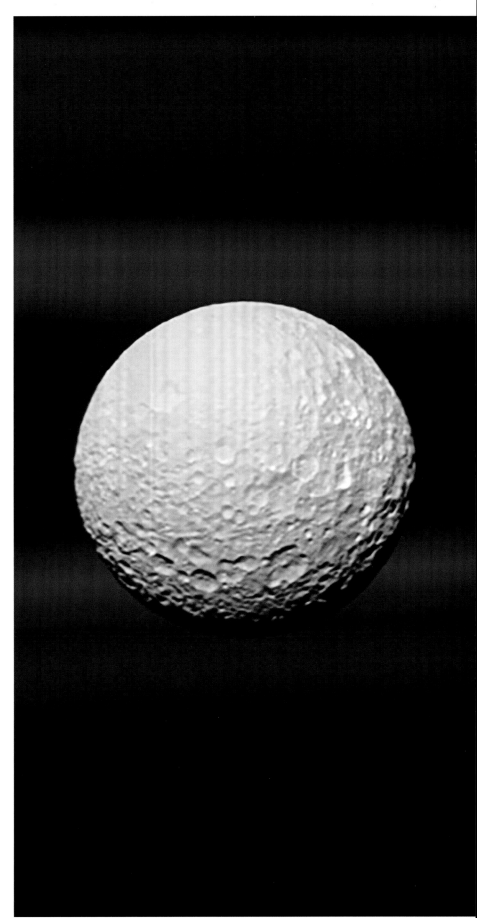

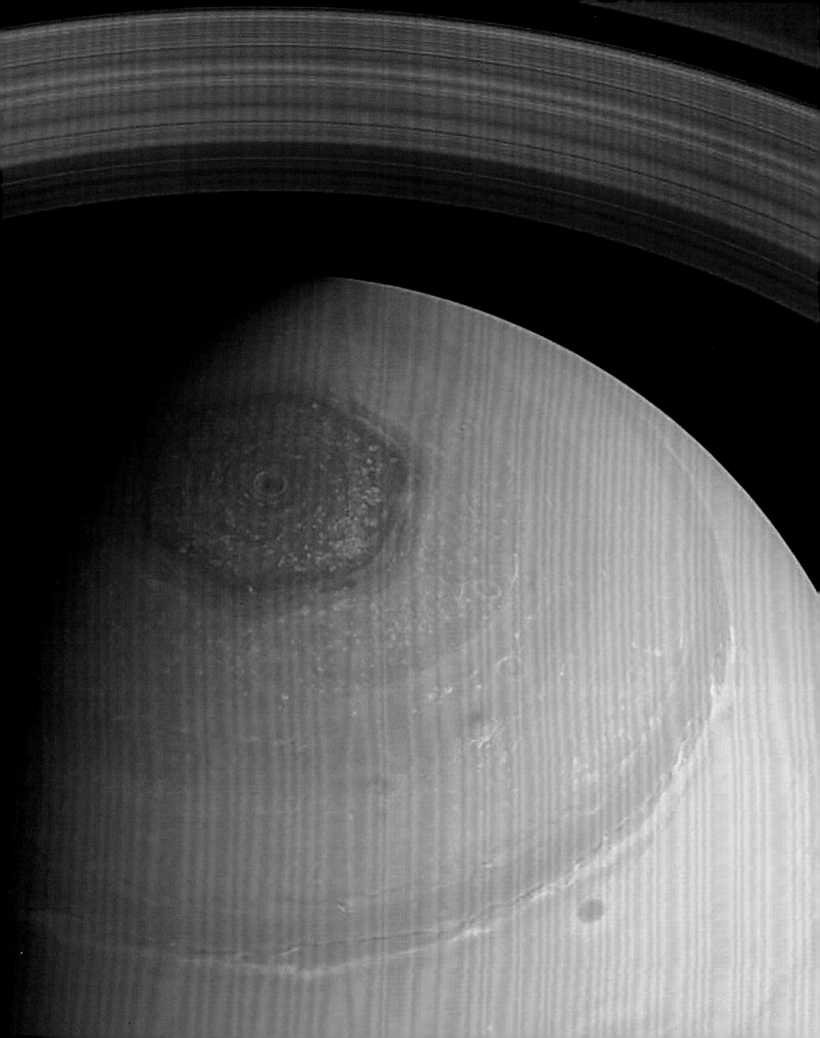

SATURN HEXAGON

Complex geometric patterns occur occasionally in nature and make for wonderful photography: Square-edged boulders formed by fracturing, mathematical spirals within some animal shells, and the infinite variety of symmetrical crystalline forms among snowflakes are but a few examples. We don't typically think of such regular patterns occurring on a planetary scale. But tell that to Saturn's north polar hexagon, a persistent six-sided cloud pattern at around 78°N latitude. The hexagon was originally discovered during the NASA Voyager flybys of the 1980s but was studied and photographed in much better detail—as in the beautiful shot here—by the *Cassini* Saturn orbiter. It's impossible to tell the scale of this natural wonder just from the photo, but the entire Earth would fit nicely inside the hexagon, with a bit of room to spare. While lab experiments and computer models have been able to simulate some aspects of what is seen here, there's no simple explanation for why a high-altitude and high-latitude jet stream of gases moving at more than 200 mph (322 km/h) would form a six-sided cloud pattern, and why this pattern only occurs at the north pole of Saturn and not the south. It's a stunning and photogenic mystery, on a magnificently grand scale.

NASA *Cassini* orbiter image of Saturn's north pole, taken on November 27, 2013.

SATURN'S RINGS: TIME-LAPSE

Sometimes it takes many years for an artistic concept or composition to come to fruition. Maybe the artist is spending that time working to fully form their ideas, or maybe they are struggling to find the time and resources to complete the project. Or, maybe, as in the case of this six-year astronomical montage, the artist is simply just waiting for their subject to be ready. The artist here is astrophotographer Alan Friedman, who operates a small backyard observatory in Buffalo, New York. This lovely seven-photo time-lapse required forethought, patience, and the cooperation of the planet Saturn over the course of six years from 2004 to 2009. Saturn's orbit is tilted by about 2.5° relative to the Earth's orbit around the Sun. Every time the Earth passes Saturn (about every 378 days), the ringed planet has moved ahead to a slightly different part of that tilted orbit, and thus we can see it from a different perspective. The rings are said to "open and close" to us cyclically over time. Especially cool and revealing is how they disappear entirely when we see them edge-on. Such ring-plane crossings are rare, occurring only once every 15 years, which is twice during Saturn's nearly 30-year orbit around the Sun.

Time-lapse montage of Saturn, created between 2004 and 2009 by Alan Friedman.

URANUS AND
EPSILON RING

Digital (non-film) space photography dates back to the use of 1950s-era vidicon cathode-ray tube technology that was first developed for television broadcasts. By today's standards, the images taken by such systems are relatively low fidelity, but they were cutting edge for 1970s deep space missions like the Voyager probes. *Voyager 2* used such a vidicon camera to shoot humanity's only up-close photos (so far) of the seventh planet, Uranus, and its faint system of rings. This example, processed by space-imaging guru Ian Regan, highlights the extremes of performance of early deep space digital cameras. The bright and bluish disk of the planet itself, while bland and cloud-free during the *Voyager 2* flyby, reproduced nicely in the camera. But, Ian told me, "I wanted to experiment with the data and produce a composite showing the faint traces of its slender ring system. Enhancement of the vintage TV camera-derived images does indeed reveal the moderately bright Epsilon ring, but also unveils the inevitable carpet of background noise and moiré-like patterns." Such extreme processing might be the only way to pull out subtle discoveries from noisy data, and, as Ian noted, might be an inevitable result of "pushing data borne of 1970s technology to its very limit."

NASA *Voyager 2* photo of Uranus and its Epsilon ring from January 14, 1986, processed by Ian Regan.

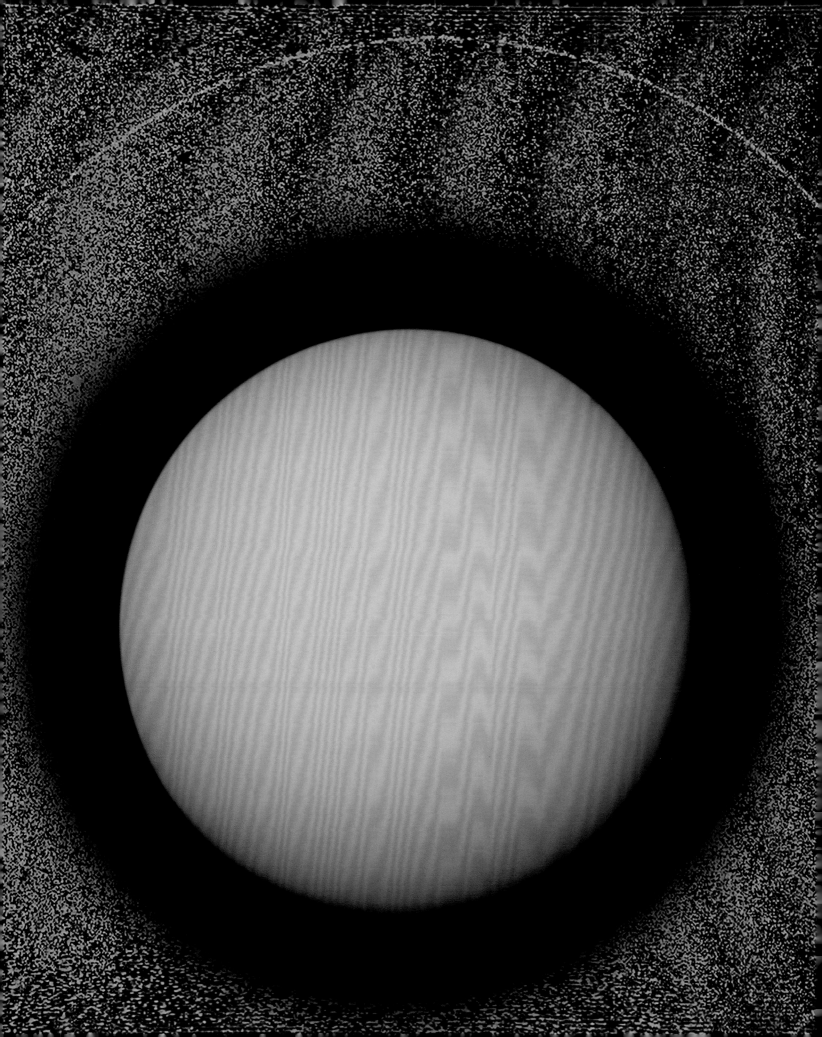

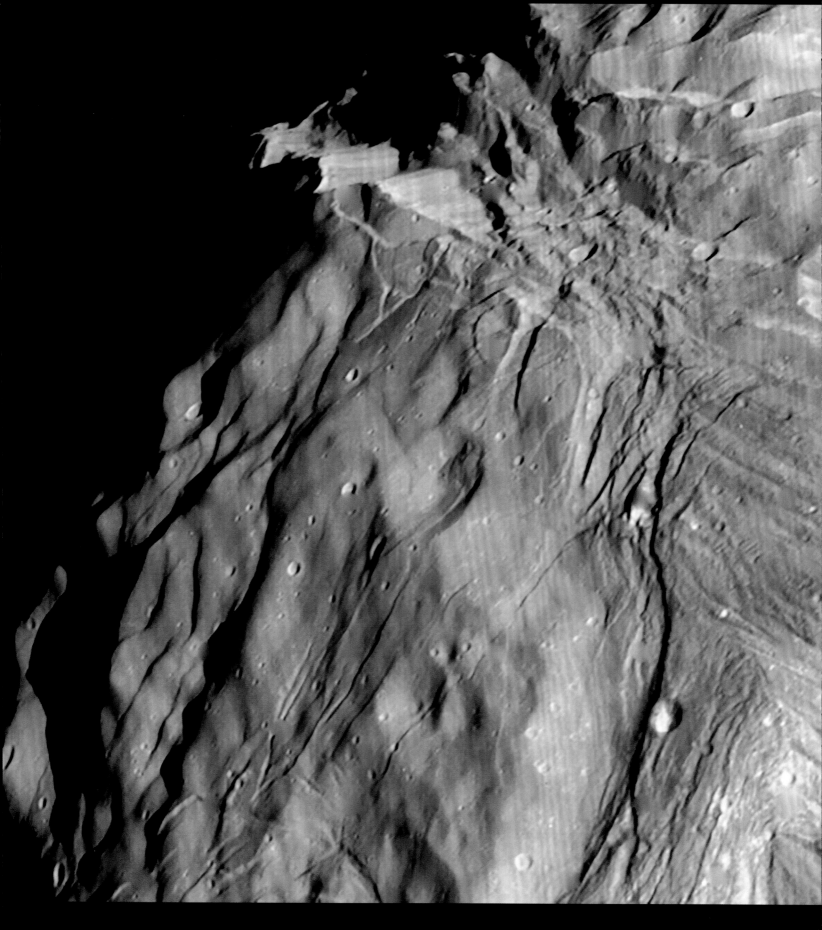

VERONA RUPES
ON MIRANDA

It's taken 60 years to get to know our planetary neighborhood, photographing and mapping the worlds around us up close for the first time. One of the results, I claim, is that we now know where most of the extraterrestrial natural wonders of our solar system can be found. These places will be meccas for nature lovers, hikers, and photographers in the centuries ahead. One such place on my personal list is a 12-mile (19.3 km) high sheer ice cliff called Verona Rupes. It was discovered in 1986 on Miranda, a small icy moon of the planet Uranus. This stunning *Voyager 2* flyby photo of the cliff is our only good view of it, and it probably doesn't do it justice. Even though Miranda is only about 300 miles (483 km) wide (with the same surface area as Texas), Verona Rupes is the tallest known cliff *in the entire solar system*. If (when) you could cliff-dive there, it would take more than 12 minutes to get to the bottom because of Miranda's gravity, which is less than 1/100th of Earth's. This photo terrifies me because of my fear of heights, but, at the same time, I am strongly drawn to it because I'm convinced that this place will be treasured in the future by our descendants.

NASA *Voyager 2* photo of the Verona Rupes cliff on Uranus's moon Miranda, taken on January 24, 1986.

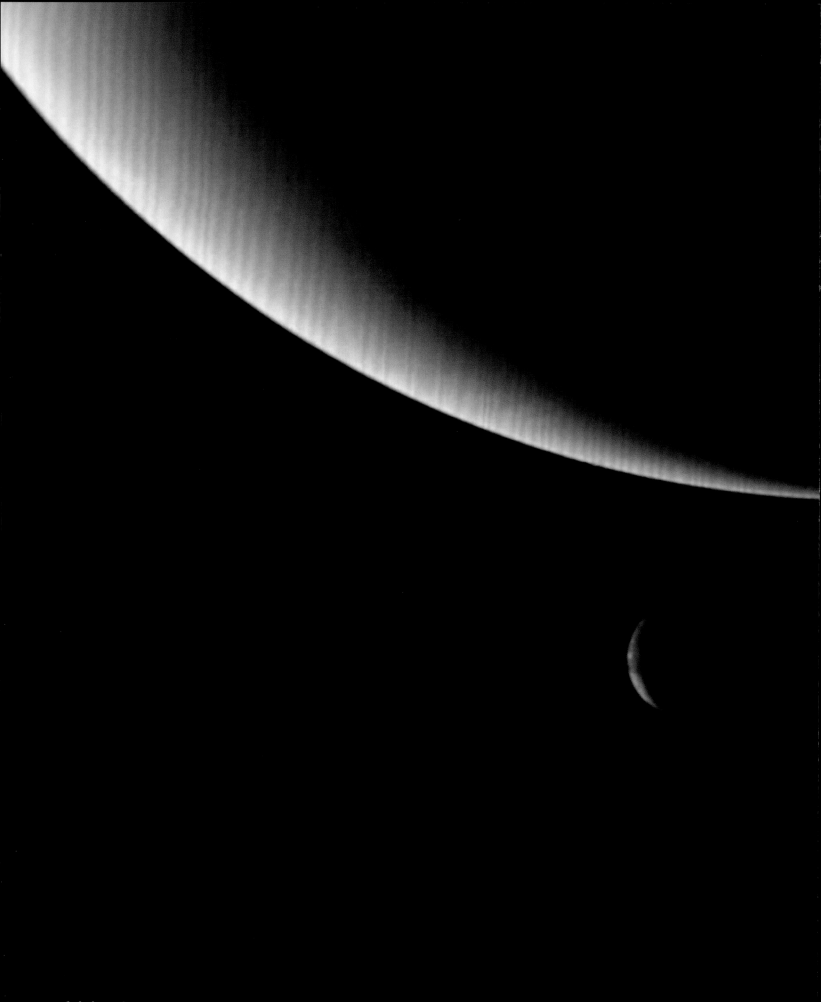

NEPTUNE AND TRITON

The *Voyager 2* mission's "Grand Tour" of all four giant planets in our solar system from 1980 to 1989 was a once-in-a-generation epic journey of discovery. The voyage was documented in thousands of stunning, historic, and scientifically compelling photos. Some of the most beautiful and poignant came at the culmination of the tour, during the flyby of Neptune in 1989. With nothing left to lose, controllers sent the spacecraft careening just above the cloud tops of this distant, azure world, using the planet's gravity to propel the probe toward a close encounter with Neptune's large moon, Triton. Both encounters yielded photographic treats like those showcased here.

The close-up view shows white, upper-level clouds of supercold methane. Even though the Sun's energy is 900 times weaker on Neptune than it is on Earth, those clouds are buffeted by the strongest winds in the solar system, with speeds above 1,200 mph (1,931 km/h). The wide-angle view shows the crescents of Neptune and Triton as the spacecraft departed its last "port of call." Never before, and perhaps never again, will so many new worlds be revealed in a single expedition. As *Voyager 2* camera team member and one of my planetary science mentors Larry Soderblom has said, "You can only discover the solar system for the first time once."

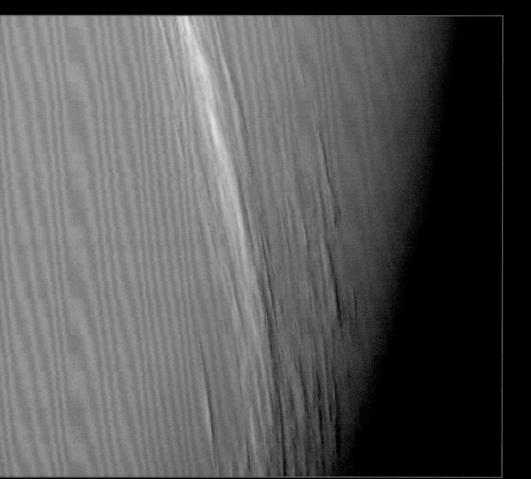

NASA *Voyager 2* photos of wispy, high-altitude clouds on Neptune (inset) and the crescents of Neptune and Triton from August 1989.

PLUTO CRESCENT

Some astronomers classify worlds according to where or what they orbit. But, in my experience, most planetary scientists classify worlds according to what they are like. As an example, this gorgeous wide-angle photo taken just 15 minutes after closest approach by the NASA *New Horizons* space probe flyby mission, processed and colorized masterfully by image-processing expert Ian Regan, provides one of the most compelling justifications I know of for classifying Pluto as a planet. Yes, it is a small world in a tilted and eccentric orbit far from the Sun. But, like other planets, it is round due to its own gravitational pull. It has an atmosphere, with more than a dozen haze layers highlighted by the backlighting here. Pluto has sprawling icy plains and rugged icy mountains and glaciers, indicating a complex geologic history and an interior likely segregated into core, mantle, and crust. It even has five moons of its own, including one half its size named Charon that is probably also a planet in its

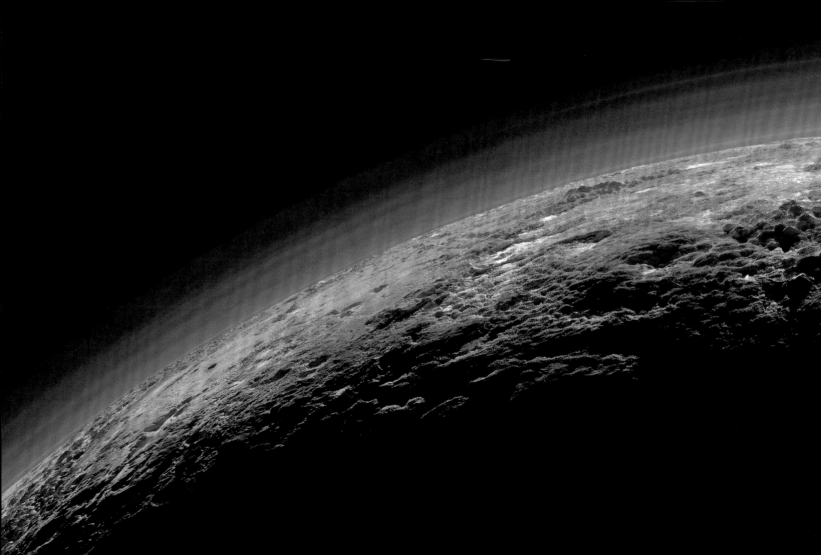

own right. "No earthbound telescope can ever depict distant worlds in such a way, and no other image from this encounter struck such a nerve," Ian told me. He finds the photo profound (and I agree) because "It gave palpable confirmation that, finally, Pluto had become a world reconnoitered by humanity."

NASA probe *New Horizons* photo of Pluto, taken on July 14, 2015, and processed by Ian Regan.

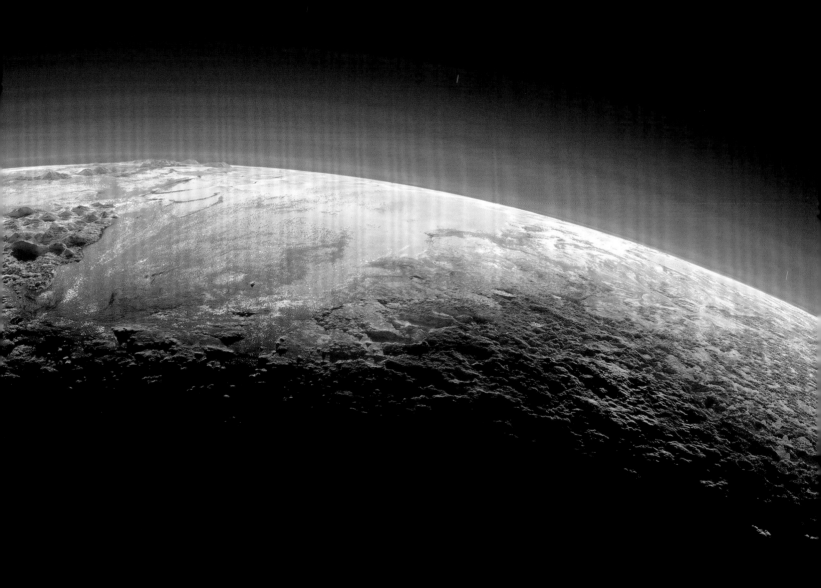

ZIGZAGGING ACROSS PLUTO

Higher-resolution, zoomed-in photos of Pluto's surface only enhance the surprise and delight in discovering so much evidence for geologic activity and complexity on such a small and distant planet. These two photos, among the most detailed shot during the NASA *New Horizons* flyby back in 2015, show a staggering variety of linear faults and circular craters, smooth to rugged textured plains, mountains more than 11,000 feet (3,353 m) tall, and strong tonal contrasts among terrains, suggesting major variability in ice composition. Where did all the heat and energy come from to drive all this action? This world is 30 to 50 times farther from the heat and light of the Sun than Earth. Tidal forces between this dwarf planet and its five moons are fairly weak. It's mostly made of ice, not rock, and thus lacks the radioactivity that heats rocky planetary interiors. What's going on here in these spectacular and artistically compelling photos from the far reaches of our solar system is a profound mystery, but one that we need to solve if we're ever going to truly understand planets—of all sizes. No one knows when we'll ever go back there with orbiters, landers, or rovers. But I believe that views like this convince us that we must.

BELOW: NASA probe *New Horizons* visible light photos of Pluto from July 14, 2015.

OPPOSITE: Wide-angle view of Pluto on the same date but in a colorized infrared composite that enhances differences in surface composition and physical properties.

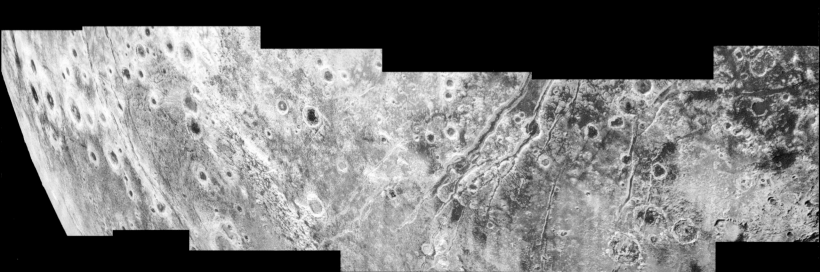

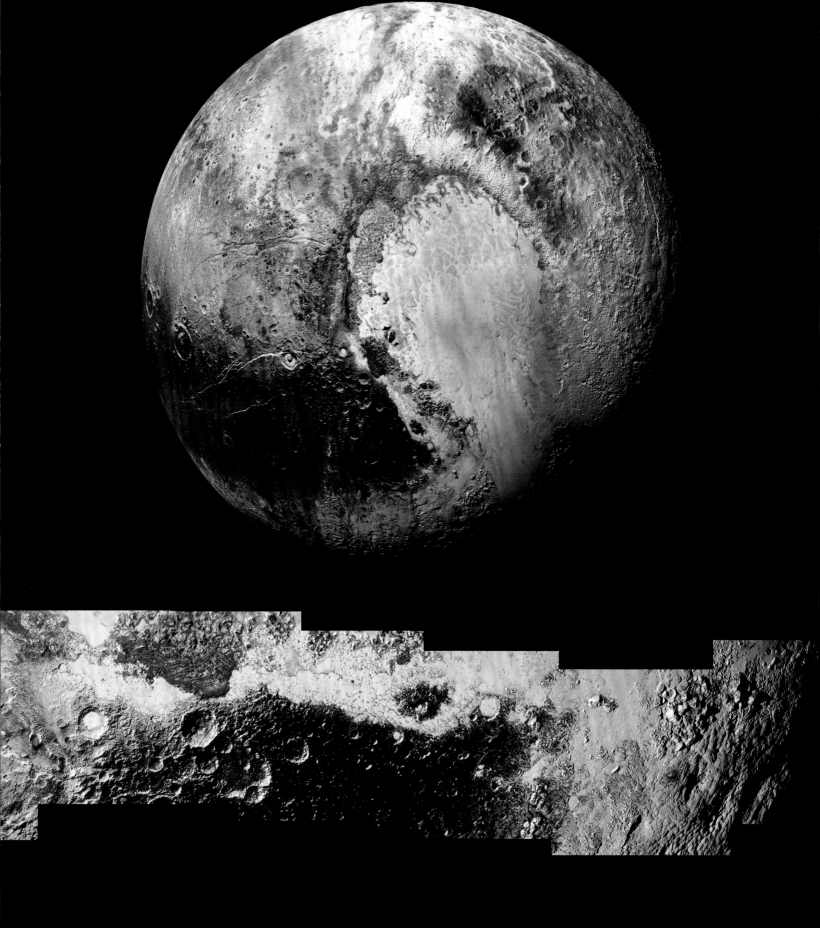

4

COSMIC FRONTIERS

Stars, Nebulae, and Galaxies

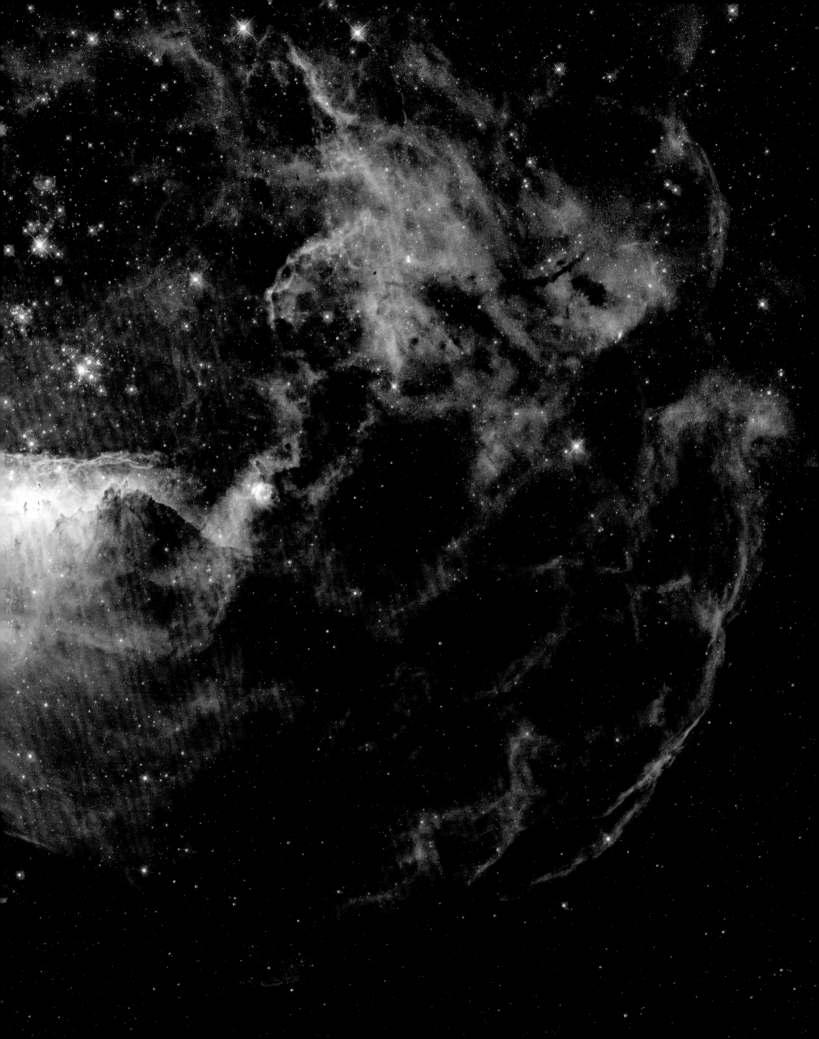

COSMIC REEF

The famous and venerable Hubble Space Telescope turned 30 years old in 2020, and NASA and the European Space Agency (ESA) commemorated the anniversary by releasing this colorful and quite artistic photo of a turbulent stellar nursery. The scene on pages 150–51 features a pair of neighboring nebulae within the Large Magellanic Cloud, a small satellite galaxy orbiting our Milky Way. The red nebula is known as NGC 2014 and the blue nebula NGC 2020. (NGC stands for "**New General Catalog** of Nebulae and Clusters of Stars," first compiled by Danish astronomer John Louis Emil Dreyer in 1888.) The scene in this image has been dubbed the "Cosmic Reef" by some astronomers because its forms and colors evoke an undersea world. Colors mean chemistry here, as in most color Hubble photos, with shades of reds corresponding to hydrogen and nitrogen and blues corresponding to superheated oxygen. This particular reef is populated by very different creatures, to extend the metaphor. The baby stars forming in these cocoons are massive—10 to 20 times the mass of our Sun—and spewing prodigious stellar winds, laced with high-energy ultraviolet radiation. Those winds form filaments and bubbles in the nebular gas and dust, and, in the most intense blue areas here, heat it to nearly 20,000°F (11,100°C). It's a portrait of both beautiful and violent stellar youth.

PREVIOUS PAGES: Neighboring nebulae in a the Large Magellanic Cloud galaxy, photographed by Hubble's Wide Field Camera 3 and released on April 24, 2020.

HL TAURI

This giant, tilted, bulls-eye pattern in the sky, opposite, is what astronomers call a "protoplanetary disk," orbiting a very young nearby star called HL Tauri. The photo isn't made from visible light, akin to what we see with our eyes, however. It was made from what are called millimeter waves—light with energy between the infrared and radio parts of the spectrum. Millimeter waves appeal to many astronomers because they are not absorbed by dense clouds of dust, and thus can be used to photograph and study objects deep inside those clouds, like newly born stars. This incredible millimeter wave photo was taken using the Atacama Large Millimeter Array (ALMA) radio telescope in the high Chilean desert. ALMA is a collection of 66 separate radio telescopes, each up to 40 feet (12 m) across, that can be widely separated to simulate the resolution of a single telescope more than 9 miles (14.5 km) wide. In that longest baseline configuration, ALMA can detect finer details than the Hubble Space Telescope. HL Tauri is less than a million years old, and what's left of the cloud of gas and dust that formed the star has collapsed into a disk. Wonderfully, the gaps cleared in the disk, like lanes on a racetrack, reveal the presence of young planets forming in a brand-new solar system just 450 light-years away.

OPPOSITE: Millimeter wave photo of the star HL Tauri and its protoplanetary disk, taken by the Atacama Large Millimeter Array in 2014.

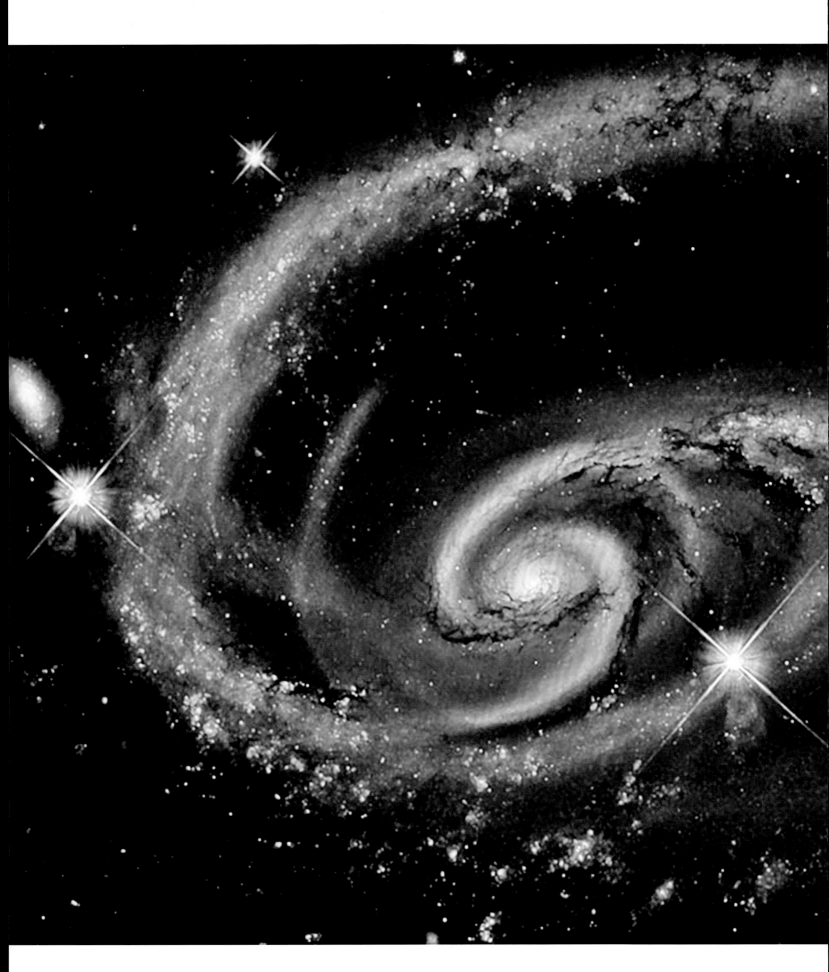

GALAXY UGC 1810

Sometimes even when you know that the action captured in a photograph was actually super slow, the dynamic composition of the scene can still make your heart race with a sense of speed and motion. That's my reaction to this dramatic and beautiful Hubble photo of one of the participants in a violent collision of two galaxies some 300 million light-years away in the constellation of Andromeda. The pair are known as Arp 273, after the American astronomer Halton Arp, who first compiled his *Atlas of Peculiar Galaxies* back in the 1960s. The larger of the pair, which is seen in this photo, a galaxy called UGC 1810, has sprawling blue arms filled with hot young stars, and a central core made of older and redder stars and dark filaments of dust. The blue outer arms of UGC 1810 are being spread out and distorted by the gravitational pull of the other nearby galaxy, UGC 1813 (well outside the field of view here), even though that galaxy is something like five times less massive. The spiral motif here evokes a three-dimensional sense of motion, as if UGC 1810 were an enormous cosmic sink drain. Brighter foreground stars with their radiant X pattern, produced by Hubble's optics, also help to give this dramatic view an additional sense of depth.

Hubble photograph of Galaxy UGC 1810, part of the Arp 273 double galaxy in the Andromeda constellation, taken on April 20, 2011, and processed by Domingo Pestana.

STELLAR SNOWFLAKES

I remember the first time I saw a clear, moonless, night sky, on a hike far away from city lights. There were *so many stars* that I couldn't even recognize the familiar constellations. Still, their combined light wasn't enough for me to hike without a flashlight. Now imagine living on a planet within a globular cluster, like the one named NGC 6441 in this spectacular Hubble photo. In our part of the galaxy, stars are about five light-years apart, on average. In a globular cluster, stars are packed five times or more closer together. Viewed from a planet there, the night sky would be teeming with stars, and starlight would be twenty times or more brighter than the light of our full Moon. No flashlight needed. This spectacular photo also shows that the sky would be teeming with a stunning array of colors—red, blue, yellow, white. I can't help but wonder: If there are intelligent beings on such planets, what is their cosmology, their understanding of where they are and where they came from? To them, is the entire Universe packed full of stars? Can they know that there are others who can hike under a truly dark sky, or is that just the stuff of their science fiction?

The snowflake-like stars of the globular cluster NGC 6441, captured by Hubble on June 5, 2020.

LL PEGASI

This wonderful study in shape and symmetry represents a collaborative photographic effort between the Hubble Space Telescope, capturing visible light from high above Earth's atmosphere, and the ground-based ALMA radio telescopes, capturing millimeter waves from the high and dry Atacama desert of northern Chile. The photo shows the binary star system called LL Pegasi, which is about 4,200 light-years away. The older star of the pair is a red giant and a so-called carbon star, with a dark sooty atmosphere that gives it a deep and almost ruby-red color. The red giant is nearing the end of its life and has started going through its death throes, shedding huge amounts of gas and dust into nearby space as it convulsively expands and contracts. The two stars orbit each other about every 800 years, and the second star appears to be plowing through the shells of gas and dust spewing out of the first, creating a bow wave that forms a massive Archimedian spiral many light-years across. It's a stunning and beautiful photographic imprint of a graceful but also wistful stellar death waltz, occurring on a grand cosmic scale as the two stars go round and round until the end . . .

The LL Pegasi binary star system, photographed by Hubble on September 6, 2010, and the Atacama Large Millimeter Array telescope on March 6, 2017.

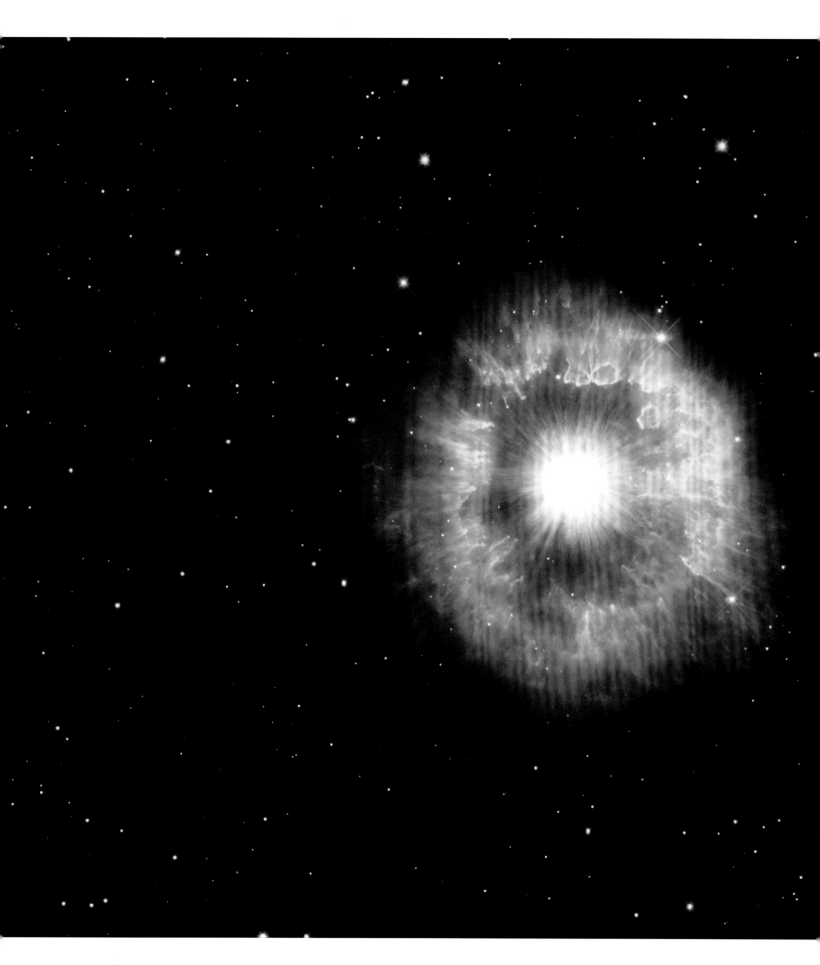

THE ART OF THE COSMOS

AG CARINAE EXPLOSION

Many of us remember stars who lived fast and died young. James Dean, Marilyn Monroe, Janis Joplin, Kurt Cobain. But few of us are familiar with the literal kinds of powerhouse stars that are the subject of this spectacular 2021 Hubble photo. This is AG Carinae, what astronomers call a "luminous blue giant." Such stars are massive, 50 to 100 times the mass of our Sun, and they shine a million times brighter. They are also petulant—this one violently shed a shell of gas and dust some 10,000 years ago that has expanded into a giant bubble, now more than three light-years across. "I like studying these kinds of stars because I am fascinated by their instability. They are doing something weird," said German astronomer Kerstin Weis in a NASA press release about the image. Personally, I love the way the pristine view, provided by Hubble, combined with special ultraviolet filters, highlights the subtle radial filaments and layers of the expanding shock wave. This show can't go on for long, though: The nuclear fuel in stars like this is used up so fast that they only live for a few million years. That's perhaps why there are only around 50 of these special gems known among all the trillions of stars in our local group of galaxies.

The luminous blue giant and relatively ephemeral star AG Carinae, one of the brightest stars in our Milky Way, photographed by Hubble and released on April 23, 2021.

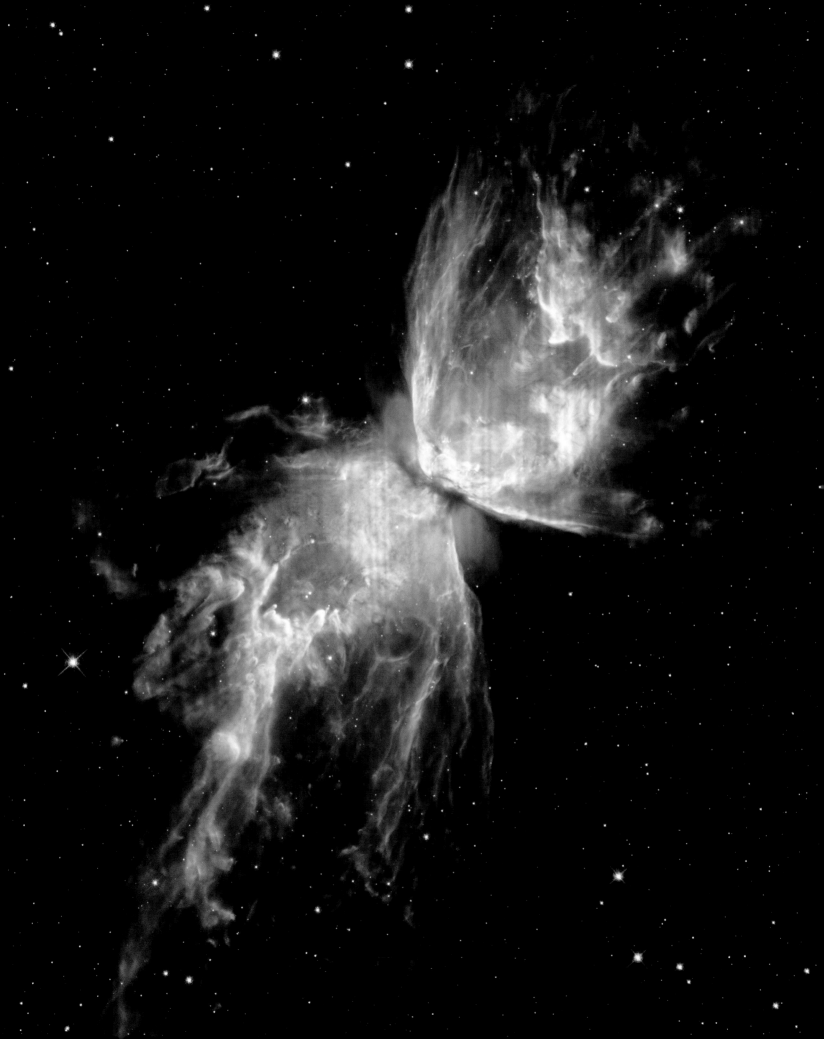

BUTTERFLY NEBULA

We see the familiar in the unfamiliar all the time. Psychologists call it *pareidolia*—defined by Merriam-Webster as "the tendency to perceive a specific, often meaningful image in a random or ambiguous visual pattern." It's what makes us see dragons in the clouds, or a man's face on the Moon. Or, butterflies in space, as in this gorgeous Hubble enhanced-color photo of the Butterfly Nebula, which astronomical purists also know as NGC 6302. The view is stunning but, for me, an important part of the artistic element in this image is its irony. Butterflies emerge slowly from their chrysalis and live their lives as gentle creatures. But the reality of this astronomical scene is all about violence and death. Something like 10,000 years ago, a massive Milky Way star more than 3,000 light-years from the Sun began to die. Rather than a single massive supernova explosion, however, this star's death throes were slower convulsions—expanding dramatically in size, puffing out huge streams of gas and dust, and then shrinking smaller again. The expelled gas is hot, more than 36,000°F (20,000°C), and moving fast, more than 600,000 mph (965,600 km/h)! Astronomers use special filters to detect different chemical elements, like iron, in the gas and combine those filters into color composites like this one that give the Butterfly an appropriately iridescent sheen.

NASA/ESA Hubble Space Telescope photo of the Butterfly Nebula from June 18, 2020.

HERBIG-HARO OBJECT

It is easy for many of us to be awed by the power of nature—lightning, earthquakes, hurricanes, and the like. Still harder to imagine are natural phenomena that are beyond the power of anything in our terrestrial experience, beyond even the power of our own local star. An example of such incomprehensibly awesome power is on glorious display in this Hubble photo of enormous lighthouse-like beams of energy streaming out of a hot young star near the Orion Nebula. The star itself is buried too deep within a dark molecular cloud to see, but the jets of ionized gas streaming out of its north and south poles are both dramatic and terrifying. This whole area is called Herbig-Haro Object 111 (HH 111), with the *HH* referring to George Herbig and Guillermo Haro, the two astronomers who first studied these rare celestial powerhouses in detail. The photo combines visible, ultraviolet, and infrared images into a beautiful false-color composite that probes different depths in the cloud. The jets of superhot ionized gas are probably focused ("collimated") by intense magnetic fields around the highly active young star. They are streaming out at over a million miles per hour, creating shock waves in the surrounding nebula. It's a fantastic display of the raw, and extreme, power of nature.

Photograph of HH 111 star near the Orion Nebula, taken by Hubble's Wide Field Camera 3 on September 3, 2021.

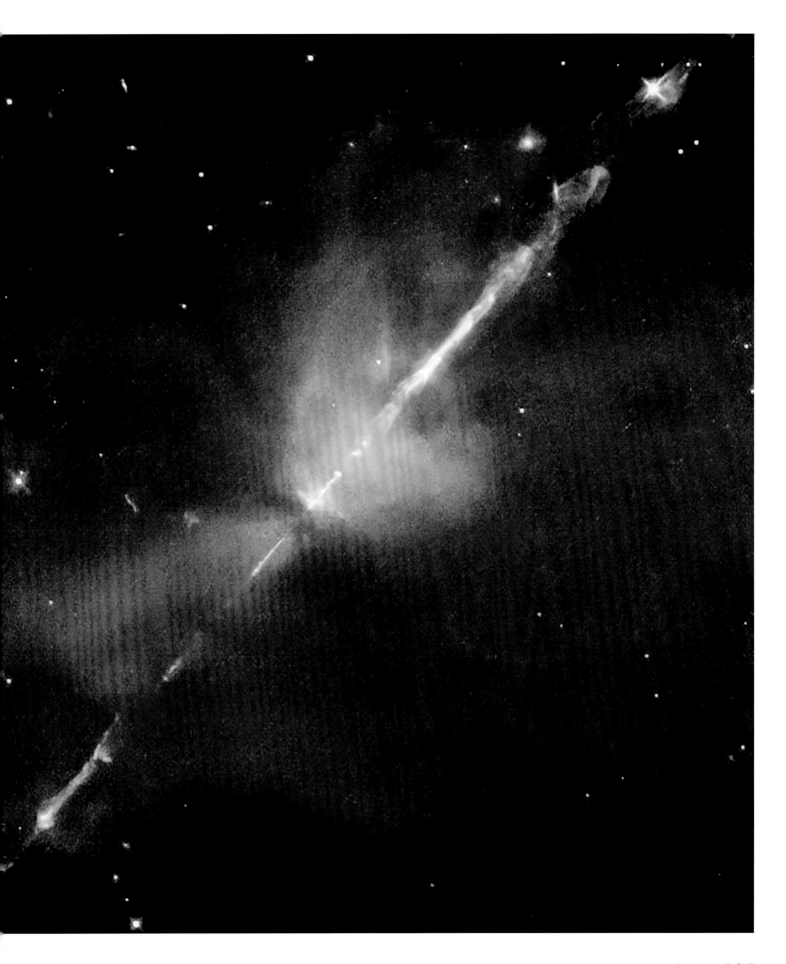

COSMIC SUNSET

I'm a big fan of sunsets, especially in partially cloudy skies. The interplay of light and shadow, color, and tone on the grand and expansive palette of the celestial sphere is a source of endless inspiration and awe. Imagine my delight, then, discovering this spectacular Hubble photo of a distant galaxy that exhibits many of the same inspirational photographic elements. This galaxy is called IC 5063 (where "IC" stands for "**Index Catalogue** of Nebulae and Clusters of Stars," a supplement to the New General Catalog first published in 1895 by J. L. E. Dreyer) and it's "only" about 156 million light-years from our solar system. That relative closeness allows Hubble to detect lots of fine detail in the galaxy, which has a supermassive black hole at its heart. Black holes are the remnants of collapsed stars that are so massive that not even light can escape their monstrous gravity. While they don't glow themselves, black holes still help create enormous amounts of light and heat as they ionize the rapidly spiraling gas and dust in their surroundings. Beams of that light are streaming out from deep inside IC 5063 "like lighthouse beams through fog," according to Harvard astronomer Peter Maksym, who studies active galaxies like this. Places where the light is blocked by dust orbiting the black hole cast long, glorious shadows into space. It's like a stunning cosmic sunset from a million suns all in one place.

Bright and dark rays stream out of the black hole at the heart of the IC 5063 galaxy, photographed by Hubble's Wide Field Camera 3 and Advanced Camera for Surveys on March 7, 2019 and November 25, 2019.

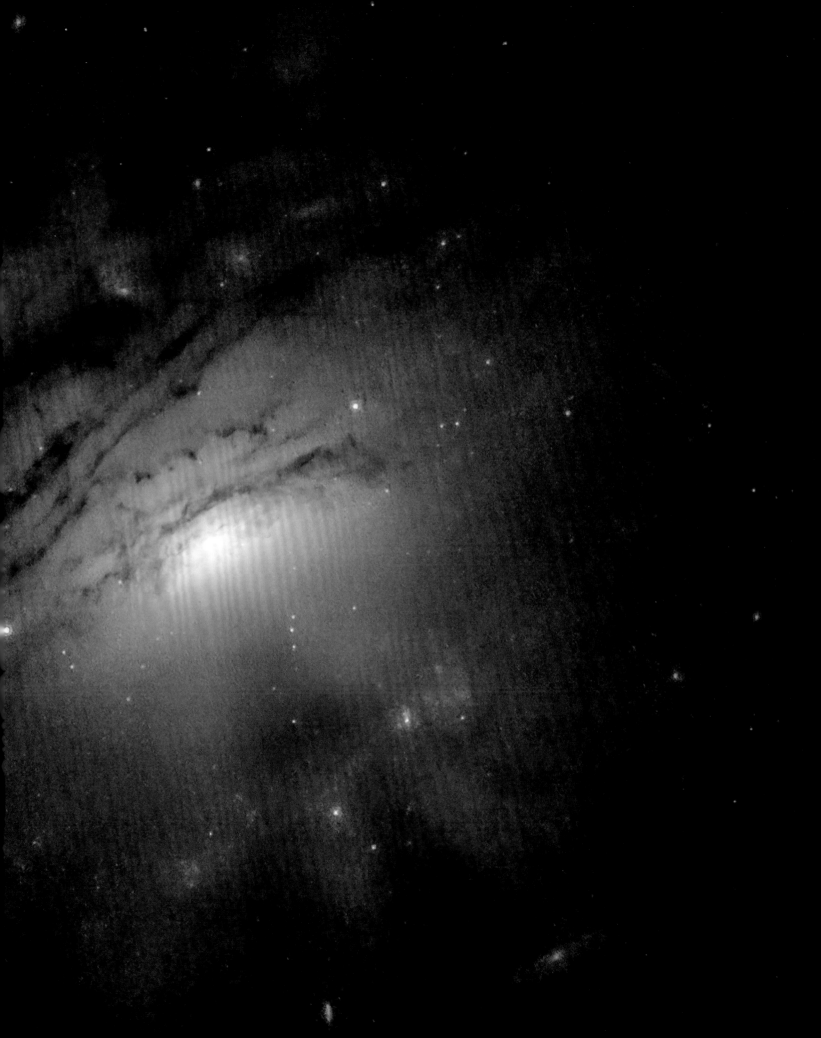

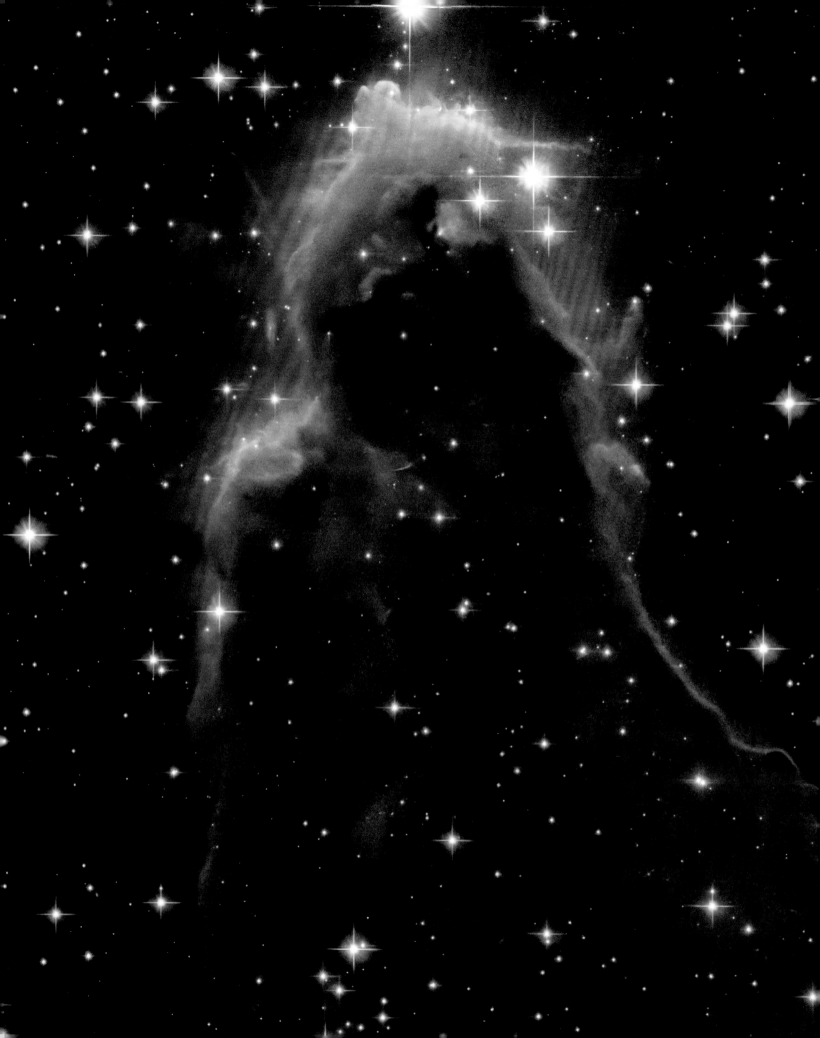

STELLAR NURSERY

Eggs are precursors of life; an early stage, not yet complete but full of potential. To astronomers, EGGs—evaporating gaseous globules—are similar; stars at an early stage of their life, not yet complete but full of potential. This shimmering and ghostly photo from Hubble, opposite, features a particularly photogenic EGG with the indecipherable name of J025157.5+600606. EGGs trace their roots to the enormous molecular clouds of gas and dust that form giant new stars. When those stars ignite, they ionize and send shock waves through the remaining gases in the cloud, forming enormous hot bubbles. The shapes and forms of those bubbles sometimes appear as columns or spires—so-called "pillars of creation" where new stars are being born. Over millions of years, these clouds of gas and dust will dissipate (the "evaporating" part) as they fall into newly born stars or into new planets forming around those stars. I am drawn to the unique patterns in these kinds of special stellar nurseries: the dense concentration of so many young and clearly related stars of similar brightness, all mingling with countless still-nascent stars that can only be seen via the glowing energy peeking out of their EGG. I can't help but wonder if our own Sun began its life among such a bevy of siblings.

OPPOSITE: Star-forming, pillar-shaped EGG nursery J025157.5+600606, photographed by Hubble on October 16, 2020.

SHOCK WAVE

Sometime between 10,000 and 20,000 years ago, an enormous star 20 times as massive as the Sun and only a few thousand light-years away exploded as a supernova. The new star was likely brighter than Venus and visible even in the daytime sky for some time. That explosion sent huge amounts of gas and dust streaming out into space, forming semispherical, expanding shells and clumps of shocked, ionized debris. By now, the debris has spread over an area more than 130 light-years across—equal to an area more than 36 times larger than the full Moon in the sky as seen from Earth. Astronomers call the visible-wavelength part of this supernova remnant the Veil Nebula; the full structure—visible only in ultraviolet and higher-energy light—is known as the Cygnus Loop. The spectacularly detailed photo from Hubble on pages 170–71 shows one tenuous and delicate part of the Veil, winding and twisting through space. The three-dimensional nature of this photo is reminiscent of ribbon candy or the delicate flame from a low-power acetylene brazing torch. But the rope-like veil effect here is an illusion, the result of viewing part of the curved surface of a bubble or shell of gas and dust edge-on. An illusion, perhaps, but a beautifully evocative one nonetheless.

FOLLOWING PAGES: Partial view of the stellar-blast remnant known as the Veil Nebula, taken by Hubble and released on August 28, 2020.

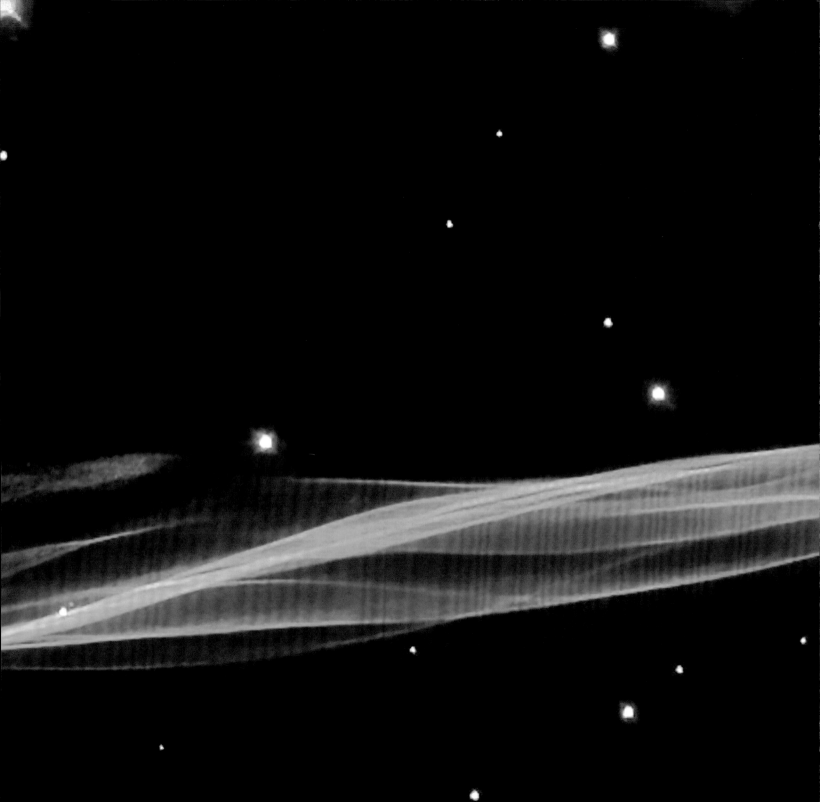

RUNNING MAN NEBULA

This is another photographically dramatic example of powerful shock waves shaping and forming enormous clouds of gas and dust. Known as Herbig-Haro Object 45 (HH 45), or more commonly the Running Man Nebula, these mounded, luminous clouds of ionized hydrogen form a companion not far in the sky from the famous Orion Nebula, within the Hunter's famous sword. The hazy and almost out-of-focus nature of this Hubble photo suggest depth and motion, as if the camera were being buffeted by winds. Indeed, the winds here are gases ejected from hot and violent, newly forming stars deep within these clouds, so-called "stellar outflows," creating shock waves as they slam into the surrounding gas and dust at speeds of hundreds of miles per second. Special filters on Hubble were used to create this color composite, merging reflected visible light with light emitted by ionized atoms of oxygen (blue) and magnesium (purple). The view also reminds me of watching distant thunderstorm clouds building on the horizon at night. Bursts of lightning momentarily light up the insides of the clouds, dancing from one part to the next. The size and energy here are on scales that dwarf those of terrestrial thunderstorms, but, still, I swear I can hear and feel the thunder.

HH 45, the Running Man Nebula, photographed by Hubble and released on November 24, 2021.

PRAWN NEBULA

If our eyes could see in infrared, ultraviolet, or X-ray light, the sky would look dramatically different to us. Perhaps most dramatic would be the spectacular glowing vistas of the many enormous clouds of gas and dust that lurk in our part of the Milky Way Galaxy but which are essentially invisible to us. The nebula associated with this wonderfully detailed and colorful Hubble photo, for example, is vast and would cover a part of our night sky more than four times the size of the full Moon if we could see all of it. This is part of what is formally called IC 4628 but nicknamed the Prawn Nebula because of its shrimp-like shape. It's a gigantic, star-forming region that spans 250 light-years across and is located only around 6,000 light-years away in the constellation Scorpius. Just as some photographers use infrared film and special filters, Hubble's cameras are equipped with special filters of their own and digital sensors that can detect some parts of the ultraviolet and infrared spectrum. The deep reds and browns here, for example, come from using a filter sensitive to light emitted by iron as it is ionized by the hot young stars forming deep within this cloud.

Hubble photograph of IC 4628, or the Prawn Nebula, released on November 19, 2021.

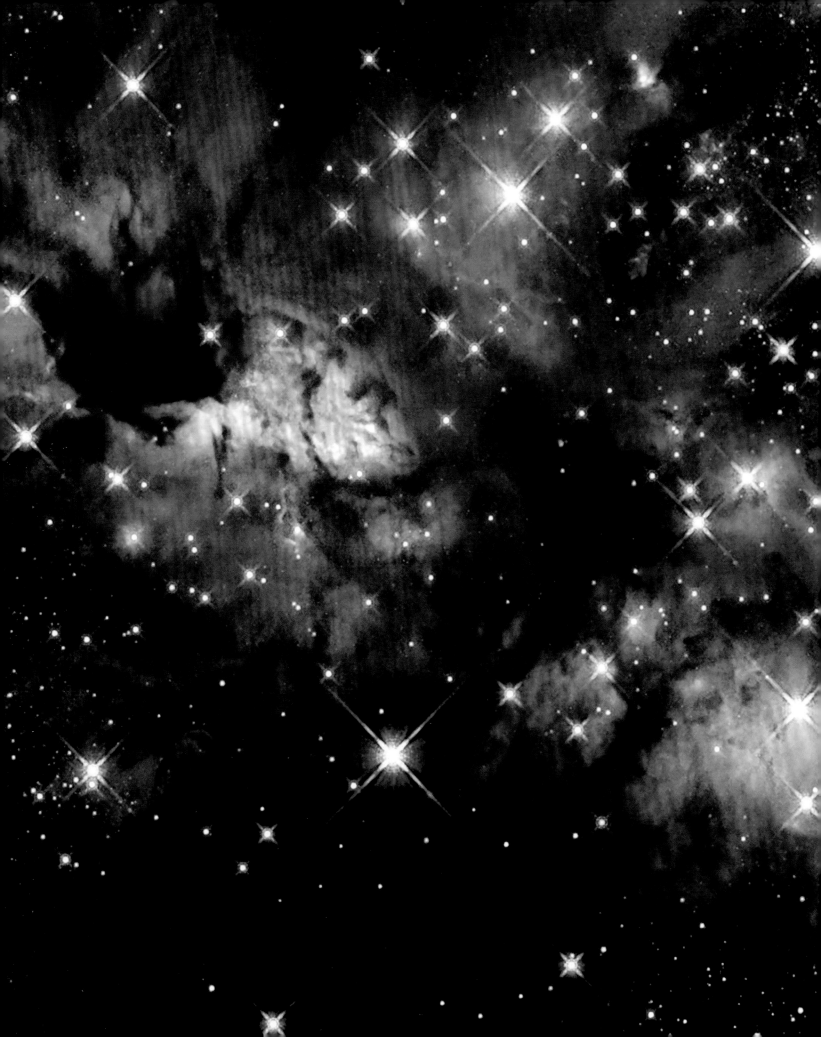

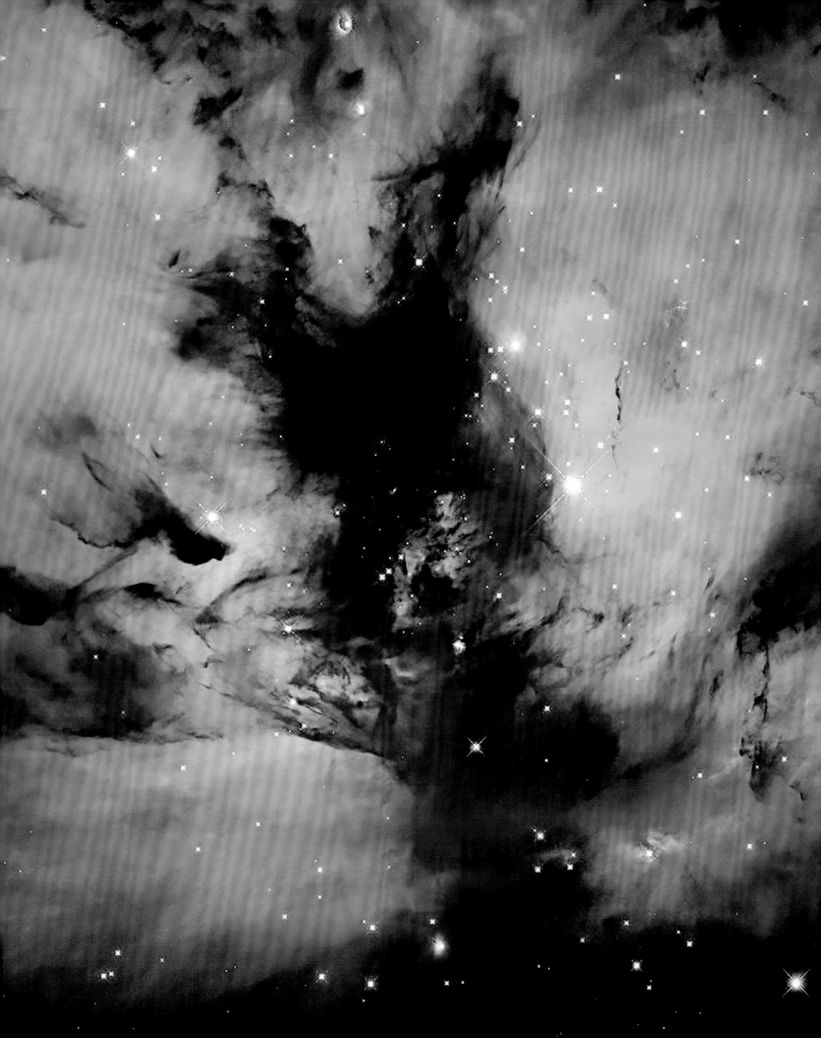

FLAME NEBULA

The wispy, delicate, and seemingly dynamic filaments
and tendrils in this colorful astronomical scene evoke
a dancing and crackling fire. That's why this region is
known as the Flame Nebula, or NGC 2024. The Flame is
part of a much larger region called the Orion Molecular
Cloud Complex, which includes the famous and iconic
Orion and Horsehead Nebulae. The scene is relatively
close to us, in astronomical terms—only around 1,400
light-years away—which is why we can see so much
incredibly fine detail in photos like this from the Hubble.
The sense of energy and motion in this piece is palpable
and also quite real. The flame-like form here is the
silhouette of dark swirls of dust seen against a glowing
background of ionized hydrogen gas. The broader context
here is that the easternmost star in Orion's famous
three-star belt, Alnitak, is nearby. Alnitak is a hot, blue,
supergiant star that emits huge amounts of high-energy
ultraviolet radiation. That radiation energizes and strips
electrons from hydrogen molecules in the nearby Flame
Nebula. When the electrons recombine with hydrogen,
they release that energy as visible light—the turquoise
blue glow here in this specially filtered Hubble photo.
The Flame will dance for as long as Alnitak shines.

NGC 2024, known as the Flame Nebula, in the Orion Molecular
Cloud Complex, photographed by Hubble and released on
November 22, 2021.

LIGHT SABER

This stunning and dynamic view in our celestial neighborhood features another lighthouse-like beacon of high-velocity ionized gas being beamed out from a violent young star into a long jet, known officially as HH 24 but nicknamed the "celestial light saber" in a nod to *Star Wars* and science-fiction fans. The beam heats and ionizes nebular gas to thousands of degrees, causing it to glow in hues of red and blue, and shock waves from the jet piling into the surrounding gas and dust clump it up and carve it into swirling shapes and forms. But this turbulent scene is not from a galaxy far, far, away. Rather, it's close by (1,400 light-years), within the enormous Orion Molecular Cloud Complex. The newly forming star creating this spectacular show is hidden, buried deep inside the dark and dusty heart of the nebula. This is just one of many jets spewing out of hot young stars in this busy and beautiful region of space. I concur with astrophysicist and Hubble repair astronaut John Grunsfeld's reaction to this photo: "There is no stronger case for the motivational power of real science than the discoveries that come from the Hubble Space Telescope."

High-velocity ionized gas beaming out from a young star in the Orion Molecular Cloud Complex, taken by Hubble and released on December 17, 2015.

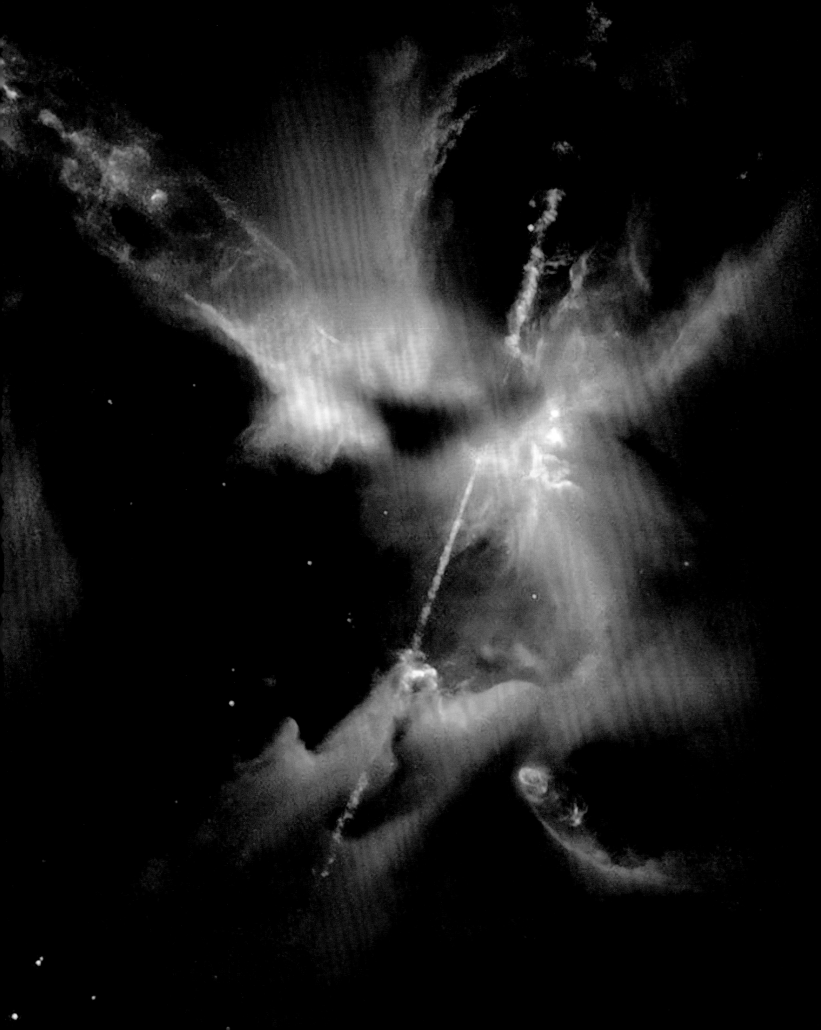

LAGOON NEBULA

The French author Marcel Proust wrote about experiencing new forms and pieces of art and music, and the viewpoint of his narrator in his 1923 novel *The Prisoner* has been widely paraphrased in translation as "The real voyage of discovery consists not in seeking new landscapes, but in having new eyes." This beautiful composite space photo is literal proof of the validity of that viewpoint. The blue and white colors of this composite are a visible-light photo of the nebula from the Mount Lemmon Observatory in Arizona. But the "new eyes" added here are the sensors on the NASA Chandra X-ray Observatory, launched in 1999 as one of the space agency's four Great Observatories. X-rays are a very high-energy form of light used by doctors to see the bones beneath our skin and used by astronomers to see deep into otherwise opaque clouds of gas and dust. Chandra's cameras were aimed into the heart of NGC 6523, or the Lagoon Nebula, a giant star-forming region some 4,000 light-years away in the constellation Sagittarius. Hot, highly energetic, new stars—shown overlaid in pink on the Mount Lemmon photo—emit huge amounts of X-ray light, which Chandra detected inside the nebula. Seeing the view with new X-ray eyes truly enhances this exquisite piece of astronomical art.

A color composite photo of NGC 6523, or the Lagoon Nebula, in the constellation Sagittarius, taken from the Mount Lemmon Observatory and the Chandra X-ray Observatory and released on August 12, 2021.

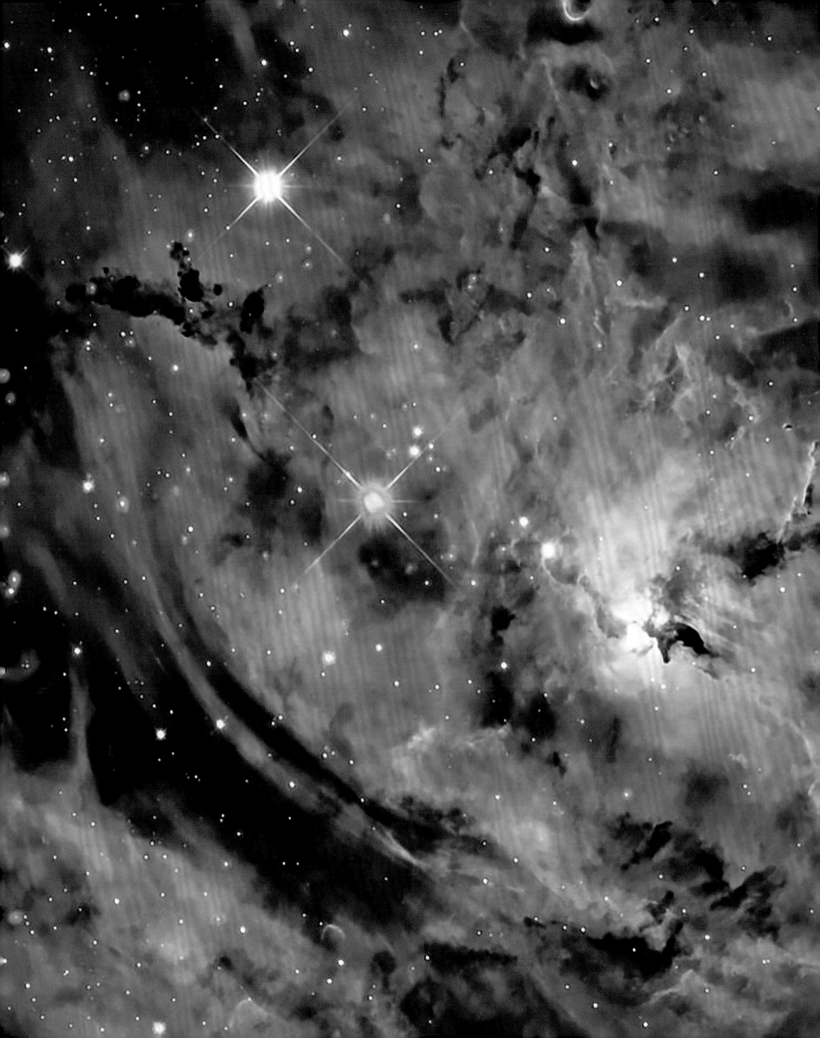

STARBIRTH

So much is going on in this gorgeous and artistic Hubble photo centered on the bright nebula known as NGC 602, which is about 200,000 light-years away in the Small Magellanic Cloud, a satellite galaxy of the Milky Way. The wispy, orange-brown ridges and tendrils of nebular gas and dust appear to form a giant "Pac-Man" in the sky, gobbling up a twinkling cluster of bright blue stars. Many more of those stars, including another cluster at center left, appear to be next on the monster's path. And the whole dramatic foreground scene is set against a backdrop of countless distant galaxies, some spiral, others elliptical, some mere tiny blobs of light. Wild! In reality, it is the hot, less than five-million-year-old stars near the center of the photo here that are "eating" (evaporating) the nebula here, capturing some of it with their increasing gravitational pull as they grow, and dispersing the rest of it with their intense, young, stellar winds. Even in the parts of the nebula that remain there is intense action, with hot, new, blue stars forming right now at the tips of many of the pointy pillars of nebular dust. Such a grand view of starbirth in action!

The Pac-Man–like NGC 602, a star-forming region in the Small Magellanic Cloud, captured by Hubble and released on January 14, 2021.

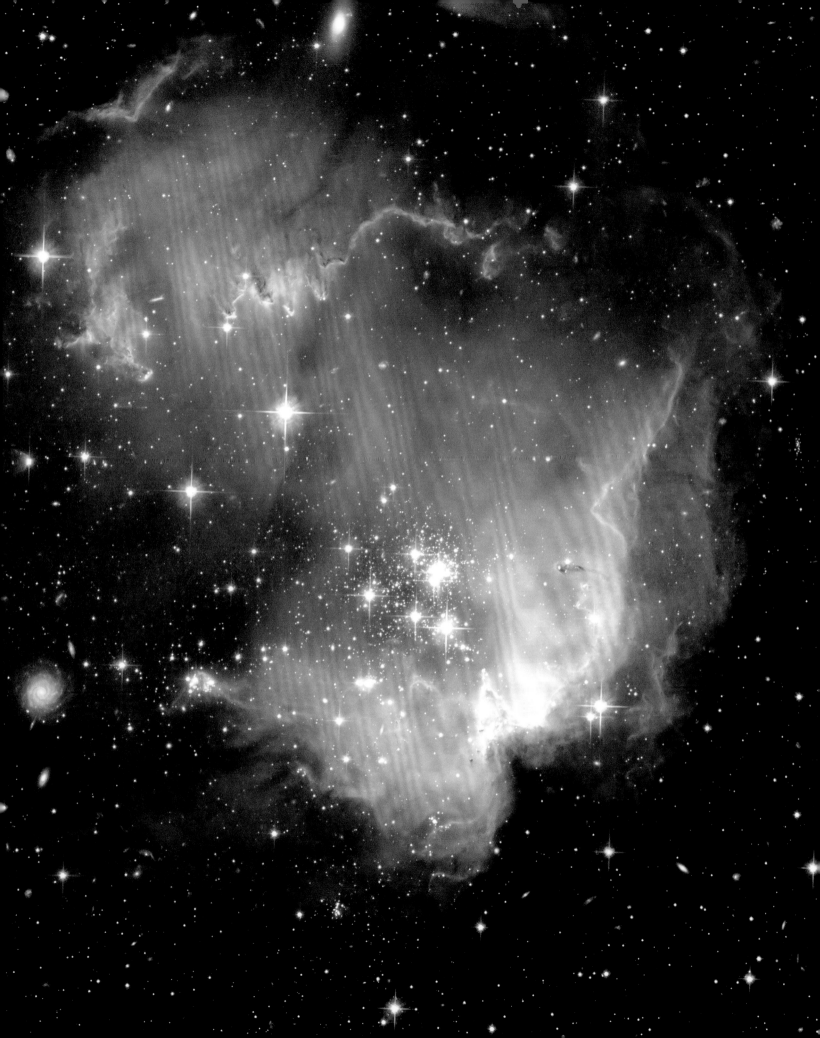

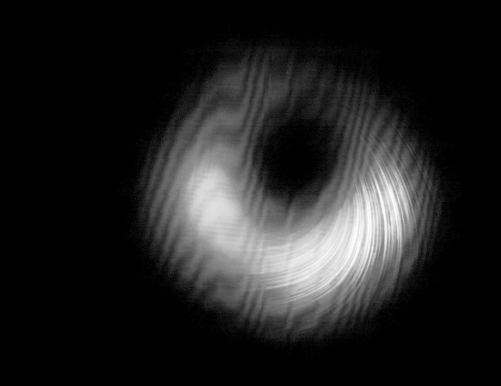
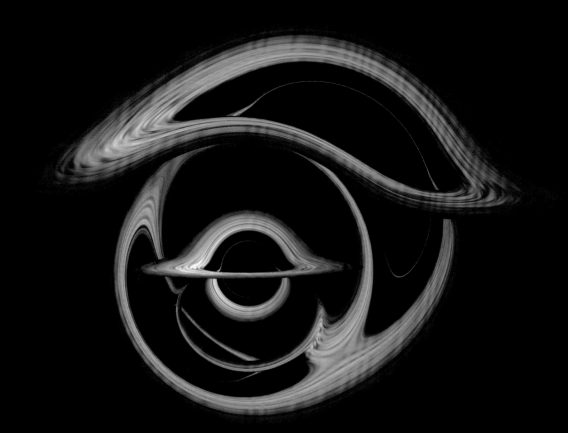

M87 BLACK HOLE

Taking photos of black holes is, by definition, problematic. They have so much gravity that not even light can escape their pull. Thus, against the blackness of space, a black hole would be . . . invisible. Not a very exciting photo. But black holes are actual three-dimensional objects, meaning that they can cast shadows. If you could shine a bright enough flashlight on one, then it might be possible to see a black hole's shadow projected onto some sort of screen in the background. That's sort of what nature has done with the supermassive black hole at the heart of the galaxy M87, in this historic first-of-its-kind photo (opposite page, top) from NASA's collaboration with the international Event Horizon Telescope (EHT). Both the "flashlight" and the "screen" for this photo come from the accretion disk, a zone of rapidly rotating and highly ionized gas and dust that mark the glowing "event horizon" of debris falling into M87's black hole. We can't see the black hole itself—which has an astounding mass of more than six *billion* times the mass of our Sun—but we can see the black hole's shadow in the middle of the debris. The spiral streaks here track the orientations of intense magnetic fields, produced as gas and dust fall into this monstrous cosmic abyss.

OPPOSITE TOP: A photograph of the M87 galaxy's supermassive black hole in polarized light, released in 2019 by a collaboration between NASA and the Event Horizon Telescope.

BINARY BLACK HOLES

The physics of space and time in the vicinity of extreme astrophysical objects like black holes defy simple intuition. Thus, computer-generated simulations and graphics, like the NASA simulation of a binary black hole system shown here (opposite page, bottom), provide important ways to view and visualize what is going on in and around these difficult-to-imagine objects. Computer graphics like this substantially enhance and augment our understanding of black holes, partly because only one so far (the black hole in M87, opposite top) has been photographically documented, and even then, that photo only shows the black hole's shadow. To me, these kinds of computer simulations constitute a form of art as well. They represent models and predictions of things that we cannot see directly. They are imaginings that follow strict laws of physics but also allow the flexibility to provide a viewer's perspective that might not actually be physically possible, given the tremendous gravity and radiation in such environments.

OPPOSITE BOTTOM: A NASA visualization of a pair of orbiting black holes, created by astrophysicist Jeremy Schnittman and data scientist Brian Powell, released on April 15, 2021.

ANDROMEDA GALAXY

The Andromeda Galaxy is a spiral galaxy like our own Milky Way, and the closest spiral to us in our local galactic neighborhood. Even so, "closest" is still two million light-years away, meaning that the light we see coming from it left there two million years ago. I get a visceral sense of appreciation for how large galaxies are by realizing that even though Andromeda is that far away, it is more than five times the diameter of the full Moon when viewed in the night sky. With binoculars or a small wide-angle telescope, we can see that galaxy almost edge-on, but because we're looking through so much dust in that orientation it's hard to discern Andromeda's spiral structure. But this lovely photo mosaic, opposite, from 10 separate shots taken with NASA's Galaxy Evolution Explorer (GALEX) space telescope back in 2003, sees through much of that dust and reveals Andromeda as we've never seen it before. The improved clarity is because GALEX used special ultraviolet sensors and filters designed to detect super high-energy astronomical objects, like newly formed hot and massive stars. Such high-energy stars form by the churn and mixing of gas and dust in the spiral arms of galaxies like Andromeda—and our own Milky Way.

OPPOSITE: Photo mosaic of the Andromeda Galaxy from images taken by NASA's Galaxy Evolution Explorer space telescope in 2003.

HIDDEN TREASURES

Mountains of gas and dust can produce landscapes as stunning and beautiful as those made of rock or ice. A case in point comes from beautiful images like the one on pages 188–89, showing part of the nebula known unceremoniously as N11 and located in the Large Magellanic Cloud, a small nearby satellite galaxy of the Milky Way. Hubble Space Telescope photos of N11 were taken in January 2000 using a variety of filters chosen by astronomers to highlight different atoms or molecules. The photos weren't widely seen, however, until they were dug out of the massive Hubble archive in 2012 by Josh Lake, a high school physics and astronomy teacher, science department head, and amateur digital-image processor in Pomfret, Connecticut. Josh won first prize in NASA's Hubble's Hidden Treasures image-processing competition with this rendering of N11. Part of the beauty in Josh's color compositing is its simplicity. Rather than mathematically combine multiple filter views into complex red/green/blue color combinations that can be challenging to interpret, he instead chose just two shades: blues to show hydrogen and reds to show nitrogen. Black streamers and "globules" of dense dust, some lit from the inside by white-hot newborn stars, add spectacular tonal variations that both contrast and modulate the colors that Josh chose to highlight.

FOLLOWIJNG PAGES: Part of the nebula known as N11 in the Large Magellanic Cloud, originally photographed by the Hubble Space Telescope in 2000 and reprocessed in 2012 into this spectacular enhanced-color interpretation by high school science teacher Josh Lake.

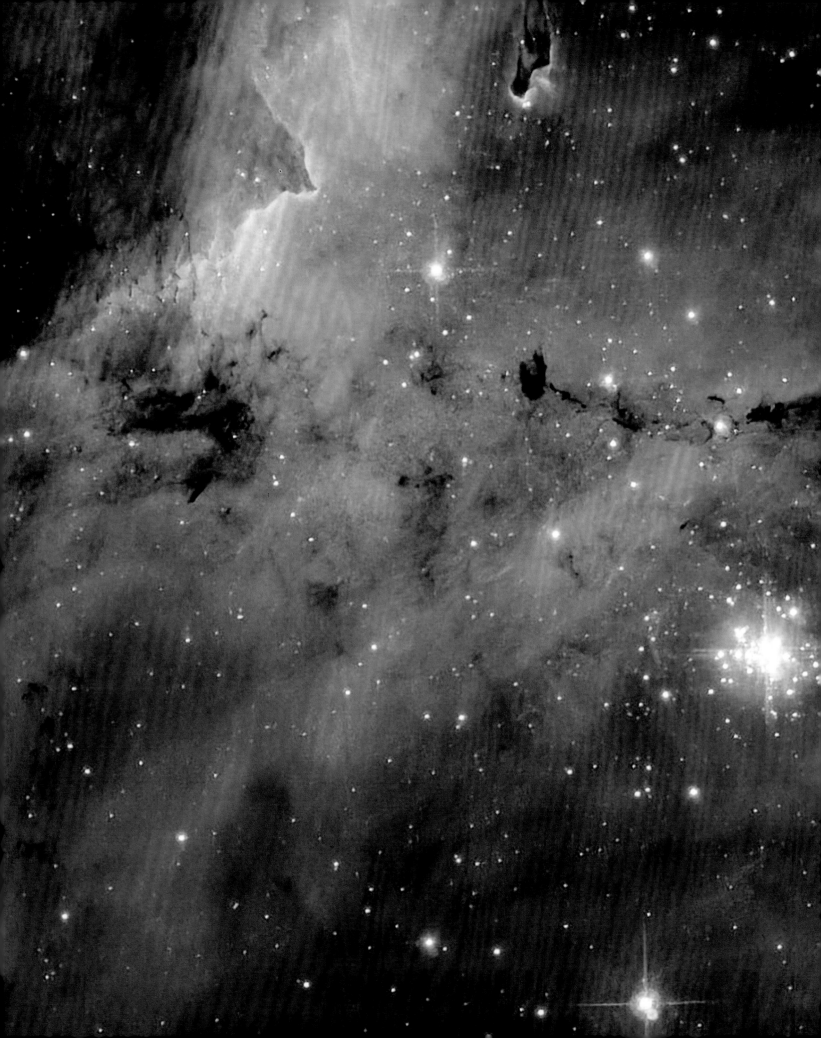

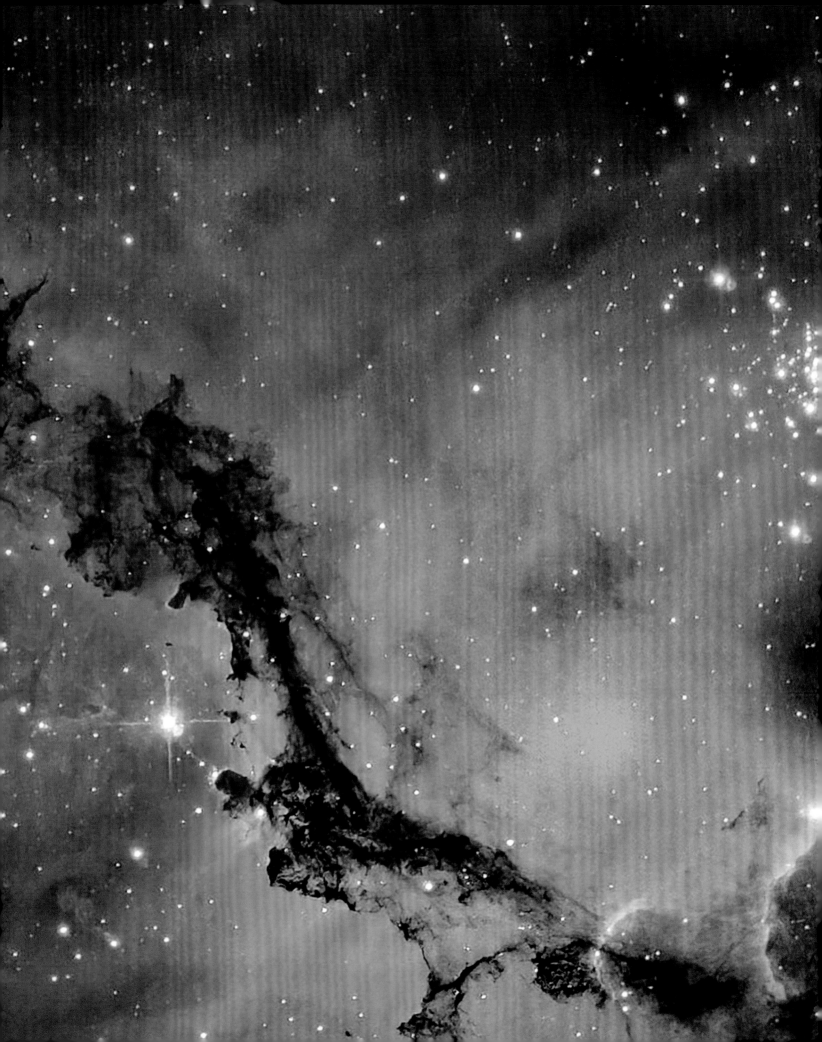

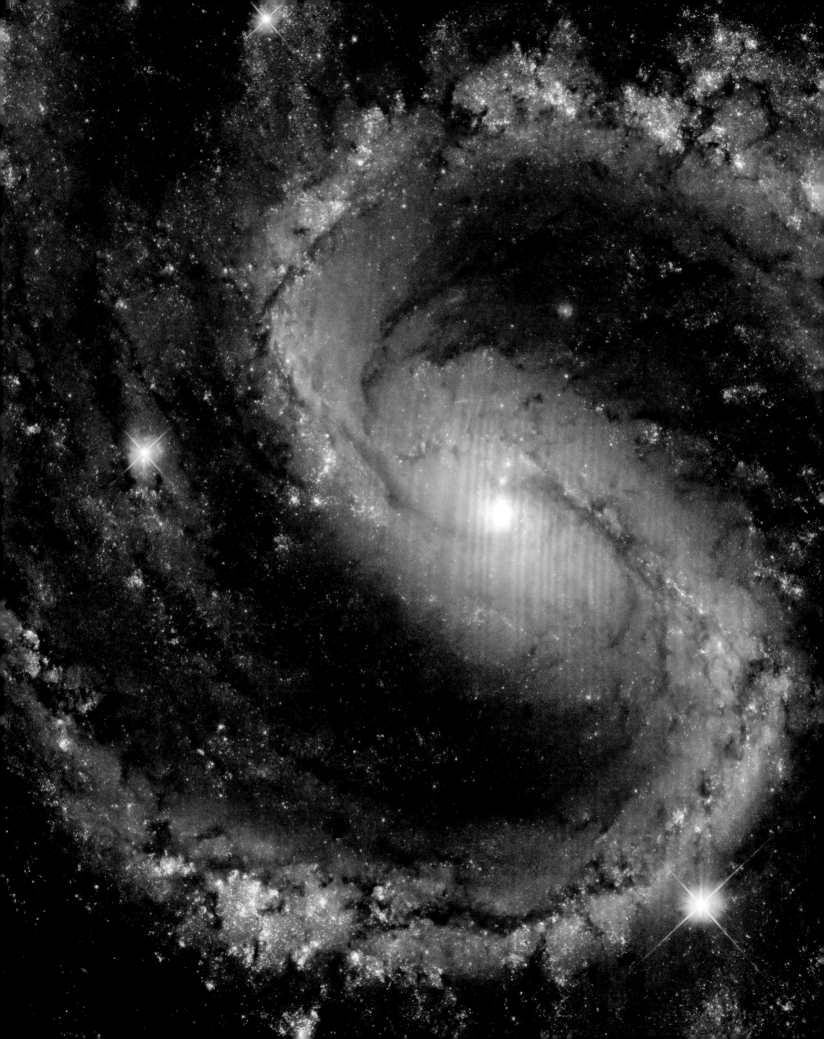

LOST GALAXY

This spectacular Hubble view of the spiral galaxy known as NGC 4535—also dubbed the "Lost Galaxy," due to its hazy appearance when viewed with a smaller telescope—has so many of the compositional elements that I consider essential to space photographic art. It is beautifully framed on the object of interest; that object displays appealing and graceful symmetries of line and shape; there are foreground and background elements that suggest depth and form; and the scene displays a pleasing range of vibrant hues. Some of these elements are also scientifically important. The galaxy is technically a "barred" spiral, with its main curved spiral arms emerging from the ends of a linear bar of stars that pierces the central core. And color here is an indicator of both stellar and galactic evolutionary processes. Bright blue clusters of hot young stars, bunched within the central bar and spiral arms, show where active star formation is currently occurring in this galaxy. Star formation is enhanced in those dynamic environments by compression and piling up of the gas and dust as the bar and arms rotate. By contrast, the brownish-yellow regions, especially in the central core, reveal older and cooler populations of stars, perhaps among the first generation to form this galaxy. It is a view both gorgeous and compelling, and worthy of artistic consideration.

An image of the spiral galaxy NGC 4535, or "Lost Galaxy," taken by Hubble and released on January 21, 2021.

COLLIDING GALAXIES

Galaxies are among the largest, fastest-moving structures in the Universe, and so it is not surprising that when they collide, the results are dramatic and profound. This wonderful Hubble photo, opposite, captures what appear to be the early phases of such a titanic collision. These two galaxies, more than 100 million light-years distant and known collectively as Arp 91 in Harlan Arp's *Atlas of Peculiar Galaxies*, are both spiral galaxies made from hundreds of billions of stars each. The lower one is seen nearly face-on and the upper one is seen nearly edge-on, from our perspective. The photo shows the enormous gravity of the lower galaxy beginning to distort and bend one of the spiral arms of the upper galaxy downward. Like a slow-motion replay of an automobile crash test, galaxy collisions take a long time to unfold and evolve—hundreds of millions of years, in fact. How this crash will end is uncertain, but some computer simulations predict that such collisions result in the merger of the two galaxies to form a new elliptical galaxy without any spiral arms. This is space photography as crime scene or natural disaster documentation, though it will still be a long time before all the damage is done.

OPPOSITE: The pair of spiral galaxies known as Arp 91 on their slow collision course, photographed by Hubble and released on October 8, 2021.

SPIRAL GIANT

Spirals are among the most lovely and graceful shapes in nature; they occur over an enormous range of size scales, from microscopic to immense. The largest natural spirals occur within spiral galaxies—disks of hundreds of billions or more stars, all spinning together, around and around like a pinwheel. Our own Milky Way is a spiral galaxy, and it took our civilization a long time to figure that out from our vantage point inside that spiral. The incredible Hubble photo on pages 194–95 shows another spiral galaxy, called UGC 2885, located 232 million light-years away in the constellation Perseus. While outwardly similar to other spirals, like the Andromeda Galaxy or the Milky Way, this one has an important difference: size. UGC 2885 is the largest spiral galaxy yet found in the Universe, two and a half times wider than our Milky Way and packed with upward of a trillion stars. "How it got so big is something we don't quite know yet," says University of Louisville astronomer Benne Holwerda in a NASA press release about the image. Holwerda led the effort to photograph it with Hubble. "It's as big as you can make a disk galaxy without hitting anything else in space." Astronomers are eager to study this and other distant galaxies with NASA's new James Webb Space Telescope, taking infrared photos to peer through their dusty shrouds.

FOLLOWING PAGES: The largest spiral galaxy ever discovered, UGC 2885, shown in a Hubble image released on January 5, 2020.

EINSTEIN RINGS

Cameras work because lenses can bend light rays and bring them to a focus on a planar surface like a piece of film or a digital sensor. The rays of light are bent because they have to travel from air (or the vacuum of space) into and through a different material where the speed of light is different. In glass camera lenses, for example, the speed of light is about 33 percent slower than in air or in a vacuum. Amazingly, early twentieth-century physicists, including Albert Einstein, realized that enormous amounts of mass can act like a lens, too, bending rays of light because of the way mass bends the fabric of space. The effect is small and requires galaxy-scale amounts of mass to detect, but finally, in the late 1990s, the first such examples of "gravitational lensing" were observed using the Hubble Space Telescope. This amazing deep space Hubble photo shows a more recent example of this strange and rare phenomenon, GAL-CLUS-022058s, where the massive gravity of a foreground galaxy is acting like a lens to distort the image of a more distant background galaxy into a long and graceful arc. Such arcs are dubbed "Einstein rings" in honor of one of the pioneers who predicted their existence more than a century ago.

Hubble image of the Einstein ring GAL-CLUS-022058s, released on December 14, 2020.

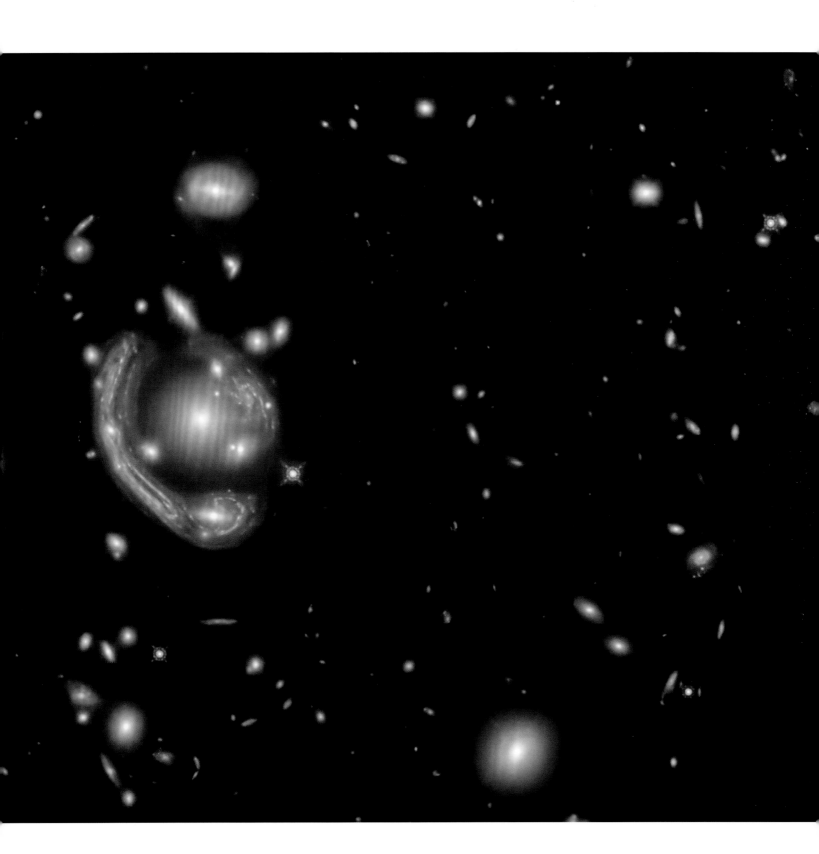

HUBBLE eXtreme DEEP FIELD

What defines the limits of space photography? How far can we see? Because of the finite speed of light, seeing farther away means looking farther back in time. Astronomers use the word *deep* to describe photos intended to capture the most distant objects possible. The deepest imaging requires the largest telescopes, the clearest skies, and the longest exposures, so for more than 30 years that has meant using the Hubble Space Telescope. Over the decades, Hubble has photographed successively deeper into space and time, first with the "Deep Field" campaign, then the "Ultra Deep Field" campaign, and then the "eXtreme Deep Field" campaign, the result of which is shown here. This stunning photo covers just 0.000003 percent of the entire sky and represents over *two million seconds*—more than 23 days spread over four different years—of exposure time on that tiny patch. As such, it is the deepest space photograph ever taken. Stunningly, every one of the more than 5,500 objects seen here is a galaxy, some of them dating back to 13.2 billion years ago, and each of those galaxies harbors hundreds of billions of stars and at least that many planets. The power of this photo, to me, is that it compels us to ask, "In all of that, how can we possibly be alone?"

Hubble eXtreme Deep Field photo—the deepest image of the Universe ever made, created from a combination of photos taken in 2002, 2003, 2009, and 2012.

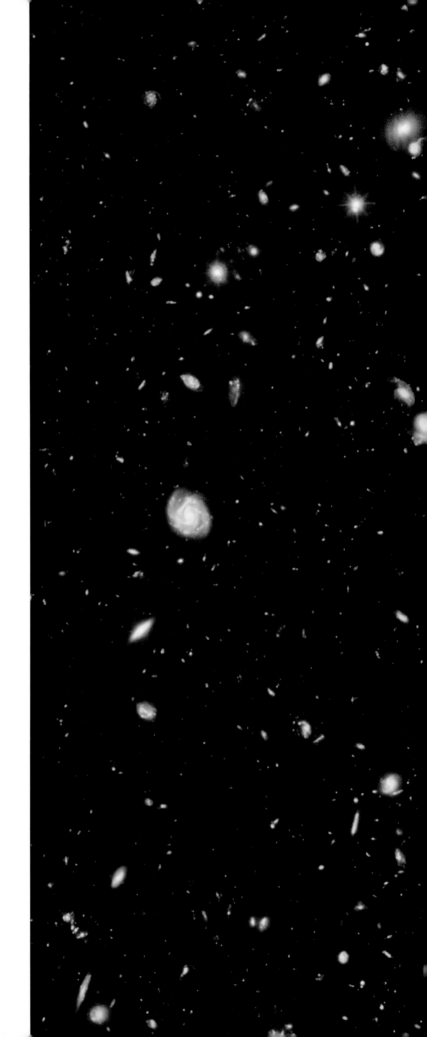

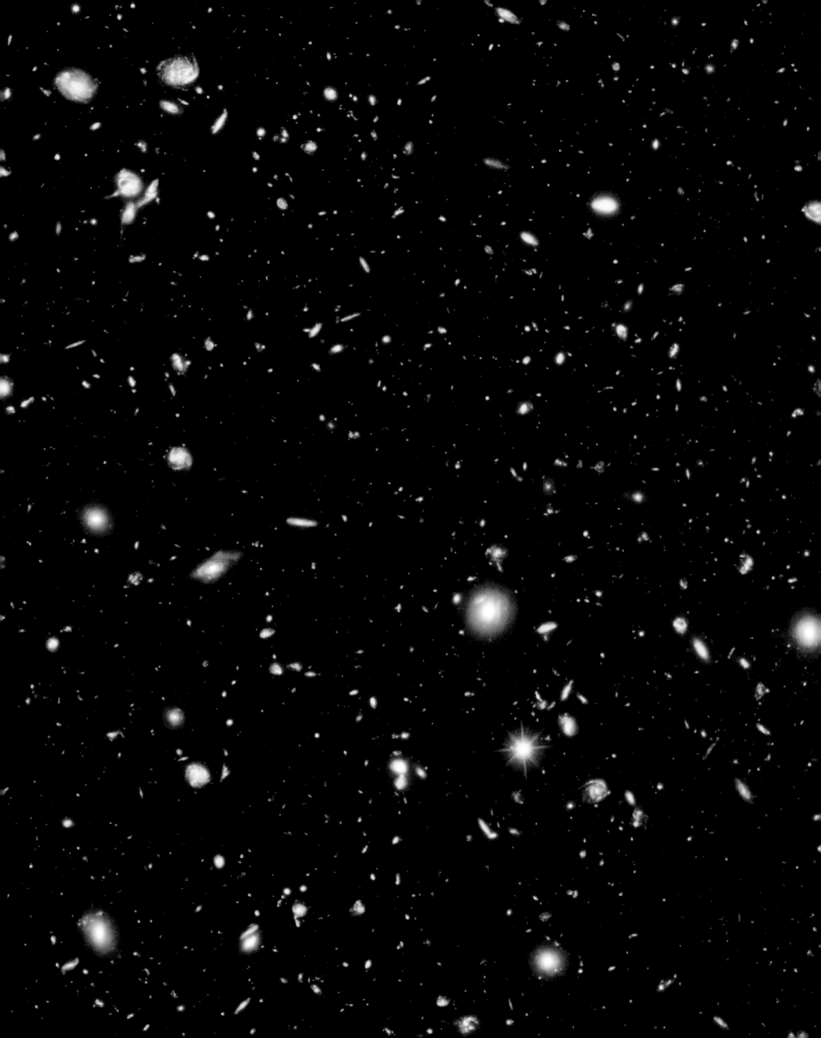

ACKNOWLEDGMENTS

Art is in the eye of the beholder, for which I am thankful because everyone beholds differently. For their support of the particular perspectives and biases that I bring to my interpretation of photographic space art, I am extremely grateful to my support team at Union Square & Co.: my editor, Barbara Berger; photography editor Linda Liang; and interior designer/creative operations director Kevin Ullrich. These colleagues have embraced this project, contributed important and meaningful scrutiny, assessment, and edits, and have shown infinite patience as I struggled to meet my deadlines. Also at Union Square & Co., I am grateful to cover designer Igor Satanovsky, project editor Michael Cea, and production director Kevin Iwano. And I continue to benefit enormously from the seemingly endless supply of support and encouragement for my space photography projects from my literary agent Michael Bourret from Dystel, Goderich & Bourret.

I also want to extend a broad and sweeping arc of immense gratitude to the hundreds of thousands of people who have worked in the academic, commercial, and government space exploration communities since the 1960s. Their work has rewritten the scientific textbooks many times over, has brought new knowledge and technologies from the space program into the classroom and the mainstream consumer economy, and has created both historic and impactful art. As a kid I was inspired and motivated to pursue a career in science and space by the many gorgeous and artistic photos being taken by team members of missions like Voyager and Viking. What an unbelievable thrill it is to now be part of that community! Pinch me.

Finally, to my sweetheart, Jordana Blacksberg: Thank you for helping me to recognize beauty in everything big and small, for being an endless source of love and support, and for sacrificing so much of our nights and weekends time while I worked to get this latest book project to the finish line. Another life, another galaxy . . .

—Jim Bell
Tempe, Arizona
April 2022

A blazing starry sky illuminates the desert around Cerro Paranal mountain, home to ESO's Very Large Telescope (VLT) in the Atacama Desert of Chile. The bright column is due to zodiacal light, sunlight reflected from cometary dust.

REFERENCES AND NOTES

INTRODUCTION

Elliot Erwitt / x
This quote from noted photographer Elliot Erwitt is from his book *Museum Watching* (New York: Phaidon, 1999).

Mars "Santa Cruz" Hill / x–1
You can find more details about this particular photo at https://mars.nasa.gov/resources/26567/chal-type-rocks-at-santa-cruz/.

Sunset on Mars / 2–3
Learn more about this particular photo at https://photojournal.jpl.nasa.gov/catalog/PIA19400.

Garish Mars / 5
NASA's Mars *Odyssey* spacecraft has been operating in orbit for more than 20 years now, making it the longest-running Mars mission in space exploration history. You can learn about the mission's major discoveries and see lots more spectacular THEMIS photos at the mission's website: https://mars.nasa.gov/odyssey.

Buzz Aldrin on the Moon / 6
The Swedish-based Hasselblad camera company has a fabulous web page called "Hasselblad in Space" that provides a detailed description and history of their many off-world photographic systems, including the 70-mm color film camera used to take this photo. Visit the site at: www.hasselblad.com/inspiration/history/hasselblad-in-space.

Chesley Bonestell / 7
For more information and details on the life and work of Chesley Bonestell, see Ron Miller and Frederick C. Durant III, *The Art of Chesley Bonestell* (London: Paper Tiger, 2001).

Étienne Léopold Trouvelot / 6, 8–9
A video about Trouvelot's fascinating astronomical drawings can be seen here: www.youtube.com/watch?v=pB7nCeAwhYg. It was created by the Huntington Library and Art Museum in San Marino, California, in conjunction with their 2018 exhibition on the artist, *Radiant Beauty*. The New York Public Library also has the full collection of Trouvelot's lithographs online, which you can view here: https://digitalcollections.nypl.org/collections/the-trouvelot-astronomical-drawings-atlas#/?tab=about.

Fraser Hagen / 10–11
For more examples of the work of graphic artist Fraser Hagen, see his web page at www.artstation.com/fraserhagen.

Josh Simpson—Planets / 10, 13
Check out more of Josh Simpson's fabulous glassblowing art at www.megaplanet.com.

Ika Abuladze / 10, 12
See more examples of Ika Abuladze's digital art at https://imgur.com/user/IkaAbuladze/posts.

Ansel Adams / 14
The quotes and wisdom from Ansel Adams, one of the most acclaimed photographers of all time, come from his book *Camera and Lens: The Creative Approach* (New York: Morgan & Morgan, 1970), 14–15.

Perseverance / 15
NASA posts the raw photos streaming back from the *Perseverance* rover every day in near-real-time as they are downlinked from Mars at this website: https://mars.nasa.gov/mars2020/multimedia/raw-images. This specific one can be found at https://mars.nasa.gov/mars2020/multimedia/raw-images/ZL0_0346_0697660713_072EBY_N0092982ZCAM05066_0340LMJ.

Comet NEOWISE / 16
A wonderful gallery of images, history of discovery and observations, and links to scientific details about Comet NEOWISE can be found on its Wikipedia page, at https://en.wikipedia.org/wiki/Comet_NEOWISE.

Crab Nebula / 17
Read more about this image at www.nasa.gov/jpl/herschel/crab-nebula-pia17563.

California Nebula / 19
To view this and other beautiful astronomical images by Luca Remidone, visit www.flickr.com/photos/29516307@N06.

GENERAL

Space Travel Posters
To view examples of wonderful Art Deco space travel posters, check out these sites:
NASA/JPL: www.jpl.nasa.gov/galleries/visions-of-the-future
Tyler Nordgren: www.tylernordgren.com/planetary-parks
Steve Thomas: www.art.com/gallery/id--a710578/steve-thomas-posters.htm
SpaceX: www.flickr.com/photos/spacex/17504334828/in/photostream, www.flickr.com/photos/spacex/17504602910/in/photostream, and www.flickr.com/photos/spacex/17071818163/in/photostream.

International Association of Astronomical Artists/Spacefest
To learn more about the International Association of Astronomical Artists, including a gallery showcasing the work of many IAAA members, visit https://iaaa.org. And to learn more about the annual Tucson space art festival Spacefest, visit www.spacefest.info.

Hubble Space Telescope Images
For a glimpse at many earlier and just-as-spectacular examples of Hubble Space Telescope images, as well as some of the science behind imaging with Hubble, check out NASA's Hubble home page at https://hubblesite.org as well as my book *Hubble Legacy: 30 Years of Discoveries and Images* (New York: Union Square & Co., 2020).

PART 1: CLOSEST TO THE SUN

Earth Selfie / 19–20, 22 (left)
A nice historical summary of NASA's *Lunar Orbiter 1*, "America's First Lunar Satellite," can be found online at: www.drewexmachina. com/2016/08/14/lunar-orbiter-1-americas-first-lunar-satellite/. Also, more details on the Lunar Orbiter Image Recovery Project can be found at: https://en.wikipedia.org/wiki/Lunar_Orbiter_Image_ Recovery_Project.

Sun Flowers / 22 (right)–23
A fun one-minute-long YouTube video showing some additional spectacular examples of the amazing resolution of the Swedish Solar Telescope can be found at www.youtube.com/watch?v=_- FuWI8GRk8.

Rare Suns / 24–25
25 top right: Learn more about Seán Doran's background and work on the BBC *Sky at Night* online profile at www.pressreader.com/uk/ sky-at-night-magazine/20210520/283068417192732.

25 bottom right: Many more great photos of Venus crossing the Sun can be found on NASA's Solar Dynamics Observatory Venus transit site at https://svs.gsfc.nasa.gov/vis/a010000/a010900/a010996/index. html.

Great American Eclipse / 26–27
To see many more examples of amazing solar eclipse photography from Williams College Professor Jay Pasachoff and his colleagues, visit https://sites.williams.edu/eclipse.

Annular Eclipse / 28–29
Personal stories and more great photos of the annular solar eclipse of February 2017 can be found in this *Sky & Telescope* article: https:// skyandtelescope.org/astronomy-news/feb-2017-annular-eclipse- reports.

Sunlight Spire / 30–31
For more background and details about the June 2021 annular solar eclipse, see the online *Astronomy* magazine article at https://astronomy. com/magazine/news/2021/11/flying-into-junes-ring-of-fire-eclipse.

Mercurial Mosaic / 32–33
"MESSENGER" is a forced acronym for this NASA Mercury orbiter mission, standing for "Mercury Surface, Space Environment, Geochemistry and Ranging." You can find more details about this particular photo at: www.nasa.gov/image-feature/unmasking-the- secrets-of-mercury.

Venus Cloud Layers / 34–35
For more information and details on Damia Bouic's image-processing work with the images from the Japanese Venus *Akatsuki* orbiter mission, visit www.db-prods.net/blog/2017/12/22/un-nouveau- regard-sur-venus-avec-akatsuki/ (note, site in French).

Anenome of Venus / 36–37
For a wonderful introduction to the NASA *Magellan* Venus radar mapping mission, and the strange, wonderful, and beautiful geology of Venus, check out planetary scientist David Harry Grinspoon's book, *Venus Revealed: A New Look Below the Clouds of Our Mysterious Twin Planet* (New York: Basic Books, 1998).

Cosmic Fireflies / 38–39
You can find more details about this particular photo at www.nasa.gov/ feature/goddard/2021/parker-solar-probe-offers-a-stunning-view-of- venus.

Venusian Surface / 40–41
Donald P. Mitchell maintains a fascinating web site dedicated to chronicling and filling in missing details about the early Soviet robotic Venus exploration program at http://mentallandscape.com/ V_Venus.htm.

Earth Airglow / 42–43
You can find more details about this particular photo at www.nasa.gov/ image-feature/earth-enveloped-in-airglow.

Space Station Auroras / 44–47
ESA astronaut Thomas Pesquet maintains a spectacular Flickr feed of glorious photos that he has shot from space here: www.flickr. com/photos/thom_astro; the Space.com article "Astronauts Capture Stunning Aurora from International Space Station" (www.space.com/ space-station-auroras-october-2021) includes details and spectacular videos of the glorious cosmic phenomena, including this one photographed by NASA astronaut Shane Kimbrough.

Auroral Display, Michigan / 48–49
For many more gorgeous examples of Shawn Malone's beautiful photographs of auroras, visit her online gallery at: https://galleries. lakesuperiorphoto.com/gallery/Northern-Lights-Aurora- photography-from-the-Upper-Peninsula-of-Michigan-Gallery/ G0000o7ySHutM5BQ/.

Colors of the Moon / 50–51
Italian astrophotographer Marcella Giulia Pace maintains a wonderful portfolio of her space photographic art online at https://greenflash. photo/greenflash-gallery/greenflash-gallery/portfolio. The *Colors of the Moon* photo featured here was also featured as NASA's "Astronomy Picture of the Day" on November 11, 2020, at https://apod.nasa.gov/ apod/ap201111.html. NASA's "Astronomy Picture of the Day" is a great site (and smartphone app!) to visit to be continually reminded of the artistic beauty of the cosmos.

Tycho / 52–53
Visit this website for additional background and interactive details about this spectacular high-res photo of the lunar surface: http://lroc. sese.asu.edu/posts/902.

Lunar Portraits / 54–57
54: NASA's online *Apollo Lunar Surface Journal* at www.hq.nasa.gov/ alsj/main.html provides minute-by-minute transcripts and links to photos and movies taken by the Apollo astronauts while they were on the Moon. The site for the Apollo 14 transcript and links, for example, is at www.hq.nasa.gov/alsj/a14/a14-prelim1.html. This particular shot was taken around mission elapsed time 114:57:20 in the transcript.
55: You can find more historical details about NASA's *Surveyor* lunar lander missions at https://en.wikipedia.org/wiki/Surveyor_program.
56: Additional photos and stories about the Apollo 14 mission can be found on NASA's fiftieth-anniversary site for the mission, at: www.nasa. gov/feature/50-years-ago-apollo-14-lands-at-fra-mauro.
57: Additional details on this specific photo can be found at http://lroc. sese.asu.edu/posts/992. More generally, back in 2016, the Smithsonian Institution's National Air and Space Museum featured an art show of

similarly spectacular photos of the Moon from the NASA/ASU *Lunar Reconnaissance Orbiter* camera team. Photos from that show are archived online at https://airandspace.si.edu/exhibitions/lroc/online/.

Family Portait / 58–59

Australian radio communications engineer Hamish Lindsay was a member of the NASA Honeysuckle Creek Tracking Station in Australia that helped relay Apollo astronaut communications from the Moon to mission control in Houston. He's written and posted a wonderful series of online essays here with his recollections of the historic events of those missions: https://honeysucklecreek.net/msfn_missions/index.html. His Apollo 16 essay, in particular, can be found here: https://honeysucklecreek.net/msfn_missions/Apollo_16_mission/hl_apollo16.html.

PART 2: MARS AND SMALL BODIES OF THE SOLAR SYSTEM

Martian River Beds / 60–61, 62 (left)

If you've always wanted to take a photo of Mars, here's your chance! *Mars Reconnaissance Orbiter* (MRO)/High Resolution Imaging Science Experiment (HiRISE) team leader Alfred McEwen and colleagues have created the HiWish website where you can suggest new targets for team to photograph on the Red Planet. Sign up at www.uahirise.org/hiwish.

Polygonal Terrain / 62 (right)–63

You can find more details about this particular photo at www.uahirise.org/ESP_016641_2500.

Great Dune Sea (64–65)

For many more examples of photographic space art from both the *Spirit* and *Opportunity* NASA Mars rover missions, plus lots of stories about how and why those photos were taken, check out my book *Postcards from Mars: The First Photographer on the Red Planet* (New York: Dutton, 2006).

Mars Selfie I / 66–67

Visit this website for additional background and details about this photo: https://photojournal.jpl.nasa.gov/catalog/PIA19806.

Mars Selfie II / 68–69

More background and details about this photo can be found at https://sci.esa.int/web/rosetta/-/54869-rosetta-self-portrait-at-mars.

Lanikai / 70–71

Visit this web site for more examples and details of close-up photos of sand and pebbles on Mars: https://photojournal.jpl.nasa.gov/catalog/PIA05651.

Core of the Hole / 72 (left)

You can find more details about this particular photo at https://photojournal.jpl.nasa.gov/catalog/PIA24796.

Pancam Avatar / 72 (right)–73

For a delightful essay on why "cuteness" matters for Mars rovers and other deep space robotic missions, see the 2011 article on the subject by planetary scientist and rover team member Melissa Rice, "The *Spirit* Rover, and Why Cuteness Matters" at https://www.planetary.org/articles/3065.

Mars in Scale / 74–75

You can follow along with the day-to-day traverse of the NASA rover *Curiosity* on Mars by visiting NASA's "Where Is Curiosity?" page at: https://mars.nasa.gov/msl/mission/where-is-the-rover.

HiRISE Enigmas / 76–77

Artist Seán Doran has put together a wonderful movie called *MARS—Real Colors of the Red Planet*, featuring spectacular NASA MRO/HiRISE photos of Mars and posted at: www.youtube.com/watch?v=FMb9yqdVML8.

77 top: This particular photo is based on original data and information posted at https://hirise.lpl.arizona.edu/PSP_007726_2565.

77 center: For additional background and details about this photo visit https://mars.nasa.gov/mro/multimedia/images/?ImageID=7142.

77 bottom: More background and details about this photo of "spider-like terrain" can be found at https://www.uahirise.org/ESP_038386_0930.

Kodiak Butte / 78–79

A little more detail about this photo, one of my Mastcam-Z "Team Favorites" so far, can be found on the Mastcam-Z public web site at: https://mastcamz.asu.edu/galleries/kodiak-dawn.

Peeling Back the History of Mars, One Layer at a Time / 80

For anyone who keeps up with space photography via Twitter, I highly recommend following NASA's Mars Science Laboratory *Curiosity* rover's feed: @MarsCuriosity for examples of that rover's continuing mission of exploration climbing Mount Sharp in Gale crater.

Surface / 81

Mars rover image-processing expert Justin Maki from NASA's Jet Propulsion Laboratory put together a great online compilation of all of the time-lapse photographs of the *Sojourner* rover taken by the camera on the 1997 Mars Pathfinder lander: https://mars.nasa.gov/MPF/ops/rvrmovie.html; see next entry for more on Ted Stryk.

Phobos and Mars / 82–83

A wonderful collection of Ted Stryk's specially processed photos of Mars and Phobos from the Soviet *Phobos-2* probe mission can be found at https://web.archive.org/web/20150717180620/http://www.strykfoto.org/phobos2.htm.

Mount Sharp / 84–86

To keep up with the ongoing mountain climbing by the *Curiosity* rover on Mars, including great new photos and personal stories from team members, visit NASA's "Mission Updates" blog site at https://mars.nasa.gov/msl/mission-updates.

Farewell to Mars / 87

More information about NASA's MarCO mission can be found on the Mars Cube One web site, at https://www.jpl.nasa.gov/missions/mars-cube-one-marco. Also, more details about this specific photo can be found at https://photojournal.jpl.nasa.gov/catalog/PIA22833.

Vesta Crater I / 88–89

More details on this photo can be found at https://photojournal.jpl.nasa.gov/catalog/PIA17662. Also, there's a wonderful series of blogs with more nformation about NASA's Dawn mission by mission director and chief engineer Marc Rayman, hosted by The Planetary

Society (the world's largest public space advocacy organization) at www.planetary.org/articles?listauthor=marc-rayman.

Vesta Crater II / 90–91
More background about this photo can be found at https://photojournal.jpl.nasa.gov/catalog/PIA17661.

Ceres Ice / 92–93
Visit this website for additional background and details about this photo https://photojournal.jpl.nasa.gov/catalog/PIA20353.

Ceres Salt Mountain / 94
You can learn more about this particular photo at https://photojournal.jpl.nasa.gov/catalog/PIA21924.

Bennu / 95
For more on the *OSIRIS-REx* probe mission's "touch-and-go" sampling of asteroid Bennu, including a time-lapse photo video, see: www.nasa.gov/feature/goddard/2020/osiris-rex-tags-surface-of-asteroid-bennu.

Zagami Section / 96–97
To learn more about meteorites and see additional spectacular photos of these space rocks, visit Arizona State University's Buseck Center for Meteorite Studies site at https://meteorites.asu.edu.

Murchison X-Ray / 98–99
More details about this photo, as well as general information about the meteorite collection at the Natural History Museum in London, can be found at: www.psrd.hawaii.edu/July09/Meteorites.London.Museum.html.

Shadow and Light / 100–101
100 (left): You can check out more great examples of specially processed deep space photography at Justin Cowart's Flickr page, at https://www.flickr.com/photos/132160802@N06.
100 (top right): For more details on this photo, and on the astrobiology science of the *Rosetta* mission, check out this ESA media story at www.esa.int/Science_Exploration/Space_Science/Rosetta/Rosetta_s_comet_contains_ingredients_for_life.
100 (bottom right): The European Space Agency's *Rosetta* website archives lots of photos, stories, and scientific results from that amazing comet rendezvous and lander mission, at https://rosetta.esa.int.

Cliff Jumping / 102–3
Visit this website for additional background and details about this photo: www.esa.int/ESA_Multimedia/Images/2014/12/Comet_on_10_December_2014_NavCam.

Neowise over Great Salt Lake / 104–5
For more amazing space (and other) science photographs, follow University of Utah Department of Neurobiology & Anatomy professor Jason Shepherd on Twitter at @JasonSynaptic. Also see https://attheu.utah.edu/facultystaff/comet-neowise-lit-up-skies-and-social-media/ for more images of Neowise taken in Utah.

PART 3: OUTER SOLAR SYSTEM WORLDS OF GAS AND ICE

Jupiter's Eye / 106–7, 108 (left)
Visit Icelandic planetary image-processing expert Björn Jónsson's website at https://bjj.mmedia.is for other spectacular specially processed and rendered space images, mosaics, animations, and how-to tips for creating great digital space art.

Jupiter and Io in Transit / 109
This and other spectacular examples of great solar system space photos can be found in The Planetary Society's online Bruce Murray Space Image Library at www.planetary.org/space-images.

Clouds of Jupiter / 110–11
See Planetary Society editor Rae Paoletta's article "The Best Jupiter Pictures from NASA's *Juno* Mission" at https://www.planetary.org/articles/best-jupiter-pictures-nasa-juno-mission, for more details on this and other amazing photos.

Dynamic Currents / 112–13
Many more wonderful examples of photos and movies from NASA's *Juno* Jupiter orbiter mission are posted on artist Seán Doran's YouTube channel at www.youtube.com/channel/UC28l88GMXXqZYfY0Ru9h50w.

Moons of Jupiter / 114–15
115 top: You can find more details about this particular photo at https://solarsystem.nasa.gov/resources/105/ridges-and-fractures-on-europa/?category=missions_galileo.
115 bottom: You can find more details about this particular photo at https://photojournal.jpl.nasa.gov/catalog/PIA01618.

Jovian South Pole / 116–17
Find out more about this stunning composite photo and the science of NASA's *Juno* Jupiter orbiter mission online at: https://go.nasa.gov/2rEgNhT.

Saturn, Titan, and Dione / 118–19
More background and details about this photo can be found at https://photojournal.jpl.nasa.gov/catalog/PIA14910.

Convergence / 120–21
For more on this image, see https://photojournal.jpl.nasa.gov/catalog/pia17171. A fascinating account of the famous "Pale Blue Dot" photo of the Earth and other planets from beyond the orbit of Neptune using the *Voyager 2* camera can be found in astronomer and science communicator Carl Sagan's book *Pale Blue Dot: A Vision of the Human Future in Space* (New York: Ballantine, 1997).

Titan Shadow / 122–123 (left)
See more specially processed deep space photography at Justin Cowart's Flickr page, at https://www.flickr.com/photos/132160802@N06.

Rings of Ice / 123 (right)–125
Visit this website for additional background and details about this photo: https://photojournal.jpl.nasa.gov/catalog/PIA21628.

B-Ring Shadows / 126–27
For additional background and details about this photo, see https://solarsystem.nasa.gov/resources/15115/the-tallest-peaks.

Hyperion / 128 (left), 129
For pure facts and figures and more great photos of Saturn's sponge-like moon Hyperion, check out its Wikipedia page at: https://en.wikipedia.org/wiki/Hyperion_(moon).

Titan Lakes / 128 (right), 130–31
The fascinating story behind the creation of this beautiful radar photo of Titan is told by space image-processing expert Ian Regan on The Planetary Society's blog, at www.planetary.org/articles/my-18-month-affair-with-titan.

Saturn-Titan Composite / 132–33
Details about this photo, including the original monochromatic wide-angle view from which Ian Regan started his gorgeous color composite rendering can be found here: https://photojournal.jpl.nasa.gov/catalog/PIA06225.

Pan Montage / 134 (left), 135 (left)
This great online story by Alan Boyle from GeekWire—"It's a UFO! It's a Walnut? No . . . It's Pan . . ." provides more details about why small moons like Pan that are orbiting in or near Saturn's rings have such weird "bulges" around their equatorial regions: www.geekwire.com/2017/ufo-walnut-pan-saturn-cassini.

Mimas / 134 (right), 135 (right)
Image-processing expert Jason Major features numerous links to news stories and many examples of his beautiful space photography work on his blog site, at https://lightsinthedark.com/. Also visit him on Twitter at @JPMajor.

Saturn Hexagon / 136–37
You can watch Saturn's enigmatic polar hexagon clouds rotate in a fascinating "Four Days on Saturn" YouTube video from NASA's *Cassini* Saturn orbiter mission, at www.youtube.com/watch?v=Q_T0z5B9IjU.

Saturn's Rings: Time Lapse / 138–39
Many more examples of Alan Friedman's wonderful space photography work can be found on his blog, at https://avertedimagination.squarespace.com.

Uranus and Epsilon Ring / 140–41
You can see this and other images by image-processing expert Ian Regan at www.flickr.com/photos/10795027@N08. For a wonderful and award-winning film by director Emir Reynolds about the incredible photography and discoveries from the *Voyager* missions, I highly recommend *The Farthest: Voyager in Space.* The PBS version of the film is available online at www.pbs.org/video/the-farthest-voyager-in-space-qpbu4y/. (Full disclosure—I have a small cameo role, as I got my start in the space mission–photography business as an undergraduate working with a wonderful mentor named Ed Danielson, one of the designers of the *Voyager* cameras and members of the *Voyager* camera team.)

Verona Rupes on Miranda / 142–43
Learn more about this photo at https://photojournal.jpl.nasa.gov/catalog/PIA01354. For details and illustrations of my predictions about "interplanetary parks" across the solar system that will be visited by future space tourists, check out my book *The Ultimate Interplanetary Travel Guide* (New York: Union Square & Co, 2018).

Neptune and Triton / 144–45
The Neptune flyby was the last "port of call" in our solar system for the *Voyager* mission. For information on these and other photos from the mission, see https://voyager.jpl.nasa.gov/galleries/images-voyager-took/neptune/. To learn more about *Voyager*'s follow-on "interstellar" mission, check out my book *The Interstellar Age: Inside the Forty-Year Voyager Mission* (New York: Dutton, 2015).

Pluto Crescent / 146–47
You can find more details about this particular photo at https://photojournal.jpl.nasa.gov/catalog/PIA19948.

Zigzagging Across Pluto / 148–49
148–49 bottom: See more on this image here: https://solarsystem.nasa.gov/resources/212/zigzagging-across-pluto/?category=planets/dwarf-planets_pluto.
149 top: Visit www.planetary.org/space-images/pluto-in-colorized-infrared for more information.

PART 4: COSMIC FRONTIERS

Cosmic Reef / 150–51, 152 (left)
This photo was released to commemorate the thirtieth anniversary of the Hubble Space Telescope. You can find more details about it at https://hubblesite.org/contents/news-releases/2020/news-2020-16

HL Tauri / 152 (right)–153
More background and details about this photo can be found at www.eso.org/public/news/eso1436/

Galaxy UGC 1810 / 154–55
This photo was featured on May 10, 2017, as NASA's "Astronomy Picture of the Day"; see https://apod.nasa.gov/apod/ap170510.html.

Stellar Snowflakes / 156–57
Learn more about this photo at https://www.nasa.gov/image-feature/goddard/2020/hubble-catches-cosmic-snowflakes.

LL Pegasi / 158–59
It was really helpful for me to see a computer graphics reconstruction of what this spectacular space spiral looks like in three dimensions: www.eso.org/public/videos/potw1710a/.

AG Carinae Explosion / 160–61
This photo was released by NASA to commemorate the thirty-first anniversary of the launch of the Hubble Space Telescope. Further information about this gorgeous photo and spectacular erupting star can be found in the press release at https://hubblesite.org/contents/media/images/2021/017/01F3N8X6NC69Y1ME5AXW3AGFG8.

Butterfly Nebula / 162–63
Details and the science behind this and other photos of nebulae formed from "puffing stars" can be found at https://hubblesite.org/contents/news-releases/2020/news-2020-31.

Herbig-Haro Object / 164–65
For additional background and details about this photo visit www.nasa.gov/image-feature/goddard/2021/hubble-snaps-speedy-star-jets.

Cosmic Sunset / 166–67
For more on the science behind this photo, check out the news release at https://hubblesite.org/contents/news-releases/2020/news-2020-58.

Stellar Nursery / 168–69 (left)
More background and details about this photo can be found at www.nasa.gov/image-feature/goddard/2020/hubble-snaps-a-special-stellar-nursery.

Shock Wave / 169 (right)–171
For additional background and details about this photo visit www.nasa.gov/image-feature/goddard/2020/hubble-views-edge-of-stellar-blast.

Running Man Nebula / 172–73
You can find more details about this particular photo at www.nasa.gov/image-feature/goddard/2021/hubble-witnesses-shock-wave-of-colliding-gases-in-running-man-nebula.

Prawn Nebula / 174–75
More details about the Prawn Nebula, including a wide-angle ground-based telescope photo of the full extent of the gas and dust cloud, can be found at www.nasa.gov/image-feature/goddard/2021/hubble-catches-celestial-prawn-drifting-through-the-cosmic-deep.

Flame Nebula / 176–77
Many of the astronomical objects featured in the New General Catalog, especially the more well-known ones, also have Wikipedia pages with additional facts, figures, and photos. The one for the Flame Nebula, for example, is at https://en.wikipedia.org/wiki/Flame_Nebula.

Light Saber / 178–79
NASA's press release about this celestial light saber also features a video that shows where it is located in the sky and gives a short 3-D view of how it is oriented in space: www.nasa.gov/feature/goddard/hubble-sees-the-force-awakening-in-a-newborn-star.

Lagoon Nebula / 180–81
Visit here for additional background and details about this photo: www.nasa.gov/image-feature/the-lagoon-nebula-gives-birth-to-stars.

Starbirth / 182–83
More background and details about this photo can be found at www.nasa.gov/image-feature/bright-blue-stars

M87 Black Hole / 184 (top)–185 (left)
This short YouTube video from the Event Horizon Telescope Collaboration provides details and a high-resolution computer animation simulation of what this stunning black hole environment would look like if we could view it closer at higher resolution: www.youtube.com/watch?v=v_Bk2997YMA.

Binary Black Holes / 184 (bottom)–185 (right)
More details and wonderful NASA videos featuring this computer graphics rendering of a double black hole system can be found at https://svs.gsfc.nasa.gov/13831.

Andromeda Galaxy / 186–87 (left)
You can find more details about this particular photo at https://photojournal.jpl.nasa.gov/catalog/pia04921.

Hidden Treasures / 187 (right), 188–89
To learn more about the N11 Nebula, the Hubble's Hidden Treasures program, and Josh Lake's winning entry, see the January 18, 2013, Space.com article by Tariq Malik "Astronomy Teacher Finds Hubble Telescope's Hidden Treasure" at www.space.com/19327-hubble-telescope-photo-galaxy-teacher.html.

Lost Galaxy / 190–91
For additional background and scientific details about this photo visit www.nasa.gov/image-feature/goddard/2021/hubble-takes-portrait-of-the-lost-galaxy.

Colliding Galaxies / 192–93 (left)
Wikipedia provides an in-depth exploration of the strange and weird examples of astronomical objects and phenomena compiled in Harlan Arp's *Atlas of Peculiar Galaxies* at https://en.wikipedia.org/wiki/Atlas_of_Peculiar_Galaxies. More details on this specific photo of Arp 91 can be found online at: https://www.nasa.gov/image-feature/goddard/2021/hubble-detects-a-dangerous-dance.

Spiral Giant / 193 (right), 194–95
Details and the science behind photos like this can be found at https://hubblesite.org/contents/news-releases/2020/news-2020-01.

Einstein Rings / 196–97
Explanations, diagrams, references, and the science behind Einstein Rings are described in wonderful detail at https://en.wikipedia.org/wiki/Einstein_ring. More details on this particular example, called GAL-CLUS-022058s, can be found at: https://esahubble.org/news/heic2109/.

Hubble eXtreme Deep Field / 198–99
Many more photographic examples and detailed scientific and technical information on all of the "Deep Fields" photographed by the Hubble Space Telescope can be found on this NASA site: https://hubblesite.org/contents/media/images/2012/37/3098-Image.html.

INDEX

A nighttime scene photographed on March 28, 2012, by one of the crewmembers of Expedition 30 on the International Space Station, while it was flying at an altitude of approximately 240 miles (386 km) over the eastern North Atlantic. The night lights of the cities of Ireland, in the foreground, and the United Kingdom, in the back and to the right, are contrasted by the bright sunrise in the background. The greens and purples of the Aurora Borealis are seen along the rest of the horizon.

PICTURE CREDITS

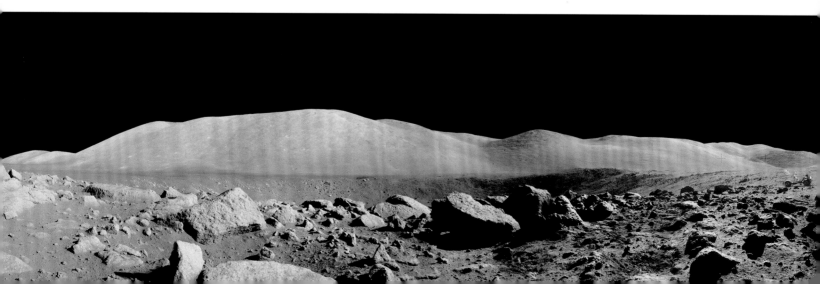

BELOW: Panoramic view of Apollo 17 astronaut Harrison "Jack" Schmitt bounding across the lunar surface; photo taken by fellow astronaut Gene Cernan on December 12, 1972; FOLLOWING PAGE: A NASA/JPL "travel" poster featuring a potentially habitable planet called TRAPPIST-1e, some 40 light-years from Earth; ENDPAPERS: An eroded mesa made up of rhythmically layered bedrock in an unnamed crater in the Arabia Terra region of Mars.

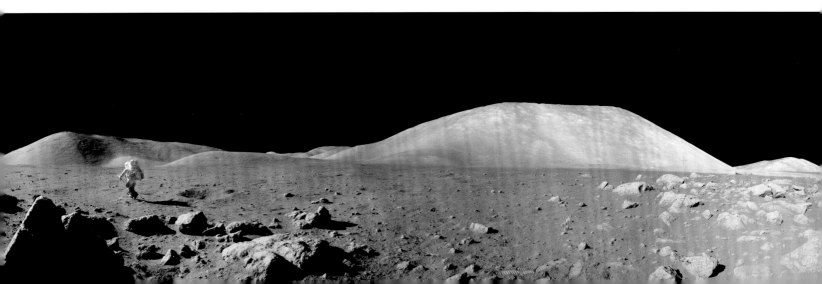